TREASURES FROM
THE BODLEIAN LIBRARY

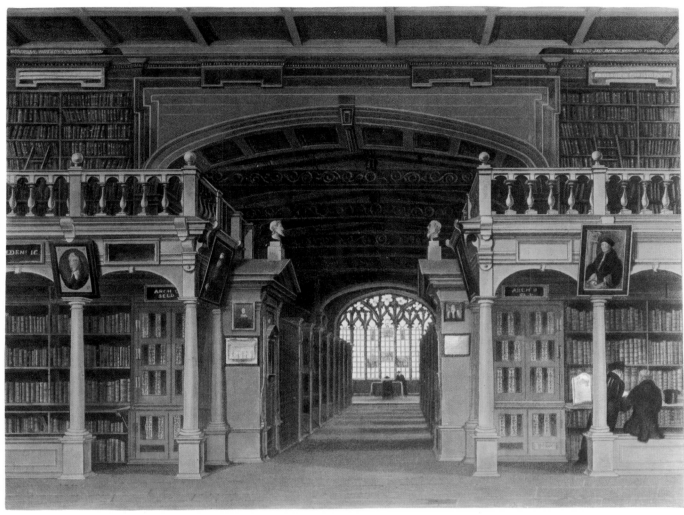

Duke Humfrey's Library from the Selden end
by R. Ackermann published in *A History of the University of Oxford*, 1814.

# TREASURES FROM
# THE BODLEIAN
# LIBRARY

A. G. AND DR W. O. HASSALL

INTRODUCTION BY

DR R. W. HUNT

KEEPER OF WESTERN MANUSCRIPTS

BODLEIAN LIBRARY
OXFORD

COLUMBIA UNIVERSITY PRESS

NEW YORK 1976

First published in Great Britain in 1976 by
The Gordon Fraser Gallery Ltd, London and Bedford
Copyright © A. G. and Dr W. O. Hassall, 1976
Introduction copyright © Dr R. W. Hunt, 1976
Printed in Great Britain

LIBRARY OF CONGRESS CATALOGING IN PUBLICATION DATA

Hassall, A. G.
Treasures from the Bodleian Library.

Includes index.
1. Illumination of books and manuscripts—Oxford.
2. Oxford. University. Bodleian Library.
I. Hassall, William Owen, joint author. II. Title.
ND2897.093H37 745.6'7'07402574 75-33231
ISBN 0-231-04060-1

# CONTENTS

# ACKNOWLEDGEMENTS

ALL STUDENTS of the treasures of the Bodleian in the Department of Western Manuscripts know the profound debt of gratitude due from art-historians to Professor Otto Pächt and Dr J. J. G. Alexander for bringing to publication the fruit of the wartime labours of the former. They issued their latest opinions on the dates and places of production of thousands of illuminated manuscripts in their magisterial three volumes of handlists: *Illuminated Manuscripts in the Bodleian Library*, vol.1, *German, Dutch, Flemish, French and Spanish Schools*, 1966; vol.2, *Italian School*, 1970; and vol.3, *British, Irish, and Icelandic School with addenda to volumes 1 and 2*, 1973.

In the present anthology, the descriptions of all except three manuscripts conclude with references to one or other of these three essential volumes – these three exceptions are Byzantine and Mexican manuscripts, for these fall outside their scope.

The prefaces of all the three volumes of Pächt and Alexander are of great importance to users of this book, as is self-evident to all specialists – and their numerous plates, albeit perforce sadly reduced in scale, give an indication of the appearance of the numerous manuscripts of which our volume only discusses three-dozen representatives.

These volumes need no praise here. But all too few have any consciousness of another debt of gratitude. This debt is owed by all users of Bodleian illuminated manuscripts and especially of the Bodleian Library's colour transparencies; and by all users of the unpublished card-index of bibliographical references to Bodleian Western manuscripts in printed works, the unpublished descriptions of the separate objects and subjects in all the separate pages of the Bodleian's illuminated manuscripts, and of the unpublished iconographic card-index of these. This is a most welcome occasion to make a public acknowledgement of this debt. For nearly twenty years a succession of devoted volunteers, unpaid and insufficiently recognized or even thanked, have dedicated much time to these labours and have made possible the selection, production, and distribution of the colour transparencies of the chief treasures of the Bodleian.

The acknowledgement of this general debt is an overdue duty; but it is indeed invidious to pick out particular names of those who have fulfilled the motto:

*Plurimi transibunt et multiplex erit scientia.*

[Many indeed will pass on and knowledge will be organized in manifold ways.]

For prolonged perseverance in describing individual pictures in thousands of manuscripts one cannot help mentioning Mrs A. Valentine and Mrs A. I. Spriggs who started a tradition which the Hon. Mrs J. Wilson and Miss B. W. Russell continue. Sir James Penney has indexed all their descriptions. I am especially grateful to Lord Phillimore and Lady Jackson who have helped to clarify my language.

Miss Ann Douglas and Miss Elizabeth Arkell have helped me with typing and Mr C. E. Braybrooke's photographic skill has helped us to see pictures in this volume almost as through the eyes of those that were young when the manuscripts were created. Finally, without Dr R. W. Hunt this work could never have been.

# FOREWORD

AN UNUSUAL CONTRIBUTION of this book to scholarship, education, and pleasure lies in its large format, its colour and its bibliographical references to the Bodleian Library's colour transparencies of the chief miniatures in the treasures in the Western Manuscript Department.

It is not generally easy, or indeed possible to study, understand, or appreciate properly a reproduction of a page of which one has never seen the original, if it has been much reduced in scale or has been translated into monochrome. Specialists in palaeography have long been aware of the importance of scale, but art-historians are perforce inured to the reduction in scale necessitated by the magnitude of easel pictures let alone of architectural monuments. Furthermore, their great tools, like the collection of photographs at the Courtauld Institute and the Princeton Iconographic Index, have much accustomed them to a grey world which has form, but is almost devoid of colour. Indeed, at least one famous art-historian actually prefers black and white reproductions on principle.

Existing facsimiles of many pages from the chief treasures of the Bodleian abound; but in them, giants have been generally changed into pygmies and the colours of the rainbow are often as if they had never been. The use of colour in mediaeval manuscripts must not be ignored. It is true that the colourist was often subordinate to the draughtsman; but, in looking at a facsimile with original tints, as well as of the original size we hope to read what was the artist's original intention, instead of a poor shorthand note of it. At least we can approximately see, as it were, through the eyes of his contemporaries. Sometimes colours are conscious symbols (like green in the hope of resurrection) and colours are always essential facts in a work of art and give significance to form.

Fresh flower colours at once suggest love and spring without any deliberate symbolism. Lurid reds and the threatening black of night can tell another story, of blood and war and the Devil and all his works. Pure white is good. Costly blue befits the robes of the Queen of Heaven, and gold and silver (when not oxidized) transport us into the resplendent world of the Middle Ages in a way that no grey reproduction can ever do.

# INTRODUCTION

THE BODLEIAN LIBRARY is the library of the University of Oxford. It has an earlier history going back to the fourteenth century which is represented now by the fifteenth-century room named after Humfrey, Duke of Gloucester, the most notable of the earlier benefactors and still used as the reading room for manuscripts and older printed books. In the sixteenth century the libraries of the Colleges replaced the University library proper, which ceased to receive new additions and was abandoned in 1556. It was not until 1598 that Sir Thomas Bodley, a former Fellow of Merton College who had left Oxford for a diplomatic career, offered to found a new University Library, which soon came to be known by his name. It was opened on 8 November 1602 after four years' planning and preparation by Bodley himself and by his first librarian, Thomas James. Two of the manuscripts in the present selection were in the foundation collection: the volume containing the drawing of Christ with St Dunstan at his feet (no.3), the earliest known English drawing, which was the gift of Thomas Allen, an Oxford resident, and the Book of Hours, illuminated by the artist known as the Master of Sir John Fastolf (no.27), which was bought with money given by Henry Brooke, Lord Cobham. Eight more illustrated in this selection were received before the death of Sir Thomas Bodley in 1613, all of them gifts, two of the most famous probably from the founder himself. These are the Alexander Romance (no.23) and the Apocalypse (no.18). The splendid thirteenth-century French Bible History (no.19) was the gift of Sir Christopher Heydon, a friend of Bodley. In 1612 the Dean and Chapter of Windsor gave to the Bodleian their collection of mediaeval manuscripts. This gift brought the Virgin and Child (no.10), one of the finest known English Romanesque drawings. Bodley and James, who was specially interested in mediaeval manuscripts, had given the Library a flying start.

In the following generation the Library received the gift of two large collections of manuscripts from Sir Kenelm Digby and from William Laud, Archbishop of Canterbury. Digby had been a pupil of Thomas Allen, already mentioned, and inherited his collection, which included the Abingdon Missal (no.30). Laud's collection was made for the University and greatly increased the range of languages represented. To him we owe the Mexican Codex (no.17). From his collection also comes another book illuminated by the Master of Sir John Fastolf (no. 29). By the end of the seventeenth century almost half the manuscripts in the present selection had been received, all of them gifts. It would take too long to enumerate each one, but mention must be made of the Caedmon manuscript, one of the very few illustrated Old English books (no.4), in the bequest of Francis Junius, the lexicographer (1677), and of the earliest manuscript in this selection, the Gospels from Birr in Ireland with an Old English gloss (no.1) often known by the name of its donor, Thomas Rushworth, Clerk of the House of Commons (c.1681).

The gifts of the eighteenth century were large, but chiefly of later manuscripts. A fine illustrated fifteenth-century French chronicle (no.28) was a gift from William Bouverie, Earl of Radnor, in 1767. The disturbances at the end of the century caused by the French Revolution, and the secularization of monasteries on the Continent gave an unprecedented chance to collectors. Two are represented in this book. The first is the Abate Matteo Luigi Canonici, a secularized Jesuit, who collected in the Veneto. A large part of his collection was purchased by the University in 1817. It greatly enlarged the representation of Continental schools of illumination, and provides examples of German and Austrian eleventh- and

twelfth-century illumination (nos.5, 13), as well as the two Italian (nos.26, 31) and the Byzantine (no.7) manuscripts. The other collector was Francis Douce, who bequeathed his manuscripts, books, and prints and drawings in 1834, being moved thereto by the courteous welcome he had received from Dr Bandinel the Librarian, on the occasion of a visit. Douce was a scholar with an eye for beautiful objects. He was able to secure illuminated manuscripts of the highest quality, and almost a quarter of the examples in the present selection are chosen from his collection. They include two of the best-known English illuminated manuscripts, the Apocalypse (no.20), fittingly called after Douce, and the Ormesby Psalter (no.22); but the Continental examples are no less fine, from the ninth-century Psalter (no. 2) written in letters of silver on purple-stained vellum to the beautiful volume of devotional works (no.33) written by David Aubert and illuminated for Margaret of York, Duchess of Burgundy, by the Master of Mary of Burgundy.

The early nineteenth century was a period of great activity in the Library, and the bequest of Richard Gough, the typographer and antiquary, was received in 1809. It included a small collection of English mediaeval service books, two of which are included in the present selection (nos.9, 21).

All great libraries are dependent on the generosity of benefactors for their chief treasures, and, as we have seen, the Bodleian is no exception, but the latest acquisition included here is a discerning and lucky purchase. In 1887 the Gospel-lectionary of Queen Margaret of Scotland (no.6) was bought at a Sotheby's sale for £6.

The treasures of mediaeval illuminated manuscripts in the Bodleian have only been fully explored since 1942 when Dr Otto Pächt, an art-historian from Vienna, forced into exile, was invited to undertake a survey. His stay in Oxford for twenty-three years was a stroke of good fortune for the Library, and it resulted in the publication of his survey, in collaboration with his pupil Dr Jonathan Alexander, between 1966 and 1973. It runs to over 2,300 items. In the meantime, Dr Hassall had become interested in the possibilities, opened up by advances in colour photography, of making more widely known the individual scenes locked up, so to say, in the pages of manuscripts. By enlisting the help of voluntary workers he has been able to build up a very large subject index, and on the basis of it to make many filmstrips. The number of separate colour slides so far available amounts to over 20,000. Dr Hassall has, therefore, had to make a choice from an abundance of riches, and I am glad that he has had the courage not to reject the familiar, and to make a volume that truly represents the treasures of the Bodleian Library.

R. W. HUNT

# TREASURES FROM
# THE BODLEIAN LIBRARY

ALL MANUSCRIPTS ARE REPRODUCED SAME

SIZE UNLESS OTHERWISE STATED

# MACREGOL GOSPELS

## OR
## CODEX RUSHWORTHIANUS

c.800, IRELAND, WITH ENGLISH GLOSS OF THE
SECOND HALF OF THE TENTH CENTURY

[PLATE I]

St Mark
MS. Auct.D.2.19 (Arch.F.c.36) folio 51ᵛ
349 × 257 mm / 13¾ × 10⅛ in. (Here slightly reduced)
Four 'author portraits' precede the Gospels, with an ornamental
page in later Celtic style facing each. There are also many small
ornamental initials and marginal ink-drawings.

## STYLE

These Gospels were written by MacRegol, Abbot of Birr in Co. Offaly, who died
in 822, and were given to the Bodleian by John Rushworth in the latter half of the
sixteenth century. This 'portrait' of St Mark is an excellent example of the ten-
dency of the early Celtic illuminators to make abstract patterns of everything,
including the human form. The point is driven home by a tenth-century ink-
drawing added on the back of our picture, in a formal but much more human
tradition. It occupies very nearly exactly the same space as our St Mark, and is
shown in much the same position (full face) and in much the same action (display-
ing a book). Even the lion leaps over his halo in the same sort of way. Further, the
proportions are roughly the same so that it seems the later artist has made his
drawing with reference to the faint markings from the earlier picture showing
through the semi-opaque vellum. But there the likeness ends. The later picture
shows a human figure treated decoratively, the earlier one a decoration which can
be interpreted as a man. Hands and feet, especially, in the later drawing are care-
fully studied and convincingly shown. In the earlier picture they are vestigial –
weakly drawn and in poor proportion – and have to be sought for. The face with
its black brows reminiscent of marks in musical notation, and the lion, with his
huge cruel claws and chequered coat, are drawn with much more spirit. When it
comes to the rendering of the purely decorative passage, however, a long tradition of
design for craftwork makes itself felt. In such passages as the interlaced beasts, the
scroll forms or the elaborate plaited ribbon shapes, there is an air of the accomplish-
ment and even sophistication that comes of traditional experience in this style.

[13]

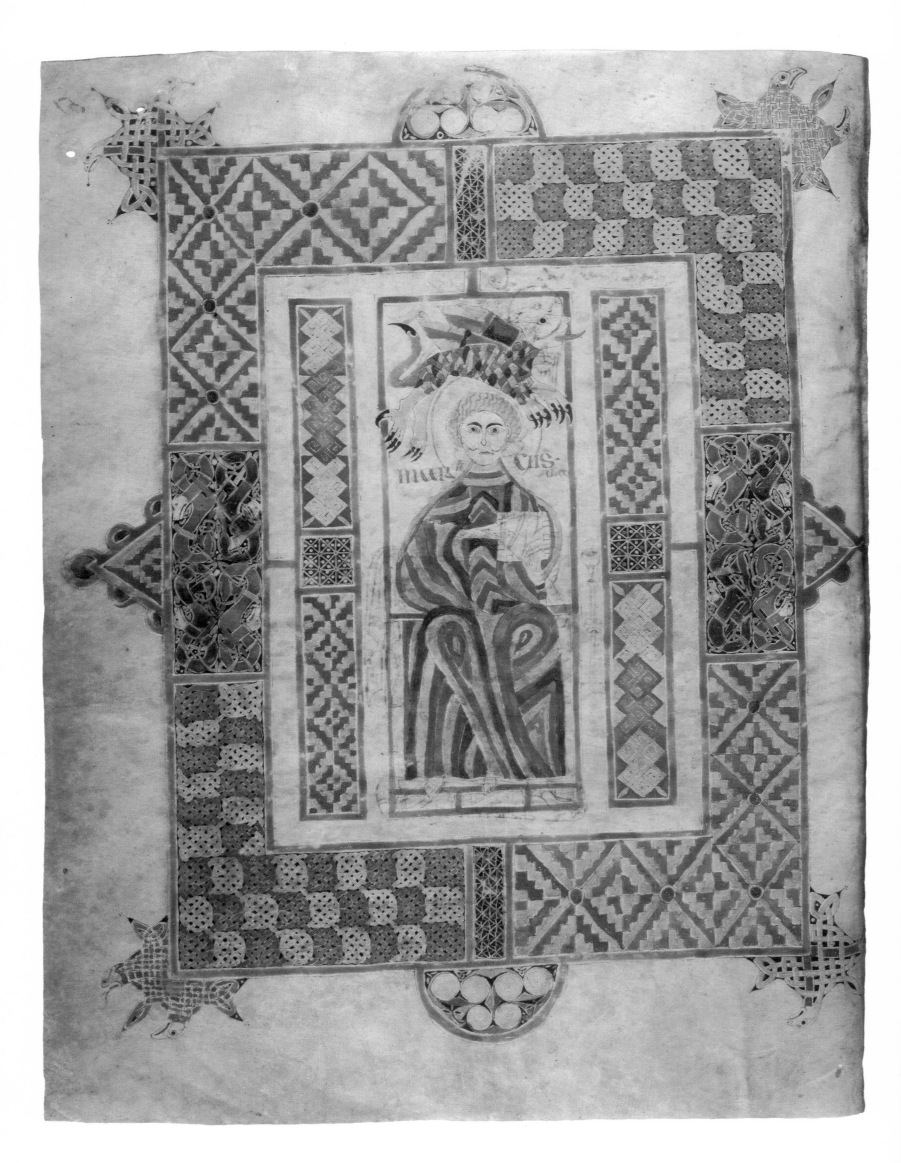

[PLATE I]

## FRAME

The page consists of an ornate border surrounding the Apostle, which is some 43 mm wide at top and bottom, and approximately 30 mm at each side. This border is divided into a series of rectangles and corner-pieces of differing proportions, each completely filled with 'carpetwork' typical of the Hiberno-Saxon style. It consists of interlaced strap- or ribbon-work in yellow and two shades of red, 'stepped' patterns in red and yellow with small circles of vivid green, like designs on graph paper for coarse weaving, and, in two narrow panels top and bottom, delicate trellis or diaper patterns formed by painting minute 'lines' in the tint of the natural vellum to tell against a black background. Two panels at the centre of the sides of the border contain writhing snakelike beasts with heads that resemble dogs twined among knotted and twisted cord. These are of great beauty and form the high-point of the style. With their vivid tints and sinuous curves, they remind us of that all too fascinating pagan beauty railed against by St Bernard centuries later for diverting Christian attention from the purer and more spiritual affairs of Christ. The border is further adorned with motifs jutting out from each corner. Two of these have yellow and red strapwork, the red continuing the outer line of the border and growing into a lizard-like head. The other two are somewhat similar in design but turn into vulture-like heads. The strapwork in the lower left-hand corner lacks the clarity given by the short black lines which border the straps. Neither of these two bird-head motifs is very clearly painted, and they suggest the work of a beginner who failed to interpret the interweaving strapwork as originally designed. Jutting out from each side of the border is stepwork within a triangle which is adorned with semicircles. At the top and bottom of the border are semicircles, patterned with spirals, the springlike lines of which are so delicate that through the centuries they have nearly rubbed away. Finally, on either side of St Mark are two tall narrow rectangles filled with step patterns and interlaces. In the centre of each a black square is decorated with red and yellow diaper patterning in lines and dots.

## PORTRAIT

St Mark is seated within a plain, narrow frame looking rather grim. He has a plain halo and is identified by his name MARCUS – one syllable each side of his head. His face, hands, feet and the book he displays are drawn in line, barely visible upon uncoloured parchment. His yellow hair, cut straight round his head, has a step pattern in red lines upon it. His robe bears stripes of green, yellow and two tints of red, and the folds are treated with great formality, especially about the legs. His symbolic beast – the lion – flies forward so as partly to obscure the saint's halo. Its face is more formal even than the lions of ancient Assyria, with its round 'blackcurrant' eye and its tongue like a young carrot. Although its wings could be a prehistoric monster's paddles, by contrast, its claws are ably painted and lovingly dwelt on – sharp, black, and wicked. A single curved claw seems to finish off its tail. Its coat, perhaps originally drawn as straps passing under and over each other, is painted in diagonal harlequin checks.

## COLOUR

The sole colours used are black for backgrounds and fine details; two reds, a pale purplish red and a carrot colour; yellow, and a very vivid, poisonous-looking green. The general effect is staggeringly minute and rather light upon the page. Opposite to this page is a brilliant pattern, abstract except for human- and beast-head terminals, and obviously designed to harmonize.

## BIBLIOGRAPHY

O. Pächt and J. J. G. Alexander iii.1269 (with ten bibliographical references)

Colour transparencies on Bodley rolls 135A (Irish and Anglo-Saxon illumination, 16 frames), 165B (early ornament, 44 frames), and 167A (details from Macregol Gospels, 10 frames)

# PSALTER

MIDDLE OF THE NINTH CENTURY

RHEIMS

[PLATE 2]

The Psalmist praying in affliction
MS. Douce 59 folio 100ᵛ
185 × 142 mm / 7¼ × 5¾ in.
This manuscript had three full-page miniatures with three full-
page initials facing them, but one of the miniatures is no longer in
the book. There are fourteen large initials for various other psalms
and small illuminated initials for the rest.

## PSALTERS

Psalters tended to be more heavily illustrated than the rest of the Bible because the
liturgically important psalms were illustrated so that they could be found easily.
While in England the psalms were divided into three (1–50, 51–100, 101–150),
farther south this division was eight-fold, illustrations being done for the first psalm
for matins each day and that for Sunday vespers. Some English psalters made the
best of both worlds and illustrated ten psalms in all: 1, 27, 39, 52, 53, 69, 81, 98,
102, and 110 (in the Authorized Version). Often these illustrations would depict
the life of Christ which, to modern eyes, may seem irrelevant in a psalter, but in
the Middle Ages the psalms were regarded primarily as prophecies foreshadowing
the events in the New Testament. The different themes chosen to illustrate differ-
ent psalms in different centres of illumination have been analysed in detail by
Haseloff to secure a basis for pinning down unlocalized psalters.

The most famous psalter from Saxon England in the Bodleian is the tenth-cen-
tury *Codex Vossianus* from Winchester which has numerous decorative initials
composed of interlacing plants or reptilian monsters (*lacertines*), but which does
not contain illustrations proper. Subsequently, psalters became the most important
productions of monastic *scriptoria* in the eleventh and twelfth centuries (see plates
8 and 9). Handsome illuminated ones are a speciality of the East Anglian school of
the late thirteenth and early fourteenth centuries (see plate 22) and superb exam-
ples were produced for the Bohun family at the end of the fifteenth century. How-
ever, no psalters in the Bodleian illustrate the actual text of each psalm like the
famous Utrecht Psalter.

[PLATE 2]

## INTRODUCTION

This portable psalter, written in gold letters on parchment stained dark purple, contains the Gallican text of the psalms which superseded the so-called Roman Psalter (followed in the *Codex Vossianus*). It has full-page miniatures only before Psalms 51 and 101, although originally a third miniature preceded Psalm 1. The late Professor Wormald suggested that their model was probably of fifth-century origin, which also served as one of the models for the Utrecht Psalter, one of the most celebrated manuscripts of the Carolingian School. However, as he noted, the Douce manuscript contains two good copies of the original both of which resemble it more closely than do the corresponding figures in the Utrecht Psalter. In the latter the general appearance is totally different, and its greater vivacity, due to the artist's vibrant, sketchy style, makes it deservedly famous as a lively work of art.

## STYLE

This manuscript is often given the name 'Charlemagne's Psalter', though there is no evidence to substantiate this claim. It belongs to that group of illuminated manuscripts, of which the Bodleian only possesses this one, associated with the Rheims school of Carolingian art. This flourished in the middle of the ninth century, and its illustrators drew inspiration from a number of 'late antique' manuscripts which still survived from the later Roman Empire (they have since perished). Ebbo, Archbishop of Rheims (816–34) and Charlemagne's librarian, became the central figure in the revival of such codices.

## FRAME

The scene illustrates Psalm 101 in the Vulgate (102 in the Authorized Version of the Bible), which begins, 'Domine exaudi orationem meam' ('Hear my prayer, O Lord'). The softly undulating scalloped border is white, brick-red, and gold, harmonizing pleasantly with the purple background. The corners (the lower left-hand one is damaged) flower into the fleur-de-lis form, with fine brushwork additions in white – a white that partakes a little of the purple tint of the ground.

## ILLUSTRATION

In the scene itself, at the back stands a dun-coloured building, picked out in gold, of classical type – a simpler variant of the Maison Carrée at Nîmes. Upon its red roof perches a plump and monstrous bird – the sparrow alone upon the house top of verse 7. God, robed in blue-grey, His left hand muffled in His garment and carrying a golden book, stretches forth His powerful right hand in a gesture of welcome from a cloud; His eyebrows, one flattened and one arched, and the feeling of movement in His pose give great vitality; the sleeve of the stretched arm is creased with the urgency of the gesture. The tortured victim has thrown back his head to regard his Saviour, and stretched out his own huge, clumsy hand towards Him. Apart from

this, the anatomy is well understood and the pink flesh-tint convincing, so that the artist has managed, even on this miniature scale, to convey an impression of distress. The poor man stands on a table, originally painted yellow, but much rubbed, and this apparently rests on a yellow plant-like form – perhaps a formal rendering of lighted straw which is burning round him – to illustrate literally the words 'my days are consumed like smoke, and my bones are burned as an hearth' (verse 3).

Of the two figures beside him, the crowned and cloaked one nearest to him stretches out monstrous hands as if to clutch him – the angle of the legs in both suggesting flight and pursuit. The crowned one wears a brick-red tunic, bordered with gold, and has brick-coloured stockings with, on his right leg, a white garter, oddly suggestive of the garter of the later Order of Chivalry. Its hanging ribbons float out with the wearer's rushing movement, his whole pose and the fretted folds of his cloak being instinct with nervous energy.

The movement of the three human figures, rushing forward, meets the counter-movement of God leaning down in the opposite direction. The flesh-coloured arms and hands form an arc of light across the dark purple (on which one can clearly see rulings made for a page of text). A feeling of climax about the two hands, the one entreating, the other stretched to succour, indicate the essential drama. In a moment they will touch, we feel, like those of God and Adam in Michelangelo's Sistine Chapel ceiling. Here is no classical sophistication, no elongated Byzantine elegance, but a sturdy, clumsy rendering, fresh with feeling and life.

## COLOUR

Purple, the imperial colour, came into wide use in the art patronized by the Emperor Otto (see plate 5) as a reflection of the imperial idea. Under the later Roman emperors, Tyrian purple was manufactured in certain imperial factories from a marine mollusc called *murex trunculus*, a univalve somewhat like a whelk but bearing rows of thin spines. During the imperial revival of the ninth century – Charlemagne was crowned on Christmas Day, 800 – artists developed various substitutes. Dr H. Roosen-Runge has studied a recipe book attributed to one Theophilus, carrying out the instructions with the accuracy of a trained chemist, and examining minutely the resulting products. In his studies he finds that one called *folium* was the most important. Sometimes this simply means purple, at other times it seems to be an alternative word for *tournesol*, a purple pigment discussed in late mediaeval treatises. More importantly the word can also refer to the leaf of a plant which was treated with urine to make purple. In the recipe of Theophilus this seems to apply to *crozophora tinctoria* or *croton tinctoria*, which was used in the South of France as recently as the eighteenth century for dyeing cloth. (Dr Roosen-Runge gives an interesting account of his first fruitless attempts to get juice for his experiments by planting seed from Palermo in the Munich Botanical Garden.)

[PLATE 2]

## DOUCE MANUSCRIPTS

Francis Douce, an irritable London antiquarian, was Keeper of Manuscripts in the British Museum, but resigned. His bequest went to the Bodleian, the biggest and most varied of all the collections bequeathed to it. It includes at least three dozen of the library's most important treasures, largely Gothic, often from France and the Low Countries. Further examples from his collection can be found in Plates 8, 20, 22, 24, 32, 33 and 35. The pictures in over 200 of his manuscripts have been indexed, and coloured microfilms published of a substantial selection of the pictures in some sixty of them.

## BIBLIOGRAPHY

O. Pächt and J. J. G. Alexander i.416 (with four bibliographical references)

*Bodleian Library Record*, vol. vii no.8 pp.359–82 (Double centenary issue)

G. Haseloff *Die Psalter illustration im 13 Jahrhundert* (1938)

Dr. H. Roosen-Runge *Münchner Jahrbuch der Bildenden Kunst* (1952–3), pp.159–71 (see also p.152 for a discussion of the word *folium*)

D. Tselos *The Sources of the Utrecht Psalter Miniatures*, Minneapolis, Minnesota (1960) p.9, fig.12

Colour transparencies on Bodley roll 230.2 (21 of the 45 frames on this roll refer to this manuscript)

# ST DUNSTAN'S CLASSBOOK

## SECOND HALF OF THE TENTH CENTURY

### GLASTONBURY

[PLATE 3]

St Dunstan at the feet of Christ
MS. Auct.F.4.32 folio 1 (Selden cupboard 64)
248 × 181 mm / 9¾ × 7⅛ in.
Other manuscripts bound in this volume are of various dates,
including a ninth-century fragment from Brittany and Wales.

## INTRODUCTION

This manuscript is a multifarious collection, including the alphabet of Nemnivus (or Nennius) derived from an old English runic alphabet and Ovid's *Ars Amatoria*, both in early Welsh scripts of the ninth century. The whole is of great interest as being one of the few manuscripts to shed some light on learning in England and Wales in the ninth and tenth centuries.

The picture illustrated is on the recto of the first page of a quire of material concerning the conjugations of the verb by the grammarian Eutyches. Though the writing is in the same hand as the text, the parchment is thinner than the rest of the quire, so that it is probably an addition.

[PLATE 3]

## ILLUSTRATION

The large, impressive Christ is shown full-length except for His feet which, with the front hem of His robe, lie behind the scalloped ground line. He inclines His head graciously towards His right shoulder, His eyes staring forward, His expression severe. He is apparently unbearded, though a curious convention of shading suggests coarse bristles that need a shave. His hair, so dark a sepia tint as to be almost black, is parted in the middle and flows down his back in crimped waves. The vermilion of His halo, between the arms of the cross which adorn it, is the only important piece of colour employed, the cross being left in the pale colour of the page. To judge from the rather scratched effect of its application, the colour has been applied with a pen.

Christ holds a sceptre and a book resembling a single sheet of writing. The former has three lines of red dots at the top, the symbolic 'flower' or 'branch'. Christ wears an undergarment with a plain band at the low neck, and an overgarment like a loose *kimono*, with a wide sash which flies unsupported into the air. With His inscrutable expression, calm pose, and the formal lines of His eastern-looking robes, He somewhat resembles an Asiatic god. At His feet kneels St Dunstan – a miniature figure in an attitude of abandoned adoration. His face rests on his right hand, whilst he gestures with his left. He wears a tonsure and a monk's hooded robe, with ankle boots, and the folds on his robe, like those of Christ, are composed in a formal pattern which reflects, but does not much resemble, natural appearances. The fretted edges to it give the drawing a lively quality, but its keynote is an ample rhythm and a practised grace. This important early drawing is monumental in its simplicity.

Along Christ's rod is written in Anglo-Saxon minuscules (the Eutyches is in ninth-century Caroline minuscules), 'Virga recta est, virga regni tui', which is part of Psalm 44 in the Roman Psalter. (In the Authorized Version this is Psalm 45.6, 'The sceptre of Thy kingdom is a right sceptre.') His left hand holds a book inscribed in the same hand, 'Venite filii audite me timorem domini docebo vos' from Psalm 33.12. (In the Authorized Version this is Psalm 34.11, 'Come ye children, hearken unto me; I will teach you the fear of the Lord.')

Mlle d'Alverny has shown that Christ's attributes are those of Christ as the wisdom of God (in three of her five illustrations, there is a small kneeling figure of some sort – one of them our own), as explained by St Paul in the first book of Corinthians (I.22–4): 'For the Jews require a sign and the Greeks seek after wisdom: but we preach Christ crucified, unto the Jews a stumbling block, and unto the Greeks foolishness; but unto them which are called, both Jews and Greeks, Christ the power of God, and the wisdom of God.' As the inscription on the book reminds us, 'Fear of the Lord is the beginning of wisdom'; the rod is a symbol both of chastisement and rule, yet at the same time it bears blossoms. A sceptre and book are also put into the hands of Philosophy by Boethius (*Consolatio Philosophiae*

I.i), where, however, the sceptre is in the left and the book in the right.

This duality is reflected also in the Latin *virga* (rod) which suggests *virgo* (virgin), as in Isaiah's prophecy (XI.I), 'And there shall come forth a rod out of the stem of Jesse, and a Branch shall grow out of his roots.' In fact, the picture illustrates in a stylized manner the 'branch out of roots', or the Latin *flos de radice* ('blossom out of roots').

## AUTHORSHIP

At the feet of Christ, above the saint, in English Caroline minuscules are two hexameter verses, 'Dunstanum memet clemens rogo Christe tuere / Tenarias me non sinas sorbsisse procellas' ('I pray Thee, Christ, protect me, Dunstan, in Thy mercy and suffer not the dark storms to swallow me'). This brings us to the question of the authorship of the drawing and text. The inscription at the top of the page, 'Pictura et scriptura huius pagine subtus visa est de propria manu sancti Dunstani' ('The picture and text seen below on this page are in St Dunstan's own hand'), would seem to give the answer, but is in fact much later and might not have been added before the early sixteenth century. The hexameter verses provide more convincing evidence that the saint was responsible for the text and might have done the drawing also. Certainly, drawing, text and scripts are all consistent with the period of his return in 957 from exile in Ghent. Although Wormald notes that the ink differs slightly in tone from that of the original design of Christ alone, yet the red is of a consistent quality in the initial of the verse, on the halo, and at the end of the rod, where the red dots seem an addition to the faint brown dots which once terminated it. Furthermore, three of the manuscript's four parts all contain additions in the same hand as that in which St Dunstan's Latin prayer to Christ is written. If this is indeed the hand of Dunstan it is interesting to recall that his earliest biography states that he corrected faulty books as soon as the morning light would allow.

## STYLE

Whether it is the work of Dunstan or not, Wormald shows that it is the first example of a new style in English manuscripts. The fluttering fold running across the body is characteristic of the lively, restless movement of Saxon figure drawings with their jagged folds. He compares the drapery found in manuscripts associated with the Gospels of Ada (perhaps the sister of Charlemagne) at Trier. Though it is less soft and flowing, he feels that the Ada manuscripts contributed to the new English style. The style of the drawing itself is notably calligraphic. This is especially apparent in the base of the fingers of the right hand of Christ which rather resemble the flourishes of the writing masters of later centuries. The grammatical contents of the quire remind one of the school-room, and this feeling is reinforced both by the humble kneeling monk, so small beside the huge Christ, and by the rod and book he bears. Christ would seem to be the 'dominie' in the Scottish sense of school-master, and Dunstan his humble pupil.

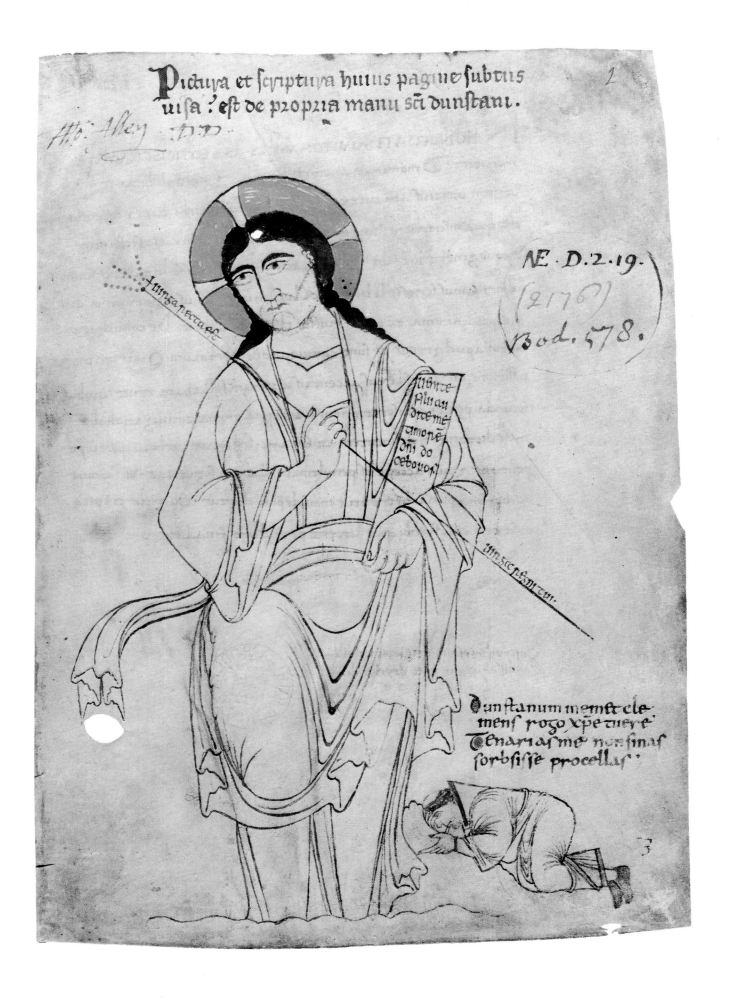

Pictura et scriptura huius pagine subtus
uisa est de propria manu scī dunstani.

Hꝰ Alley DD

NE. D. 2. 19.
(2176)
Bod. 578.

Dunstanum memet clemens rogo xpe tuere
Tenarias me non sinas sorbsisse procellas:

[PLATE 3]

## CATALOGUE NUMBERS

The 'L' in the top right-hand corner is the foliation in the hand of Gerard Langbaine. Langbaine (1609–58), a native of Westmorland, was Keeper of the Archives (1644) and Provost of Queen's (1646) and the father of a literary name-sake (1656–92). His description of this manuscript was the basis of that in the 1697 catalogue. The figure '3' in the bottom right-hand corner is part of the old Bodleian shelfmark given in the 1620 catalogue. This was later altered to NED.2.19. The number 2176 below this was the running number for this manuscript in the catalogue of 1697 and is the number under which the manuscript is found in the catalogue of Western manuscripts. 'Bod.578' is a press-mark assigned to the manuscript about the middle of the eighteenth century but it lasted only until the end of that century.

## BIBLIOGRAPHY

O. Pächt and J. J. G. Alexander iii.24 (with seven bibliographical references)

M.-Thérèse d'Alverny 'Le Symbolisme de la Sagesse et le Christ de Saint Dunstan' in *Bodleian Library Record* (1955–6), pp.232–44

R. W. Hunt *St Dunstan's Classbook from Glastonbury Codex Bibliothecae Oxon. Auct.F.4.32* in Umbrae Codicum Occidentalium iv (1961) complete black and white facsimile

F. Wormald *English Drawings of the Tenth and Eleventh Centuries* (1952)

D. R. Howlett 'The Iconography of the Alfred Jewel in *Oxoniensia* volume 39 (1974) pp.44–52 shows that 'The Alfred Jewel is iconographically in the mainstream of representations of Christ as Wisdom' and compares portrayals of Christ in the *Book of Kells*, the Junius Psalter and the Dunstan Drawing

Colour transparency on Bodley roll 135A (Irish and Anglo-Saxon illumination, 16 frames. Frame 16–slide B.44)

# CAEDMON GENESIS

c. 1000,

PERHAPS EXECUTED AT CHRIST CHURCH

CANTERBURY

[PLATE 4]

Fall of Lucifer
MS. Junius 11 page 3
324 × 197 mm / 12¾ × 7¾ in.
Important drawings occur on fifty-two pages of which four are
later additions. After p.73 a second artist is detectable who uses
coloured ink and whose work also appears in Corpus Christi
College, Cambridge MS.23.

## INTRODUCTION

The Caedmon Genesis (MS.5123 in the Bodleian classification) is a manuscript of
the Saxon period and illuminated in the idiom of Saxon life as known by the artists.
Although often ascribed to Winchester it may have been sent to Christ Church
Canterbury, since the illumination shows kinship with Canterbury work. It con-
sists of a metrical paraphrase of the Biblical narratives by the pseudo-Caedmon,
i.e. the Old English poems of Genesis (pp.1–142), Exodus (pp.143–71), Daniel
(pp.183–212), and Christ and Satan (pp.213–29).

It was written about A.D.1000, on parchment in Old English with normally
twenty-six (pp.1–212) and twenty-seven (pp.213–29) lines to the page, and is the
work of several hands. Sir Israel Gollancz, who has edited a facsimile, has done a
great deal of detective work on the artists concerned with the illustrations and
capital letters in this volume. He identifies three artists, the first of whom is a less
nervous draughtsman than the second and whose work is our concern here. His
illustrations are also somewhat less crowded than the second artist's compositions,
so that at times, though not in this illumination, they have a rather empty look.
The third artist appears to have worked on only one illustration and even that is
unfinished.

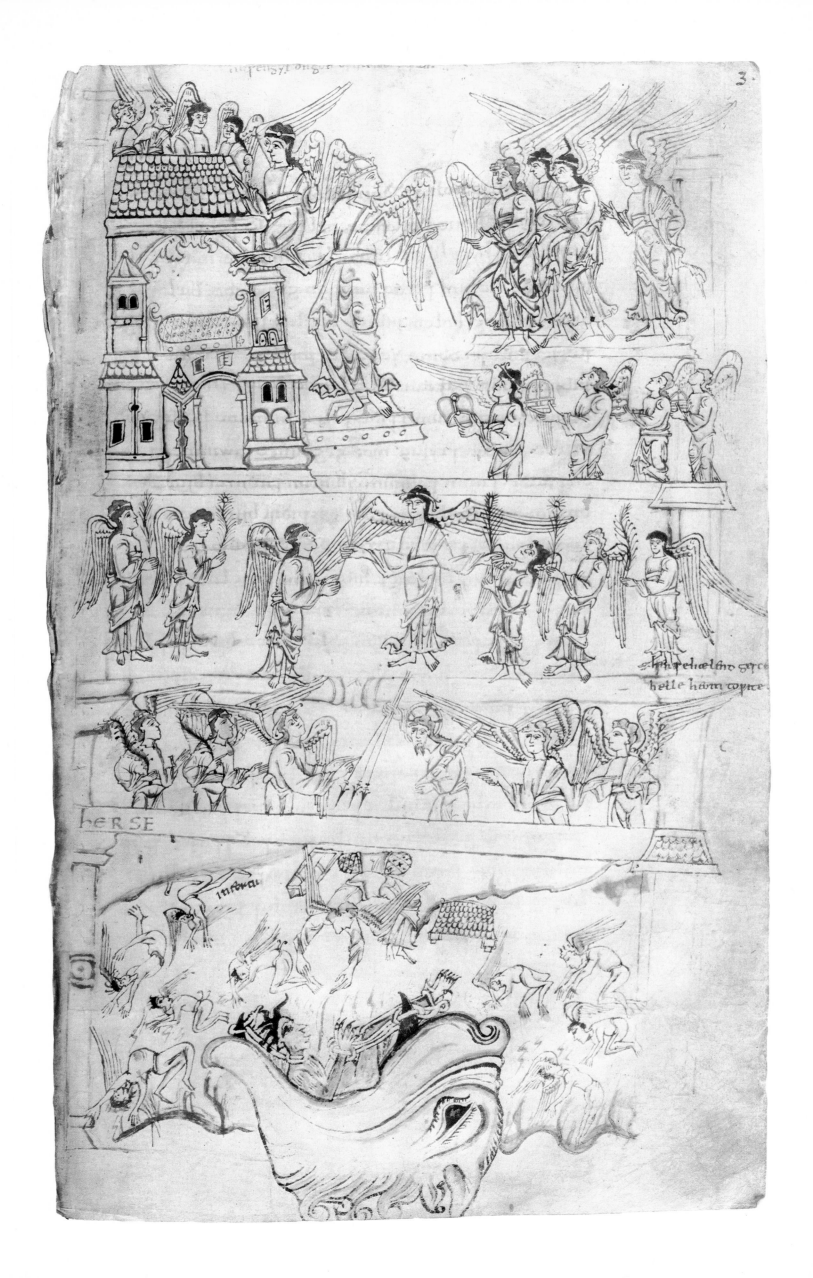

[PLATE 4]

## CAEDMON

The origin of the narratives is uncertain but the Venerable Bede in his *History of the English Church and People* recounts a traditional story of how a shepherd called Caedmon was inspired by God to write Biblical poetry:

'One night Caedmon had left the house in which entertainment was being held and went out to the stable . . . . At the appointed time he lay down to sleep and in a dream saw a man standing beside him who called him by his name. "Caedmon," he said, "sing me a song." "I don't know how to sing," he replied. "But you shall sing to me," the angel said. "What shall I sing about?" Caedmon replied. "Sing about the creation of all things." And Caedmon immediately began to sing verses he had never heard before . . . in praise of God, the Creator. When Caedmon awoke, he remembered everything he had sung in his dream and soon he added more verses, in the same style, to the glory of God.

'Having told his superior, the reeve, about this gift he had received, he was sent to the Abbess of Whitby who ordered him to recount his dream and the verses in the presence of many learned men so that they might decide their quality and origin. They all agreed that Caedmon's gift was from God and read to him scriptural passages which he soon put into excellent verse. The Abbess was so delighted with God's gift to Caedmon that she encouraged him to become a lay-brother in the community. He was instructed in scriptural history and turned it into such "melodious verse" that his delightful renderings transformed his teachers into his audience. Through his verses he always "sought to convert his hearers from delight in wickedness, and to inspire them to love and do good".' It was a natural mistake to attribute the poems in this manuscript to the famous Caedmon himself.

## LUCIFER

The story of Lucifer is mentioned in Isaiah XIV.12–15, Luke X.18 and Revelation IX.1–11, but does not occur in Genesis. However the *Bible Moralisée* (see Plate 19) equates the separation of light from darkness with the division of the angels into good and bad. In a version of the Creation different from that of the Bible, Ludolph of Saxony (d.1378) explains that God created man to fill the vacancies left by the revolt, and made Adam out of clay so that he might be more humble. In the mediaeval play acted by the craftsmen of Coventry God is shown on His throne adored by angels. Lucifer asks if their hymns of praise are intended for God or for himself, to which the good angels reply that they honour God. When Lucifer usurps the throne and is worshipped by bad angels, God expels him to the lower regions. The fall of Lucifer became a theological commonplace but was given new life in Milton's epic retelling, *Paradise Lost* (1667).

## COLOUR

All the illustrations are drawings with little solid tint. The ink is sepia in colour, and in our illustration some patches of solid sepia, almost black in tint, appear in such places as the hair of the fallen Lucifer, the eye and wicked fangs of Hell. Some working-up of the drawings with ink diluted to quite a pale brown has masked the delicate line in a rather clumsy manner. The artist has also introduced some colour symbolism. The angels and Heaven are red, while not only are the devils and Hell brown, but also the bad angels before the fall and the tempter in disguise. In other places the artist has used both red and green.

## ILLUSTRATION

This picture is laid out on a basis of four registers separated by parallel horizontal bars. Beginning at the top left-hand corner we see a splendid two-storeyed building, the Palace of Lucifer, its rooms open to view as in the sections of houses in the Bayeux tapestry – younger than the Caedmon manuscript by two generations. The roof has fishscale tiles which adorn two turrets. The windows are both round-headed and square. A round-headed arch in the centre of the building under the roof has a remarkable moulding of a free-flowing, plant-like nature. Within the palace on the upper floor is revealed Lucifer's empty throne, backless but with arm-rests and a well-cushioned seat. (Milton develops this theme which is very rare in art.) Angels of various sizes crowd the roof, while on a plinth stands Lucifer as high as the house, from which he turns, indicating it with two fingers of his right hand to a crowd of four angels who lean towards him encouragingly. Lucifer wears a crown. His left hand holds a staff but he manages also to point with his left forefinger to the four angels towards whom he is turned. He appears to be smiling. Below, also to the right but truncated by the dividing bars of the picture, four more angels advance towards Lucifer with crowns in their hands, offered as symbols of authority. In the second register the black-haired figure of Lucifer, now the dark Satan with a simple wreath instead of a crown, triumphantly receives gifts of palms and flowers from bad angels on either hand.

Having dealt with the rise of Lucifer in the two upper registers, the artist devotes the two lower to his fall. In the third register a haloed figure with a forked beard and bearing on his left arm what is probably an Anglo-Saxon sceptre of the type found at Sutton Hoo, raises his right hand threateningly, shaking three javelins in anger. He is, of course, the avenging Creator. Angels appear on either side of Him, apparently in expostulation. Two carry palms. The vivid bottom register contains the final drama. Hell's mouth, as so often, is seen as a vast head, jaws gaping, maned like a lion, and with a large and lively eye. Within its fleshy jaws lies Satan, no longer a handsome blond, the most beautiful of all angels, but wild and ugly, open-mouthed and choking, linked to one fang of the monstrous Hell by a strangling neck rope, while his manacled hands and feet are tied to another. His feet and fingers have become claws, his dark hair as agitated as the flames that consume him. Lucifer appears twice in this register by virtue of what is known as 'continuous narrative'

[PLATE 4]

representation. Above the ugly Satan writhing in the mouth of Hell, can be seen the falling Lucifer, contorted but not without traces of his former beauty, and wearing a pensive look. Around him there fly in pieces the throne, the roof, portions of his palace, and, in grotesquely expressive positions, the disobedient angels. Two have only one wing apiece and one has the back legs of a frog.

## CONCLUSION

The illustration is notable for its vivid interpretation of how Lucifer, the Prince of Light in Heaven, lost in his fall all his angelic qualities. The depiction of Hell's mouth, a popular mediaeval motif, is interesting because this was a contribution of Anglo-Saxon art to Christian iconography. Another early picture of the fall is in the Aelfric manuscript now in the British Museum.

## HISTORY OF THE MANUSCRIPT

Francis Junius was born in 1589 at Heidelberg where he was educated by his father and by G. J. Vossius. In 1620 he was in France, but the following year came to England as librarian to Thomas Howard, Earl of Arundel. While a member of the Howard household he frequently visited the Bodleian Library, and published a number of works on antiquarian and philological subjects, later becoming tutor to the Earl of Oxford. He visited the Netherlands in 1642 and 1644–6, and in 1651 went to live with his sister in Amsterdam and The Hague. From there he visited Frisia and mastered the language of its people. During the next twenty years his interest in the northern countries resulted in the publication of a number of works, the chief of these being a glossary of the language of the Goths, produced before 1665. The laborious Junius came back to England in 1674 and two years later returned to Oxford to live near his old pupil, Dr Marshall, then Rector of Lincoln. Before his death on 19 November 1678, Junius gave all his Anglo-Saxon manuscripts, including his Ormulum, the Caedmon poems, and his philological collection, to the University.

Before it came into his collection the MS. was owned in turn by Isaac Vossius and by Archbishop Ussher until 1651. The text was published by Junius (Amsterdam, 1655) and again by B. Thorpe (London, 1832), the drawings in *Archaeologia*, vol.24 (1832) as plates 52–101. The whole has now been reproduced in facsimile for the British Academy with an introduction by Sir Israel Gollancz.

## TEXT

At top of the page mutilated by binder:
hu s[e] engyl ongon ofermod wesan
'How the angel began to be proud.'

At right hand side:
her se hae lend gesce [op]
helle heom to wite
'Here the Saviour created Hell
as a punishment for them.'

At left hand side:
Her se . . . [uncompleted line]
'Here the . . .'

inferni [in later hand]
'The infernal'

## BIBLIOGRAPHY

O. Pächt and J. J. G. Alexander iii.34 (with seventeen important bibliographical references)
I. Gollancz *The Caedmon Manuscript of Anglo-Saxon Biblical Poetry* (Oxford, 1927)
T. H. Ohlgren 'Five new drawings in the MS. Junius 11: their iconography and thematic significance' in *Speculum* vol. xlvii (1972) no.2, pp.227–33
T. H. Ohlgren, 'Visual Language in the CÆDMONIAN GENESIS' in *Visible Language* vol. vi (1972) no.3, pp.253–76
O. Pächt *The Rise of Pictorial Narrative in Twelfth Century England* (1962)

Colour transparencies on Bodley rolls 172 (41 frames), 172E (22 frames) and 228.6 (10 frames)
    A complete black and white filmstrip is published (with notes by W. O. Hassall) by Educational Productions, East Ardsley, Wakefield

# GREGORIAN SACRAMENTARY

c.1020 OTTONIAN STYLE

'REICHENAU' (OR ALSACE)

[PLATE 5]

The Empty Tomb
MS. Canonici Liturgical 319 folio 95ᵛ
244 × 181 mm / 9⅝ × 7⅛ in.
This manuscript contains six important illuminated pages: a gold
cipher, the Crucifixion, the Nativity and the Annunciation to the
Shepherds (in two panels), the angel appearing to the women at
the tomb, the Ascension and Pentecost.

## SACRAMENTARIES

A sacramentary was reserved for the celebrant of the Blessed Sacrament, and it
contained those parts of the Mass which never varied throughout the year, and the
collects for the whole year (but not the epistles). The canon of the Mass, as the
prayer of consecration is called, begins, 'Te igitur clementissime Pater oramus'
('Most merciful Father we humbly pray and beseech you'), and in an age which
loved symbolism, this opportunity for the artist to give special attention to the
letter T must have seemed a particularly happy one, since it lent itself so con-
veniently to a depiction of Christ on the cross; indeed the cross is sometimes rep-
resented in the exact shape of a letter T and called a 'tau cross' after the Greek word
for that letter.

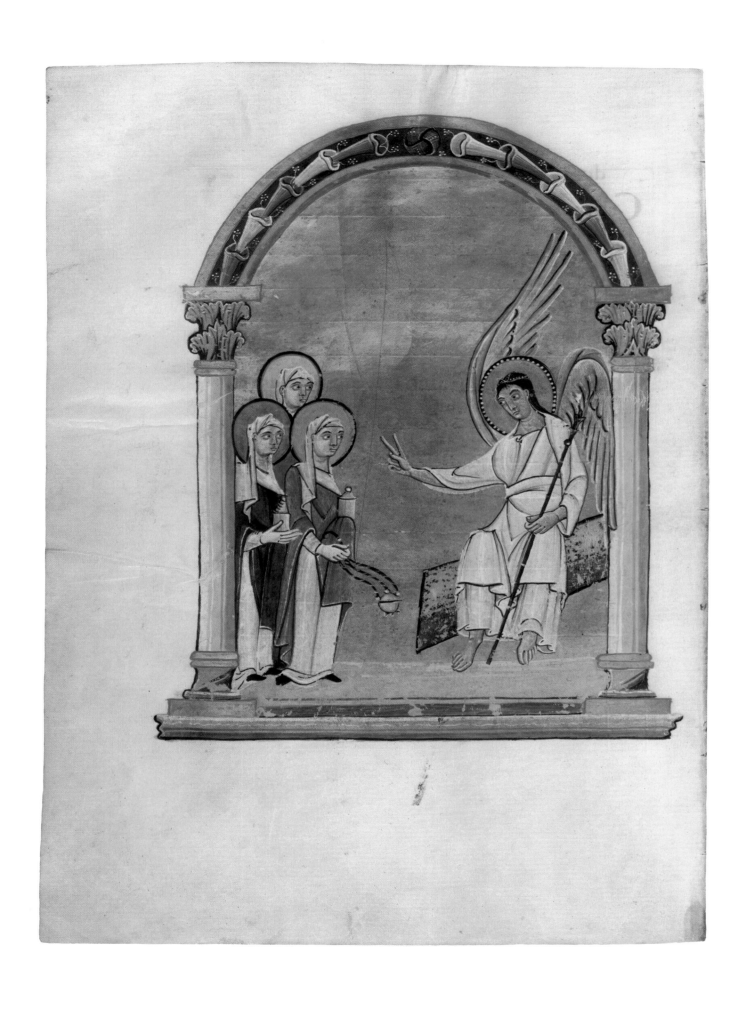

[PLATE 5]

Sacramentaries rank with Bibles, psalters and gospels among the great books of the Merovingian and Carolingian periods. Yet even before the eleventh century missals had begun to incorporate the sacramentary with much else, giving increased attention to those parts of the service which vary during the liturgical year. As a result sacramentaries were obsolete by the thirteenth century.

## THE OTTONIAN RENAISSANCE

D. H. Turner has exploded the accepted belief that this Sacramentary was produced at the Benedictine Abbey of St Mary, Reichenau, sometime before 1042, for in that year Eberhard, Canon of Reichenau, was made Patriarch of Aquileia Cathedral in north Italy, and he appears to have taken it with him. Reichenau, an ancient monastery founded in 724 on a small island in Lake Constance, became one of the great artistic centres of tenth-century Europe (many of whose manuscripts are now at Karlsruhe). It reached the height of its fame during that revival of art between 912 and 1002 often referred to as the Ottonian Renaissance after Otto I (the Great, 912–73) and his two successors, likewise named Otto. While the style of its art, both in manuscripts and wall-paintings, is based on early Christian models, a particular fondness for patterned backgrounds composed of geometrical designs of birds or monsters reflects a somewhat Oriental spirit, possibly due to the influence of the Carolingian school at Trèves. Gold backgrounds, haloes with dotted borders, and large prominent hands are common features of the Ottonian school. But the local variants of Trèves, Cologne and Echternach are an interesting field of inconclusive controversy between specialists. An existing Byzantine influence was reinforced when in 972 Otto II married the daughter of the Byzantine Emperor, Romanos II (959–63). Like Byzantine manuscript illumination Ottonian art depends upon variously formed masses of colour and is the antithesis of the linear art of Anglo-Saxon England (plate 4).

## FRAME

The plate illustrates the three Marys at the empty tomb, unfortunately somewhat defaced by ruling, horizontal for the writing and vertical for the margins. The scene takes place under a round-headed arch whose central motif is a ball consisting of a twisted strap with shading. On either side of it, trumpet-shaped forms, somewhat floral in appearance, are arranged decoratively – one emerging from the other. Shading and white highlights clearly indicate their form, and delicate formal sprays embellish them. The arch rests on columns of classical form with acanthus capitals. These are not mere decorative supports. Shading is consistent and 'flutes' and other architectural details are clearly shown.

## ILLUSTRATION

The background is clear gold and the lid of the coffin upon which the angel sits floats unsupported. The three Marys, crowded together on the left of the picture, stare at the angel with raised brows, big-eyed and uncertain. The bluish shadow round their eyes, noses, and jaws is treated with particular delicacy and skill. Each Mary wears a white head-kerchief with blue shading, and a mantle over a white undergarment, all three varying in tint – pale purple, grey blue, and a dull purplish crimson. Their haloes, unlike that of the angel, are not gold but contrast pleasantly with the mantles worn – palish blue, ochre yellow, and the curiously flat green in use in this manuscript. The women's shoes peeping from under their garments are black. Their heads, all shown three-quarter face, are highlighted skilfully with white on pale buff complexion. A crease in the neck, which the French call *collier de Vénus*, is clearly indicated in two cases. One Mary carries an ointment pot with fingers that do not really hold it; her white sleeve protrudes from her mantle. Another swings a censer with one hand and has pulled back her mantle to give her right arm free play. The details of the censer, such as the three minute legs on which it can stand upright and the way the cords are gathered together into a toggle at the top, are clearly shown. The censer-swinging Mary has muffled her left hand in her cloak, and also carries an ointment pot. The third Mary's hands are not visible as she stands behind the others with only her face and a portion of her mantle showing.

The angel, somewhat larger in scale than the Marys, regards them rather admonishingly, making a sign of benediction to them with his right hand whilst in his left he carries a staff, which bears a crucifix-shaped terminal. He is seated on the lid of the sepulchre but, whereas his legs are quite ably foreshortened as if studied from a model sitting in a chair, the angle of the lid is sharply tilted so that his position on it is not a natural one. Even so, it is much more telling and dramatic than if seen in 'correct' perspective, sideways on. The angel wears a larger halo than the woman, gold and surrounded with a decorative band. His face is pinker and less delicately tinted for although it bears the same white highlights, the shadow does not have the delicate bluish tint of theirs. He has long, straight black hair and wears a small, decorative white circlet on his head. His robe is white with plentiful blue shadow, his overmantle pale yellow with shadows of greenish blue. It is worn over one shoulder in graceful, classic style, and the falling of this overmantle over the knees is particularly convincing. The angel's hands and feet are coarse, however, his gesture of benediction like a child's gesture at shadow play; the left thumb holding the staff appears swollen. The wings are a violet grey with summary, but convincing plumage. The right wing stands proudly displayed, but the left is folded over in an uncomfortable position in order to be packed into the frame.

The Marys walk on green flooring and surge forward on their errand. The angel's gesture is arresting, but though his head turns towards them his body is nearly frontal. It was a long tradition – Duccio was still following it in Siena in the late thirteenth and early fourteenth centuries – to show the coffin lid, as here, presented to the spectator. Its

[PLATE 5]

bright green with darker shadows or markings suggests the resurrection of nature like that of Christ at Easter time. The painting well conveys a lively expectancy disappointed.

On the opposite page to this scene is a somewhat similar frame containing an initial letter on a purple ground.

The Three Marys were said to be three daughters of St Anne by three different husbands. The best Biblical texts do not say that three Marys visited the tomb, but they do occur in a text of the Vulgate which was common in the middle ages. The *Historia Scholastica* spread the idea that Mary Magdalene, Mary Jacobi and Mary Salomé were the three Marys who visited the tomb, but identification of the three Marys differs.

## HISTORY OF THE CANONICI MANUSCRIPTS

The manuscript itself comes from the collection of Matteo Luigi Canonici (1727–1805), a Jesuit collector. After the suppression of his order in Parma in 1768 he not only lost a great number of medals and books but also a collection of pictures that his superiors disapproved of. After a second suppression in 1773, Canonici retired to study history in Venice, where he formed further collections of books and manuscripts, including the libraries of the Duke of Modena and Giacomo Soranzo among his purchases. When he died his heirs inherited about 3,550 manuscripts which, twelve years later, the Bodleian Library bought in one of its largest acquisitions. These are now divided into eight sections: Greek (including four of the most handsome Byzantine manuscripts in the Bodleian – Canon. Gr. 36, 38, 103 and 110), Latin classical, Latin Biblical, Latin patristic, liturgical, miscellaneous, Italian and Oriental.

### BIBLIOGRAPHY

D. H. Turner 'The Reichenau Sacramentaries at Zurich and Oxford' *Revue Bénédictine* lxxv (1965), pp.240–76. (He calls this the 'Liuthar' style of Ottonian illumination, points out that Eberhard was a Canon of Augsburg not of Reichenau and shows that this Sacramentary lacks connections with Reichenau)

O. Pächt and J. J. G. Alexander i.25 (with three bibliographical references)

# ST MARGARET'S GOSPELS

## 1025–50, ENGLAND

[PLATE 6]

St Matthew
MS. Latin Liturgies f.5 folios 3ᵛ and 4.
172 × 111 mm / 6¾ × 4¼ in.
This manuscript contains four fine 'author portraits' with
decorative pages of text facing, of which this is one.

## ST MARGARET

St Margaret (d. 1093), to whom this gospel-book belonged, was the granddaughter
of Edmund Ironside and the Queen of Malcolm Canmore, who succeeded his
father, Shakespeare's Duncan, after Macbeth was defeated in 1054. Through her
daughter, Matilda, Queen of Henry I, she became the source of the only Anglo-
Saxon blood in the veins of King Edward I. We have a very attractive biography of
her by her chaplain, Turgot, who says that her best-loved book was a beautifully
bound gospel-book with portraits of the evangelists in gold with gold capitals. It
was once dropped, unnoticed, into a stream at a ford, and was found lying open.
The water had washed away little bits of silk inserted to protect the gold from
rubbing but otherwise it was, by a miracle, practically undamaged. Elsewhere
Turgot tells us that, though the King could not read, he doted on this book be-
cause Margaret loved it so much.

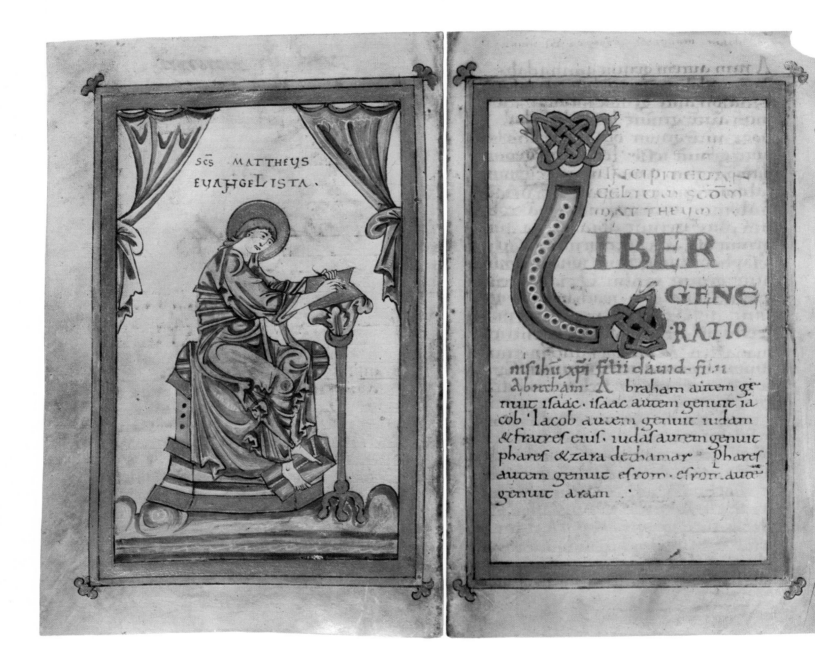

SCS MATTHEVS
EVAHGELISTA.

LIBER
GENE
RATIO

nis ihu xpi filii dauid· filii
Abraham· Abraham autem ge
nuit isaac· isaac autem genuit ia
cob· Iacob autem genuit iudam
& fratres eius. iudas autem genuit
phares &zara dethamar· Phares
autem genuit esrom· esrom autem
genuit aram·

[PLATE 6]

## GOSPEL-BOOKS

Gospel-books were a great feature of the ninth and tenth centuries. The Book of Kells at Trinity College, Dublin, and the Lindisfarne Gospels are supreme examples of the early 'Hiberno-Saxon' type exemplified in the Bodleian only by the MacRegol Gospels (see plate 1). Early ones follow the order of the Bible but later they use a liturgical one for convenience in the services – sometimes in selected form for use on important occasions and sometimes complete.

## STYLE

A full-page miniature of each evangelist precedes the passages for his gospel, and as in most Byzantine gospels the customary symbols of the evangelists are not shown. Opposite each portrait there is a decorative page of text with the beginning of the gospel in a frame which matches one on the facing page. Facing the picture of St Matthew, writing, there is an illuminated initial 'L', standing for *Liber*. It is decorated with the kind of interlace which is especially characteristic of Celtic art but the portraits show very little trace of the Celtic fondness for turning every form into an abstract surface pattern. The main colours are dark red, blue, green, and gold, the backgrounds being left uncoloured. Margaret Rickert points out that the style is not unlike the impressionistic technique of Rheims as seen in the gospels of Ebbo, Archbishop of Rheims (816–45), now in Epernay Municipal Library. For a good discussion of related works of art see Wormald's *English Drawings of the Tenth and Eleventh Centuries* (1952).

## PORTRAIT

### 'SANCTUS MATTHEUS EUANGELISTA'

Within a plain rectangular frame whose outer corners sprout into the form of modest Byzantine palm-leaves sits St Matthew, writing. Curtains, one slate blue, one carrot colour, are knotted back to reveal him, as he turns towards us with a non-committal expression, half-eyeing his work. Over an undergarment of soft blue, whose rather loose sleeves are tucked up to facilitate writing, he wears a toga-like mantle of a somewhat cooler blue, elaborately folded and allowing only the sleeves and lower skirt to remain revealed. His left hand holds open the golden pages of his book and in his right he holds a quill that has curled at the end because the feathering has been stripped away. He works at a rather improbable lectern that resembles a long-stemmed flower supported on three legs; his seat, which has neither back nor arm-rest, bears a drapery flung over a striped bolster and is elaborately moulded at the base. The saint's bare feet rest upon a footstool the perspective of which, as with footstools elsewhere in this manuscript, appears to have given the artist peculiar difficulty. The carrot-coloured ground, because it is scalloped into three vigorous hummocks and finished with a blue horizontal stripe next to the margin, could even be read as uneven ground near the banks of a stream.

## COLOUR

Colour plays an important part on the page here, redeeming it from a certain sparseness, the effect of which is more evident in monochrome reproduction. The darker portions echo, in part obscure, the delicate quill pen underdrawing, though they serve to brighten and lend emphasis to the appearance of the page. There are altogether three types of blue in this picture, each with two degrees of intensity.

The two shades of carrot colour, one browner than the other, are both in at least three shades of intensity from quite dark brown to a pinkish brown nearly transparent. The saint's halo, his book, the stem and foot of the lectern, parts of the seat and the inner part of the frame are of gold and there are a few delicate gold areas elsewhere. A very little fine opaque line-work in white may just be made out here and there, notably on the carrot-coloured curtain. Apart from a minute touch of pinkish fawn on the right foot, the saint's skin is left the natural colour of the parchment, giving it – at least in the case of his rather monstrous writing arm – the look of dead flesh.

## CONCLUSION

Drawing and colouring are throughout of an extreme formality – witness the formal arc-like curves on knee and shoulder and the fretted ends of the drapery which, typical of this school and style, appear to be raised and floating. Although the most treasured gospel-book of a pious Saxon lady, it has nothing feminine about it, being, indeed, in general appearance somewhat severe.

## HISTORY OF THE MANUSCRIPT

The manuscripts classified under the heading 'MS. Latin Liturgies' in the Bodleian catalogue are those which came by miscellaneous routes to the Library and did not form part of some great private collection or library like the Douce, Gough, and Canonici manuscripts. The letter 'f' in the middle of the shelfmark is a standard Bodleian indicator of the size of the original volume.

The St Margaret's Gospel contains the names of various owners and was bought in 1887 for £6. W. Forbes-Leith produced a facsimile in 1896. The portrait of St Luke may be seen in *English Art* by D. Talbot Rice, and St John in Miss O. E. Saunders' *English Illumination*.

[PLATE 6]

TEXT

Incipit Euan
gelium secundum
Mattheum
LIBER
GENE
RATIO
nis Ihsu Christi filii Dauid. filii
Abraham. Abraham autem ge
nuit Isaac. Isaac genuit Ia
cob. Iacob autem genuit Iudam
et fratres eius. Iudas autem genuit
Phares et Zara de Thamar Phares.
autem genuit Esrom. Esrom autem
genuit Aram

Here begins the Gospel according to St Matthew. The book of the generation of Jesus Christ, the son of David, the son of Abraham. Abraham begat Isaac, and Isaac begat Jacob; and Jacob begat Judas and his brethren; and Judas begat Phares and Zara of Thamar; and Phares begat Esrom; and Esrom begat Aram . . .

## BIBLIOGRAPHY

O. Pächt and J. J. G. Alexander iii.44 (with eleven bibliographical references)

W. Forbes-Leith *The Gospel Book of St Margaret* (1896) facsimile

H. Roosen-Runge *Farbgebung und Technik Frühmittelalterlicher Buchmalerei* (1967) pp.69–71

Colour transparencies on Bodley roll 135A (5 of the 16 frames refer to this manuscript)

# GREGORY
## OF NAZIANZUS,
# SERMONS

c.1100, CONSTANTINOPLE

[PLATE 7]

Gregory of Nazianzus
MS. Canonici. Gr. 103 folio 2ᵛ
311×241 mm / 12¼×9½ in. (Here slightly reduced)
There are twelve illuminated pages in the manuscript of which
one is the portrait here reproduced; four have decorative
headpieces and all, except the portrait, have ornamental initials.

## INTRODUCTION

This manuscript containing the sixteen homilies of Gregory of Nazianzus, which were read on certain feast days, was illuminated at Constantinople during the late eleventh, or early twelfth, centuries, and is one of twenty manuscripts in existence that illustrate all, or most, of the sixteen homilies. There also exist manuscripts which illustrate all forty-five homilies of Gregory. Three manuscripts of the homilies are in the Bodleian Library, the pictures from which Professor George Galavaris has reproduced (see Bibliography). However, since they are in black and white only, it is impossible for them to demonstrate visually what he says of MS. Canon. Gr. 103, 'The subtleties and brilliance of the color point to Constantinople as the place of origin.'

## GREGORY OF NAZIANZUS

Gregory was born at Nazianzus in Cappadocia. Having studied at Athens for at least ten years, he left it in 356. Although he dreaded the responsibility of becoming a priest he eventually did so, and after some ten years' service as such, in 372 he was appointed a bishop.

In this portrait Gregory is shown writing. Such early pictures of authors at work yield a wealth of details about chairs, writing-desks and reading-lamps. This is particularly interesting for the information it gives us for such objects during centuries from which few 'bygones', let alone good antique furniture, can survive. Thus, in spite of the high seriousness which informs all Byzantine art, this particular illustration abounds in homely, even at times playful, detail.

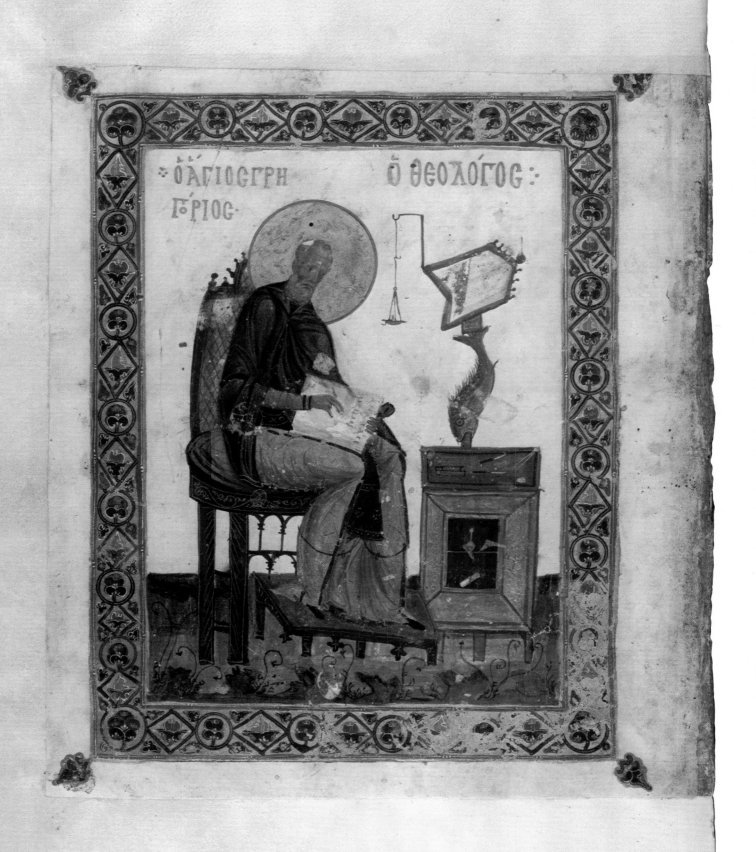

[PLATE 7]

## FRAME

A rectangular gold frame surrounds the portrait with narrow inner and outer borders of red touched with a white line. At each outer corner there is a formal, unidentifiable plant form, in gold, with touches of red and white, mainly painted in the deep indigo blue which characterizes rather similar ornaments within the border. These corners are not precisely alike, three having a somewhat trefoil form. That at the bottom right-hand corner is more slender and the blue trefoil mass has lost its identity under a spontaneous little running line of white which gives the impression of the artist's release after a day's labour. The border is painted with alternate touching circles and lozenge shapes, the circles being larger at each corner and filled by a flower rather similar to those at the outer corners but clearer and simpler. These could be interpreted as indigo-coloured pansies with vermilion centres and touches of white. The lozenges are filled with flower-like forms in profile, having blue sepals and vermilion petals, as if folded before opening out. Miniature leaf forms, in the blue touched with white, spring from four positions in the circles, except that the large ones at the four corners have three of the leaves and, in the extreme corner where room is limited, each bears a brisk little curl in blue and white. The leaves are inclined to the trefoil form but the centre runs at times to a sharp point. They are not identical and remind one of the plainer, less indented, sorts of ivy.

## PORTRAIT

Against a plain background, instead of the customary Byzantine gold, sits Gregory, tall, thin, ascetic, with light hair, beard and moustache. The length of his age is indicated by bushy eyebrows, deep eye-sockets, and a lined, dome-like forehead; his mouth droops at the corners and his cheeks are sunken. His musing gaze, concentrated on the little flame of his lamp, suggests a snapshot portrait taken when, his pen at rest in his hand and with a genteelly straightened little finger lying still on the volume, the saint had paused for a moment to shape a sentence or pursue a thought. Although the physiognomy follows the general Byzantine rules to depict men of grave and saintly character, this portrait is much less formal than the rest of the picture. With fresh, pink cheeks on an aged, putty-coloured skin and modelling in soft-grey blue, his head is conceived in a painterly fashion and lies oddly against the enormous halo of gold with a vermilion edge. Gregory wears a carrot-coloured undergarment, the right sleeve of which protrudes from an overmantle of deep grey-blue. A border runs round the hem of the latter. Above it two conventional flowers give the effect of a minute stencil and serve to indicate the form beneath. On the upper part of the mantle, inside and under the right arm, a pale border of parallel lines and the pattern OXO can be discerned. All this and the highlights of the mantle are picked out in varying degrees of pale grey-blue, leaving the basic colour to suggest folds and the passages in shadow. A different technical approach is employed in the undergarment. Here the folds and shadow are painted in a darker, brownish red, at times with a very fine, wiry line. There seems also to have been an attempt to highlight and to run round the hem rather fretfully in a colour that was perhaps white originally but which has become grey-blue with age. Narrow black shoes peep out from the hemline and a crude and summary line of black both outlines the front profile of the legs and touches the cuffs of the figure. A fine black line, caught up in the middle of the hem of the overmantle, runs round the figure at shin height, as if to keep the voluminous pleats of the undergarment bunched against the legs.

He sits with knees at a sharp angle so as to support a book. On it are visible the two lines of buff letters he has written, though his small, red-brown pen rests on the page some way from them. His right hand holds the pen in a fashion that cannot have been comfortable – the thumb is tucked right out of sight, the next two fingers protrude in a rigid arc, the third is tucked under and the little finger shoots out as if to hold the parchment down. If Byzantine writers really wrote in this position it must have required a very great deal of practice. The left hand clasps the book and here the upper garment is bunched up in a very natural fashion against the volume.

Gregory is seated in an elaborate chair upon an oval cushion of cobalt blue and vermilion – except for the gold the brightest passage on the page. A small semi-circle rather like a neckrest springs out of the wooden top of the chair, which is adorned with lively turned knobs. Diagonal lines in a deeper red-brown that criss-cross over the basic carrot colour of the chair-back and 'neck rest' inside the wooden frame bring to mind the padding and buttoning of much later upholstery. The wooden part of the chair is painted a dull dark brown picked out in white lines, with a running curvilinear pattern of spray form round the seat. The most interesting part of the chair occurs below the seat and consists of very delicate round-headed tracery forms, in two rows, one above the other, but difficulties with perspective make it unclear quite how these are placed.

The writer's feet rest lightly on a rectangular footstool, the wooden part of which matches the wood of the chair while the 'upholstery' (or leather) is of a darker red-brown. Between the legs hang down carved trefoils. Again, the artist has experienced much difficulty with the perspective and positioning of the legs. Though three corners are visible only two legs spring from them; a front one at the left has missed its corner which is filled instead with a hanging trefoil. The front edge of the stool has three legs which may be interpreted in various ways, though one, at least, probably represents the leg at the back. If this really did show in natural vision, the footstool could not have been so steeply inclined towards the spectator. This tip-tilting is a universal error in children's drawing, though sometimes given an important significance by writers on Byzantine art. Similar perspective difficulties over the 'lectern' and the cabinet on which it stands have beset the artist at every turn. The 'lectern', adorned with turned knobs and painted white with pale blue shadow, is so

[PLATE 7]

tilted that it should perhaps be interpreted as a reflector for the lamp, especially as it is directly behind it. This consists of a shallow bowl, suspended from a metal bracket and swinging from a hook, where a tiny flame is produced, presumably, by a wick floating in oil. The whole is painted in very fine lines of bright blue. The 'reflector' (or 'lectern', although I incline towards the former) has one large knob at its angle which perhaps could be turned to adjust it and is supported on a block resting upon the tail of a very lively curved fish. This is swallowing a thick rod placed upon a flat support, tilted upright like a perpendicular wall so as to display an array of delicate penknives and writing aids. The fish itself is painted with some *bravura*: a row of spines along his back suggest fins; his eye is round; his expression as, writhing, he swallows the pole or rod that supports him, suggests dismay. The brown fitment on which he rests is supported on a carrot-coloured cabinet, with three legs visible and much adorned with fine, grey-white tendril patterns in line. The side of this cupboard which faces us is mitred and has a rectangular opening painted black. A fine grey line across this black passage indicates a shelf, on which rest objects not easy to identify but presumably connected with writing, and below which lies a tiny white scroll, tied with crossed red ribbons.

The saint's chair rests upon a ground of green, shading to blue-green, as if he were working out of doors, still a custom among modern icon-painters. Wherever there is room for them on the green are patterns in blue, very freely executed – irregular masses, both sharp and curved (perhaps intended to be clods of earth), and delicate, rhythmic lines, perhaps attempts at uncurling fronds of grass.

The paint is not wholly opaque so that it is fairly easy to identify which colours were applied above others in some passages. Thus, the white page was painted over the dark overmantle, and the centre fabric – if fabric it be – of the stool was laid on after the elaborate tracery underneath the chair.

The blank margins of the leaf have been patched and mended. It is mounted onto fresh parchment making it a standard size with the other leaves of the book. Colour has flaked, notably on the side of Gregory's head, his left arm, part of the chairback and the bottom right-hand margin, where much of the colour is lost but the gold below the pattern remains unspoiled. The patching has been done somewhat unsympathetically, a plant form at the top right-hand corner being partly obscured by a strip of parchment that might better have been affixed to the (blank) back of the page.

Both in ornament and facial type, as also in the use of window tracery to decorate furniture, one sees the beginnings of characteristic Gothic forms of some two centuries later.

This manuscript was exhibited in the Byzantine exhibitions at Edinburgh in 1958, and Athens in 1964.

## TEXT

Ὁ Ἅγιος Γρηγοριος     Ὁ Θεολόγος
The blessed Gregory     The Theologian

## BIBLIOGRAPHY

O. Pächt *Bodleian Library Picture Book* no.8, pls.7, 25, 26 and 29
*Edinburgh Festival Society Catalogue of Byzantine Art* (1958) no.204
G. Galavaris 'The illustrations of the liturgical homilies of Gregory Nazianzenus' in *Studies in Manuscript Illumination* no.6 (1969)
E. B. Garrison *Studies in the History of Mediaeval Italian Painting* (Italy, 1962) vol. iv, no.2, p.133

Colour transparencies on Bodley roll 103B (all 12 illuminated pages)

# PSALTER
## AND LIFE OF CHRIST

1175–1200, NORTHERN ENGLAND

[PLATE 8]

The Crucifixion with Mary and St John
MS. Douce 293 folio 13
257 × 174 mm / 10⅛ × 6⅞ in.
Fourteen full-page scenes of the life of Christ from the
Annunciation to the Resurrection, arranged in historical order,
lead up to one full page of the Virgin and Christ enthroned and a
second at the beginning of the Psalter proper, 'Beatus vir'
('Blessed is the man'), the opening to Psalm 1. These precede
handsome initials for the liturgically important psalms. The text is
written in lines of alternate red, green, and blue.

## INTRODUCTION

This psalter was connected with Durham between 1170 and 1183, and is an inter-
esting example of twelfth-century art. An experienced hand was responsible for
the psalm initials, but the sixteen illuminations illustrating the life of Christ are
bold and primitive, even crude. For example, the gold-leaf is not well applied; the
artist only attempts full face and profiles, and in some cases has clearly experienced
difficulty with the latter. This illumination, which is treated as a picture within the
frame of a decorative border, is perhaps the most conventional of the whole spec-
tacular series. The treatment is broad and simple, the analogy with wall-painting
clear.

[PLATE 8]

## FRAME

The border consists of a green line bent in a form similar to the Greek key pattern. The two upper corners are mitred and the pattern adapts itself to this, though the right-hand arrangement is considerably larger than the left. The bottom left-hand corner is also mitred and the pattern fitted around this in a somewhat desultory fashion; however, the lower right-hand corner is not mitred and the pattern here does not match. Inside the green key pattern are arcs of blue and pale mauve, the spaces between which it was intended to fill with gold, but this has been carelessly applied so that it is missing more often than not.

## ILLUSTRATION

The colours are opaque and bright. The cross is green, symbol of the living tree, and the background a raw bright orange, enriched with little clusters of white dots arranged in threes. On each arm of the cross, at the top of the picture, is a demi-figure in profile, facing inwards and carrying upon his shoulder the martyr's palm.

Christ hangs suspended from the nails in the palms of His hands. His hair hangs down in black locks, but the colourist has failed to realize the intention of the draughtsman here and painted two locks on each side instead of the three clearly drawn. The flesh is white, outlined in black, with a little work in greenish grey to indicate shadow, and both Christ's face and that of His mother are a shape characteristic of the artist, a long oval. The mouths, too, are typical – a shape not unlike a seriffed capital 'I' lying on its side, and a single dot placed above it. Christ has a pale mauve halo, with a golden cross upon it. His eyes are closed, shadowed below. His ribs and belly are formally indicated in grey-green. His right foot lies above His left, but the nails have not been indicated; instead a knot of green fastens Him to the cross. (Our artist delights in knots, and has tied the Virgin's veil at one side into an unnecessary knot.) He wears a blue clout, edged with gold, lined on His right with green and on His left with a pinkish mauve, and hanging down in front is a sort of apron in this same colour – perhaps a misinterpretation on the painter's part of an ordinary fold, which ought to have been blue.

The Virgin inclines her head towards Christ, her hands crossed over her breast. Nose and eyes are summarily indicated in grey, while a little black hair is visible under the veil. Under this she wears a blue mantle, a wide green skirt decorated with intersecting diagonal white lines and below this an underdress of the same colour as her veil, bordered with gold, the train of which is shown, as elsewhere in this manuscript, in an odd manner, like a bowl on its side. Small pointed black shoes peep out from under her golden hem.

The Virgin and St John both have haloes of plain gold. The saint inclines his head towards Christ but his body draws away from the cross. He carries a golden book in his left hand, but his right hand supports his face, which pose combined with his two currant eyes gives him a look of alert surprise. His beard is long and, like his hair, outlined in black and painted in blue and white stripes. His bare feet impinge upon the border. His right arm wears a sleeve of a pink mauve tint, the folds of which, gathered into a plain banded cuff, appear to have been misinterpreted. Flung over one shoulder is a pale blue mantle, revealing robes of two colours below: the uppermost, of the same tint as the one visible sleeve, has a gold band at the hem in front, which incorrectly turns into a red band after a pleat, and beneath this is a green robe, also with a hem of gold; the skirt of this is adorned with a thin design in black and white, of lines and dots.

J.–K. Huysmans has popularized in *The Cathedral* the idea that St John the Evangelist was a virgin. According to the *Historia Scholastica* John was intended to be the bridegroom at the marriage of Cana, but Christ persuaded him to remain celibate and provided a less spiritual husband just as he changed the water into wine. That is why it is unusual to find St John bearded, as here, when the Virgin is entrusted to his care at the foot of the Cross. Though St John has a beard in Apocalypse pictures his hairless face normally distinguishes him sharply from St John the Baptist.

## CONCLUSION

The whole has the crude vitality of peasant art, but the colourist makes a somewhat summary job of his part in the business. This is particularly notable in a band of gold behind the scene just above the level of Christ's knees, and which is not only not carried right across, but only outlined in part.

The pictures in this manuscript have all been reproduced as colour transparencies and some are familiar through two of the Bodleian Library picture-books.

## BIBLIOGRAPHY

O. Pächt and J. J. G. Alexander iii.168 (with five bibliographical references)

Professor C. Nordenfalk 'Insulare und Kontinentale Psalter illustrationen aus dem xiii Jahrhundert' in *Acta Archaeologica* (1939) pp.107–20

Colour transparencies on Bodley rolls 167F (12 frames), 171B (20 frames)

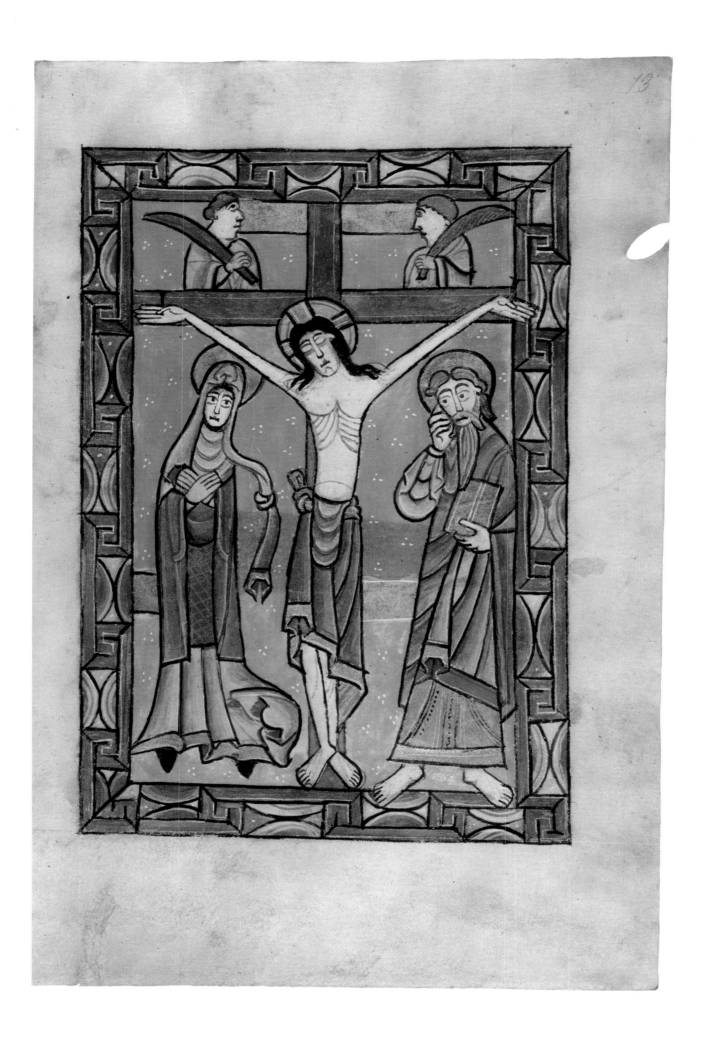

# PSALTER

[PLATE 9]

The Annunciation to the shepherds
MS. Gough Liturgies 2 folio 14
260 × 190 mm / 10¼ × 7½ in.
A series of twenty-two vertical full-page illustrations of the life of
Christ with one picture of David, followed by historiated initials
for certain psalms.

## INTRODUCTION

Although six of the pictures in this psalter are reproduced in two of the Bodleian
Library picture books and T. S. R. Boase's *English Art 1100–1216* (Oxford, 1953),
they are not so well known as they should be because Margaret Rickert does not
mention the manuscript in her *Painting in Britain: the Middle Ages* (Penguin Books,
1954).

[PLATE 9]

## FRAME

A simple border in parallel stripes of green, gold, blue (with paler dots) and shades of pink frames this picture, leaving the ample margins plain. Above, in red, is written the subject. The tall announcing angel, a very masculine figure, with short wavy hair, and a somewhat quizzical expression, takes one stride forward, right hand raised, the index finger stiffened to command attention. In his left hand he carries, somewhat awkwardly, the scroll of his announcement, which has been left without writing and which swings across to the opposite corner of the page. This interferes with the free movements of the shepherds, the oldest one of whom has grabbed at it with his hand, as if to lift it out of his way.

## ILLUSTRATION

The background is rich gold. The ground is formally arranged with green hummocks on which are summary suggestions of plant form. Standing upon the hummocks, with their contorted attitudes dictated by the small amount of room allowed them, are the three shepherds. The artist conforms to the tradition so often exemplified by the three Magi by making one an old man, one middle-aged, and one a stripling youth. The old man wears a green hood, and is using his shepherd's crook like a crutch. His long pointed beard is brown, his forehead furrowed, and he gives the angel an intent, glaring look, as he steps upon a green hummock in bare feet. He is clothed in a short blue tunic, a pink cloak and grey trousers gathered tight to the ankles. His middle-aged companion looks back at him, whilst indicating the presence of the angel with his right hand. In his left hand he holds his crook, which somewhat resembles a modern hockey stick, awkwardly between his feet as he steps forward with bent legs in some danger of tripping over it. He wears a cloth thrown over his head and shoulders, a short grey tunic, pink hose and black ankle-boots laced and buttoned with white. The youngest shepherd rests his left leg, with knee bent, on a green hummock, his right leg being straight, the foot treading on lower ground. His left elbow rests on the raised knee and this hand holds his crook. He looks up at the angel, his right hand indicating the marvel with an expressive gesture. He wears a pink hooded cloak and a green tunic, fawn hose, and black ankle-boots with white lacing. The green hummocks are crowded with the horned sheep, lying or standing, among which frisk three long-horned goats coloured dark blue. Two form a motif famous since the times of remotest antiquity, standing upright on either side of a formal tree from which they are browsing with their heads thrown back. A coarse-haired hog snuffles avidly against the bottom margin, and a curly-tailed dog, of the type so often seen in English monumental brasses, barks at the appearance of the angel.

In the case of the last two animals, the fawn-coloured paint has partially rubbed off, and it is possible to see the delicate red lines of the draughtsman underneath. These outlines the colourist has tidied up with a strong black line, and given the dog a collar with a single bell hanging from it, where it would seem three little bells around the neck were originally intended. Many awkward passages, especially in the cloth hanging over the angel's left arm, which somehow comes out at the right side, suggest a misinterpretation by the colourist. A sheep lying on the hillside has a long tail hanging over the horns of a goat which is in fact in front of it, while the dog's left forefoot is painted over the tree which is in front of him – in short, the illustration is concerned with ideas, not accuracy of visual appearance. The angel's wings, for instance, are not of the same proportions, because their size is dictated by the amount of room allowed to them. Also, the artist is obviously fascinated by a formal method of indicating a fold in the hem of garments, a shape which resembles a black arrow pointing upwards, touched up in white. The general effect is of a flatter form.

## COLOUR

The colours are limited to pale green, blues in several shades, a fawn, which has not adhered too well in some larger passages, grey and a carrot pink. As so often, one is left with the impression that the colouring is by a coarser hand.

## GOUGH MANUSCRIPTS

Richard Gough (1735–1809) went to Cambridge, where he did not take his degree, and later became Director of the Society of Antiquaries (1786–99). By inheriting a fortune in 1774, he was able to pursue his hobby of book-collecting so that in the end his library contained seventeen liturgical books; most of his large collection was devoted to English topography and incorporated many books and views collected by earlier enthusiasts like Ducarel, Blomefield, Peter Le Neve and Hutchins. In fact topography was his main interest and the subject of most of his own publications. Perhaps his most famous acquisition is the earliest English road map, produced in the fourteenth century, and now generally called the Gough Map. He made an important bequest to the Bodleian, including part of a series of drawings of monuments in France presented by the artist, M. François-Roger de Gaignières, to Louis XIV. The rest of the series is in the Bibliothèque Nationale in Paris.

## BIBLIOGRAPHY

O. Pächt and J. J. G. Alexander iii.290 (with three bibliographical references)

Five of the miniatures are reproduced in 'Scenes from the life of Christ' in *Bodleian Library Picture Book* no.5 (1951)

Mrs G. M. Spriggs discusses shepherds of the Nativity and their crooks in 'Shepherds abiding' *Country Life* (Christmas number 1974) pp.710–14

Colour transparencies on Bodley roll 161F (26 frames, all from this manuscript)

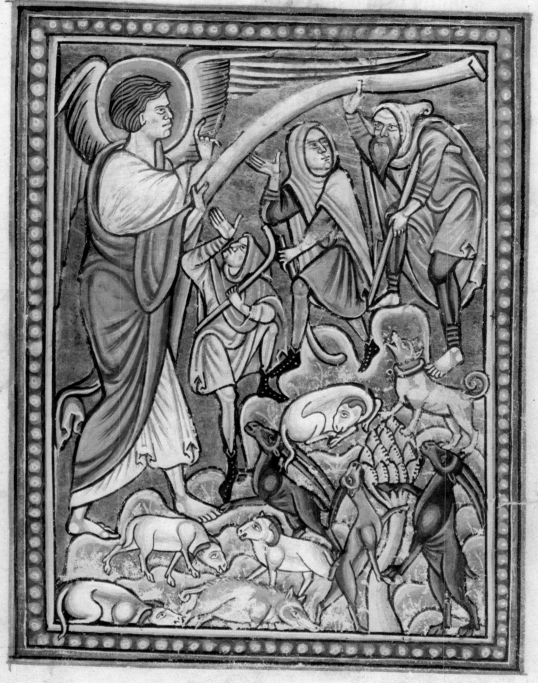

# AUGUSTINE,

## COMMENTARY ON

## PSALMS CI–CL

1125–50,

EYNSHAM, OXFORDSHIRE

[PLATE 10]

Virgin and Child
MS. Bodley 269, folio iii
393 × 286 mm / 15½ × 11¼ in. (Here slightly reduced)
This manuscript contains one miniature with a capital E (for
*Ecce*) on the verso elaborated with leaves and with human and
animal heads. Most of the other initials have been left untouched
by the illuminator. On three leaves (folios 48ᵛ, 49, and 75ᵛ) there
are small creatures drawn in the margins.

### PROVENANCE

No certain evidence exists that this copy of St Augustine's *Commentary* on the last
fifty psalms originated in Eynsham, but it must have been in the monastery by the
fourteenth century as it bears the library pressmark. Because this mark, 'B IIII' in
red, is not unlike the press-mark of Titchfield priory, it was suggested in *The
Summary Catalogue of Western Manuscripts* (1922) that there might be some connec-
tion. However, the library catalogue at Titchfield has been printed and it has been
noted that this Manuscript would not naturally have been placed in that division
of the library at Titchfield to which this mark would have applied.

The Benedictine abbey of Eynsham, on the Thames some six miles upstream
from Oxford, was first founded in 1005. Aelfric the Grammarian was the first
abbot and has left in the *Colloquies* an intimate picture of the various occupations
pursued in the Anglo-Saxon settlement. At the Norman Conquest the monks all
fled, but the monastery was re-established under the patronage of the Bishops of
Lincoln. Its most famous monk, Adam, who became chaplain to Hugh, the saintly
Bishop of Lincoln, in 1197, wrote the *Vision of Edmund*, a monk of Eynsham who
described a visit to the other world made with St Nicholas in 1196. Adam became
abbot in 1213 but was deposed for incompetence and perjury in 1228.

[PLATE 10]

## DRAUGHTSMANSHIP

The colours used in this illustration are, as is to be expected at this period, of a rather transparent nature – inks rather than paints – and they appear to have been applied by a fairly coarse quill in the case of the large areas of green and purple in the two circles of the figure of eight. However, the outer border of scarlet in the upper circle does not bear these scratch marks and is more opaque. It may well have been applied with a brush, like the opaque blue on the initial letter on the verso. The ink is dark sepia, diluted to varying degrees of intensity.

## FRAME

Miss Dorothy Callard has recently noticed that the rows of rectangles in the margin contain varying linear patterns which were apparently an early equivalent of dominoes. Some form of ruler must have been used on the outer rectangular border and the guidelines continue downwards (in scratched form) beyond a half-completed horizontal ink line which suggests the beginning of another 'domino' in the perpendicular part of the border. In the centre of this part of the border the artist has drawn in the corner of one 'domino' but forgotten to put the pattern in it, while the two final 'dominoes' of the half-finished horizontal border are not complete, almost as if the artist was interrupted before he had finished. The two large circles have undoubtedly been produced by mechanical means, both for the underdrawing, which is continued beyond the ink work of the lower circle at the point where the upper circle cuts it off, and for the ink-drawing itself, where varying degrees of pressure of the pen support the idea of its being attached to some form of compass. Indeed the prick made by the compass-point is clearly to be seen for each circle, that on the lower being just below the Christ Child's left foot, that on the upper just above His right thumb. The radius of the lower circle is approximately 84 mm, that of the higher about 83 mm. (The circle of the brilliantly executed curved initial E on the verso corresponds very nearly with one of the inner circles of the upper portion of the illustration, and the green paint from the initial-letter page has unfortunately worked through.)

## COLOUR

There is very little solid colour, apart from the broad stripes of the circles in the figure of eight, the Child's green halo, the green object He holds, which is presumably a book, a few trifling touches like the green shadow in the folds of His robe at the hem, and the tongues of the beasts. These last are the only significant touches of colour, the shape of which is freely painted in, without being either an echo or an infilling of a pen-drawn design. In the main, the colour lies side by side with the ink lines and serves to emphasize them, but also to mask their precise drawing. While most of the drawing is in sepia ink, certain passages – the hands of both figures, the feet of the Child and most of His face – are drawn in scarlet paint only. The coloured line embellishments are in red, pale purple and green. Some

of the purple on the Child's robes and the Virgin's sleeves is not supported by darker lines but freely drawn in.

## DECORATIVE MOTIFS

Several decorative motifs are dominant, among them the fleur-de-lis form with a blade-like central leaf and curved outer leaves like thick tendrils. It tops the sceptre which the Virgin balances insecurely between her third finger and thumb, her forefinger stuck out straight. It also occurs in the centre of the Virgin's crown (evidence suggests that it appeared frequently on royal crowns) and, in elongated form, it decorates handsomely her somewhat pointed shoes. These are in dark sepia ink, nearly black, and the ornament is left the natural colour of the parchment with a thin line of scarlet. The centre leaf of the fleur-de-lis on the sceptre is terminated by a tiny sphere on which there perches a bird with a curved beak.

The second decorative motif to persist everywhere is the circle. It may be filled in or hollow, or it may, as in the case of the 'dominoes', be parchment-coloured (whereas the ground around has been filled in with dark sepia ink). There are oval shapes also, used decoratively on the border of the ample veil which the Virgin wears under her crown, on the crown itself and on the lower part of the throne. These latter are not full ovals and are further embellished with simple linear patterns.

Both mother and baby have long oval faces, the pupil of each eye a single black dot. The Virgin's severe face, with brows that meet above the nose, is especially compelling, the mouth and the flanges of the nose being most exquisitely drawn. Colour in her cheeks has been suggested by a few light strokes of the pen, and it has been used to suggest the rotundity of the dimpled chin, the dark rims below the eye and the shadow on either side of the nose. The Child's head lacks this emphasis and is almost completely in pure line as befits a younger, smoother face. While the Virgin stares forward frontally and apart from her arms her pose is nearly symmetrical, the Child's is more mannered. His three-quarter face turns to the right, His torso is frontal, but from the hips downwards He turns to the right again. The Virgin has Him between her knees, and her hand steadies His boat-shaped thighs.

## CONCLUSION

Geometry seems to dominate this picture: it is solemn, even threatening, in its aspect, but profoundly impressive and drawn with a satisfying feeling for contrast, balance and the clean precision of a Greek vase. Indeed, although there is no attempt to win us in this austere pair, as they glare at us in sombre fashion, we are drawn by the sure professionalism of the lyrical line. For although the treatment of the garment covering the Virgin's knees resembles nothing so much as a tall Norman shield, adorned with lines that curl like fronds at the tip, yet the directness and professionalism of such passages as the line from the thumb to the little finger across the palm of the Virgin's right hand, or the beasts' heads on the throne, are the work of a master of the style.

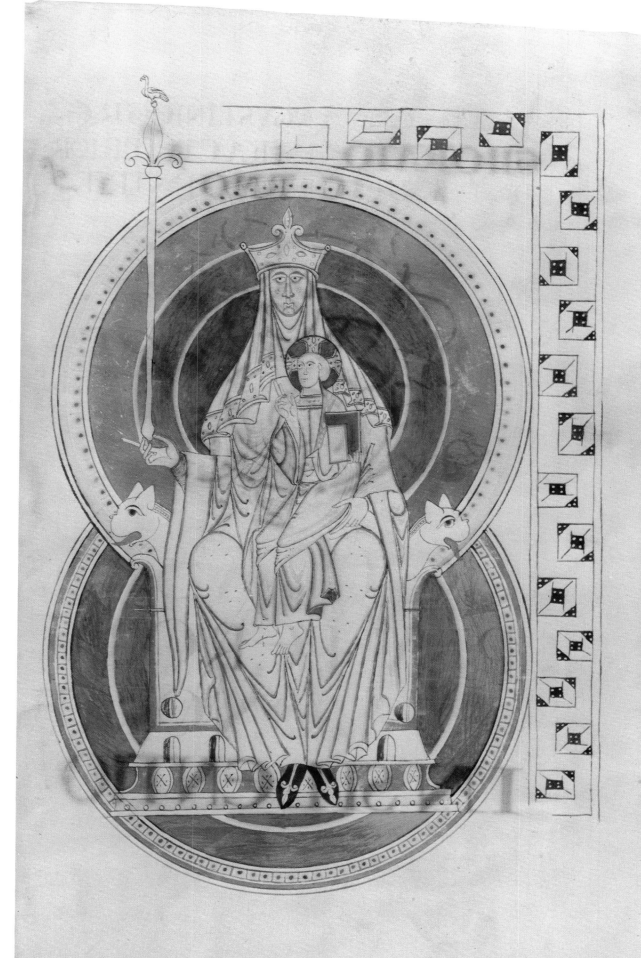

[PLATE 10]

The high seriousness of the picture may be a clue to why it has been left unfinished. Professor Pächt proposed in his 1972 Lyle lecture at Oxford that many English illuminations of this period were left partially in their drawing stage because the artist could not bear to disfigure his clean line with colour. However, this would not account for the uncompleted border, and a better reason for its unfinished state may be that it was felt irreligious to embellish the Virgin and Child with what may have been a frivolous game.

BIBLIOGRAPHY

O. Pächt and J. J. G. Alexander iii.102 (with eleven bibliographical references)

F. Wormald 'A Romanesque drawing at Oxford' in *Antiquaries' Journal* xxii, pp.17–21

Colour transparencies on Bodley rolls: 131B (only 6 of the 14 frames refer to this manuscript), 167B (7 frames)

# BOETHIUS,

## DE CONSOLATIONE

## PHILOSOPHIAE

1125–50, PERHAPS WINCHESTER

OR HEREFORD

[PLATE 11]

Boethius in prison consoled by Philosophy
MS. Auct.F.6, folio 1ᵛ
190 × 120 mm / 7½ × 4¾ in.
This manuscript contains only one full-page picture (shown here)
and one historiated initial showing Boethius writing.

## PROVENANCE

Although the manuscript can be clearly assigned to the twelfth century, both its provenance and exact date are uncertain. Margaret Rickert suggests that this picture may 'represent the typical twelfth-century hardening and formalizing of an earlier, freer style'. It differs from the famous St Albans (or Albani) Psalter at Hildesheim and the Bury Bible at Corpus Christi College, Cambridge, in showing no signs of any new influence of the monumentality which characterizes Byzantine art. It appears to be English, according to Pächt and Alexander, and in fact the peculiar facial type of Boethius, the details of the drapery and architecture are found in less exaggerated form in the British Museum Cotton MS. Caligula A.XIV, a manuscript associated with Hereford. The text is in the same hand as a psalter from Shaftesbury (BM. MS. Lansdowne 383).

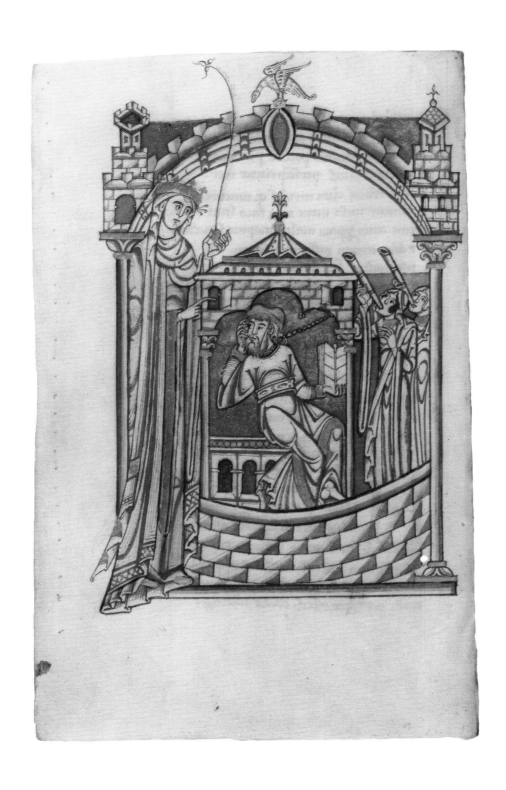

[PLATE II]

## ILLUSTRATION

Boethius is the author of the famous *De Consolatione Philosophiae*, which he wrote in prison prior to his execution in 524 by his former friend and master, Theodoric the Great. This full-page illustration incorporates the letter C, within which Boethius sits: the letter has been ingeniously arranged as a slender column, weighted down with an elaborate small tower. From the capital of the column springs a rounded arch, castellated, and with an almond-shaped central motif, topped by a ball, upon which perches a bird, its wings expanded. This arch forms the upper curve of the C – while the lower curve is formed by a low stone wall. Although there is no doubt an element of fantasy in the architecture, students of the Romanesque period will recognize characteristic forms, as well as that delight in building motifs used decoratively, that is a feature of the later Middle Ages.

Philosophy is a crowned lady, tall and graceful, her mantle floating, her green, red, and blue robes edged with gold. She inclines her head towards Boethius, and in her left hand holds a golden sphere from which springs the 'living lily' – resembling a long feather tipped by a trefoil; Mlle d'Alverny has noted that Philosophy normally holds a separate globe and sceptre, and a book, but here she is content to indicate the book of Boethius, with the right index finger elegantly held out towards it.

Beneath the three-headed archway of a handsome little building, which is crowned with an elaborate finial, sits the prisoner tethered to it by a cord around his neck, and seated on what is perhaps an ornate bench of architectural form. In his left hand he holds a book, his *Consolation of Philosophy*, and supports his face with his right hand, as he turns to regard Philosophy with a serious, considering look. He wears an outer garment, beneath which narrow sleeves and a long undergarment are revealed, and with a jewelled belt and ornamental hem at the neck, and one foot, presumably bare, thrust out. The two curious V-shaped creases under his arms suggest the inevitable bunching of sleeves of 'magyar' cut. He also wears a brimless hat, bordered with gold, the crown slightly dipping in the middle. Beyond the prison two female figures raise trumpets in the air, perhaps to sound together a note in celebration of a fame that triumphs over prison walls.

## DRAUGHTSMANSHIP

The pen-drawing is distinguished by an extreme formality and curvilinear grace, with the colour applied in part to echo the line-work and in part in mass or unassisted line. A clear cobalt, a fresh emerald, a red-brown and a grey-mauve, with a sparing use of gold, are the tints employed – quite arbitrarily, as Boethius has a green beard. Masses of solid colour occur rarely and are then mainly the grey-mauve or the cobalt, the latter being especially opaque. The folds of the garment are purely schematic so that Philosophy's overmantle and Boethius' stomach and right thigh are treated like a passage in cloisonné enamel.

## HISTORY OF THE MANUSCRIPT

William Harwood, prebendary of Winchester, presented the manuscript to the Bodleian in 1612. The press-marks, Auct.D, Auct.E and Auct.F, recall the fact that in 1787–9 James Wyatt fitted up, as an extension to the library, a room half-way up the front stairs of the Bodleian, which was previously the old anatomy school; this developed into a museum of curiosities. The first of a series of expansions necessitated by the increasing number of books, it was called the 'Auctarium', and tall wire-fronted bookcases lettered A to Z lined the walls and blocked its north and west windows. Since the Auctarium manuscripts did not fill the room, it also contained much else including the Barocci manuscripts.

## BIBLIOGRAPHY

O. Pächt and J. J. G. Alexander iii.103 (with nine bibliographical references)

P. Courcelle *La Consolation de Philosophie dans la Tradition Littéraire* (1967)

M. Rickert *Painting in Britain in the Middle Ages* (1954) p.84

H. Swarzenski *Monuments of Romanesque Art* (1967) p.59

Colour transparencies on Bodley rolls 190A

# COMMENTARY ON
# THE APOCALYPSE

FIRST HALF OF TWELFTH CENTURY

GERMANY

[PLATE 12]

The opening of the seals
Illustrations to Revelation VI. 1, 2–5, 8–9, 12–15
MS. Bodley 352 folio 6ᵛ
343 × 235 mm / 13½ × 9¼ in. (Here slightly reduced)
This manuscript contains twenty full-page miniatures and one
illuminated initial.

## APOCALYPSE MANUSCRIPTS

The Apocalypse or Book of Revelation is one of the most profusely illustrated
books of the Bible. Its iconography owes less to Byzantium than to Spain, as we
can see from the twenty-four existing illustrated manuscripts of the *Commentary
on the Apocalypse* of Beatus of Liébana (d.798). However, it was not until the con-
ception of the Apocalypse as seven periods of sacred history was popularized by
Joachim of Fiore (d.1201) that books illustrating it became popular both in England
and across the Channel. Some of these are of superb quality, and of course this
dramatic subject was depicted in 1498 by Dürer in his fourteen famous woodcuts.
Oxford is fortunate in housing several examples of the manuscript: copies are in
Lincoln, University and New College Libraries, and the Bodleian owns no less
than ten (a dozen colour filmstrips are devoted to Apocalypse illustrations; see
also plate 18), two belonging to the twelfth century, six to the thirteenth, and two
to the fourteenth. Of the two twelfth-century copies, one was produced in the
second half of the century, and the other, our manuscript, before the middle of the
century. It is generally attributed to Haimo, Bishop of Halberstadt in the diocese
of Paderborn (d.853), but it was actually composed by his contemporary and
namesake, Haimo, a monk of Auxerre – most of whose works were wrongly
attributed in Tritheim's catalogue of ecclesiastical writers in 1494 to Haimo of
Halberstadt. Haimo's commentary is an important one and is printed in Migne's
*Patrologia Latina* vol.117, 938–1220.

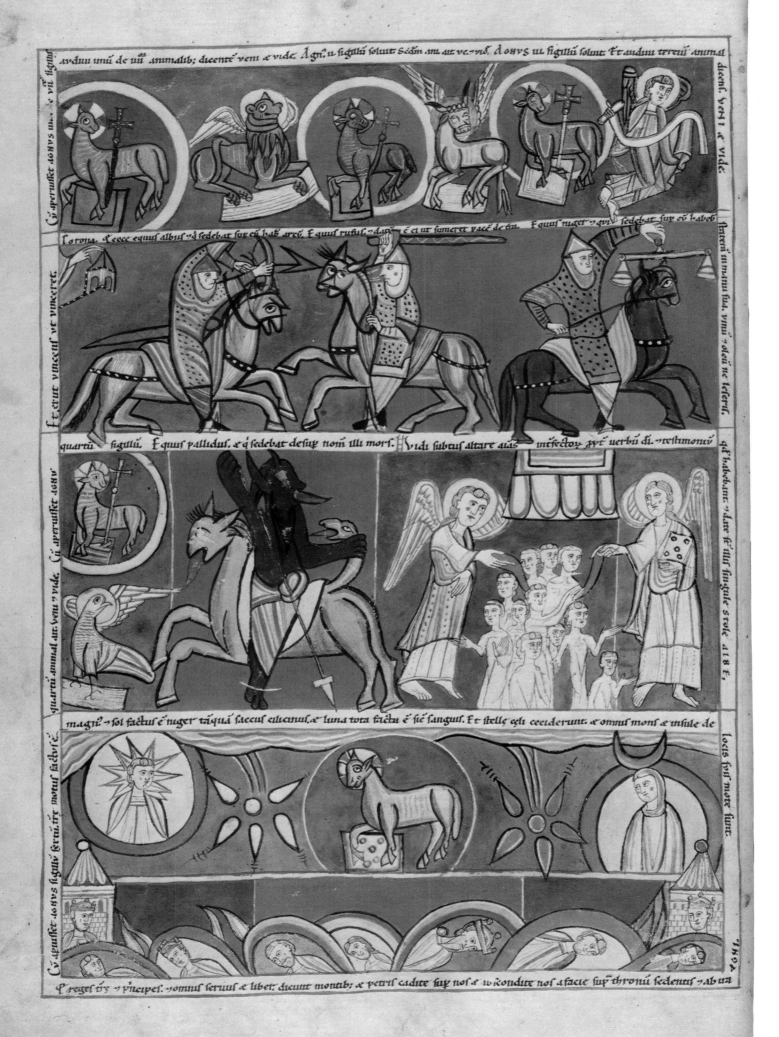

[PLATE 12]

## FRAME

The large illustration fills the entire page, apart from the margins which vary between one and two inches in width. The picture is framed by parallel lines drawn in red ink and filled with writing summarizing the passages in the Apocalypse depicted within each of four registers. The verses illustrated here concern the opening of six of the seven seals by the Lamb, and the visions that accompanied this.

## COLOUR

The basic painted colours are opaque and are used in lighter or darker shades, according to the white mixed with them. They consist of two reds – scarlet and a darker crimson; two greens – a dark green and a lighter, bluer green; a dark and a paler blue and a very dark olive used to interpret black when it occurs in the text. By various ingenious devices the apparent range of tint is extended – notably by picking out highlights in white on a coloured ground, or by drawing coloured lines close together on the parchment, as opposed to colouring in mass.

## ILLUSTRATIONS

The first (and last) register illustrates Revelation VI.1. Against a blue background, we see three red circles, diminishing in size from left to right: each contains a holy lamb, wearing a halo, and making an awkward attempt to carry a cross. The lambs, which are not identical, appear to be standing on books whose seals they should be opening. Two winged Apocalyptic beasts – presumably the lion of St Mark and the bull or calf of St Luke – with haloes and what are perhaps books also, appear to invite the visionary writer to 'Come and see.' In the extreme right of this upper register, an angel kneels, holding a scroll – perhaps the beast in the shape of a man, the symbol of St Matthew, who is often shown as an angel.

The second register illustrates Revelation VI.2–5. The background is divided equally into green and scarlet. From the left-hand margin emerges an arm, indicating the scene before us, with a small building alongside. Then follow in lively and contorted attitudes the three horsemen revealed at the opening of the first three seals. They wear pointed bascinets and mail shirts (the rings indicated by sparse dots) from which sleeves protrude; the legs are covered by a loose, trouser-like breech clout and striped 'saddles' might be rugs. The horses – one blue ('white' in the text), one pink ('red') and one olive-green ('black') – posed many problems for the artist. One, full-face, has features arranged in human fashion while another turns his back towards us – but the colourist has misinterpreted the draughtsman's work so that the tail issues from the side of the rump.

The first horseman shoots a huge arrow from his bow, his hands held high and his reins looped over his left arm. He is in combat with the second horseman whose sword, raised above and behind his head, ready for the strike, does not, by the standards of the day, seem particularly 'great', despite the text. The third horseman holds the 'balance'

above his horse's head with his left hand, and the reins with his right. The colourist has drawn the outline of the horse's back right through his rider at the waist, like a belt. Only the faces and hands in this register have been left without full colour so that the delicate drawing is revealed.

The third register illustrates Revelation VI.8–9. At the upper left-hand corner is the Lamb, with halo, cross, and books; below stands the winged and haloed eagle, symbol of St John who 'looked and beheld a pale horse'. From its mouth protrudes a flame-like tongue, and on its back sits a demon ('Death') of deep olive-green, horned and naked save for a knotted breech clout, and likewise with a tongue of flame. He sits backwards on his horse, lance in his coarse right paw, while his left hand strangles a snake – which is also the tail of his mount. The background to this pair is red.

The third division of this register shows, above, the altar mentioned in the text, under which stand two angels. Between them is that crowd of 'souls' – shown as assorted naked people – who have been 'slain for the word of God'. One angel holds a book and each seems to offer the souls a red object, perhaps originally intended as part of a scroll containing 'the testimony which they held'. One soul reaches up his hand to take hold of it, literally. The hands and feet of both angels and human beings are overlarge. On their cheeks they carry 'Dutch doll' red dots, and the hair is frequently parted in the middle with a knot of hair concealing the parting. The background is divided into blue and green.

The fourth register shows the earthquake St John beheld when the sixth seal was opened (Revelation VI.12–15). The sun here is personified as the bust of a man with a pointed halo, and the moon as the bust of a woman wearing a kerchief with the crescent moon above her. They are placed at the top left and right hand of this scene and look towards each other, the moon slightly inclining her head. The sun is not 'black as sackcloth of hair' nor has the moon 'become as blood', though it is touched with red lines. In the centre is the Lamb. All three are roughly framed in circles. Simple, flower-like forms between them, against a green background, with speed trails indicated, are presumably 'the stars of heaven' which 'fell into the earth', the separate 'petals' like the 'untimely figs' shaken down by a 'mighty wind'.

At the very top of the picture wavy lines in stripes of blue and white suggest an agitated sea. Below, at each bottom corner of the design, is a little building, with a crowned king's head facing inwards. Between these, against the bottom margin, crouch those who 'hide themselves in the dens and in the rocks of the mountains' – the dens presumably being the arcs that curve over them. The variety of folk shown, bearded, clean shaven, crowned, and with varied hairdressing, suggests the range of social position in the text.

## DRAUGHTSMANSHIP

The illustrative style of the four scenes varies according to

[PLATE 12]

their relationship with the draughtsman's experience. A naïve charm has been bestowed on the animals, who seem to be giving gay and lively glances owing to the eccentric placing of the wide open eyes and their pupils. On the other hand, since actual fights were something the draughtsman would, presumably, have been present at, he has been able to seize the action of the fighting horsemen. The earthquake, however, so dramatically described in the text, falls quite outside the range of his experience with the result that he has interpreted it with rigid formality.

Furthermore, two styles are markedly apparent. Firstly, the draughtsman's work is visible in the faces and hands of the horsemen, the human beings and the angels, and receive no more added colouring than can be made with pen strokes. Secondly, passages of solid colouring – the beasts of the evangelists, the bodies of the four horses and their

riders – indicate the hand of a colourist who filled in the draughtsman's work with paint and finished off with thick black line. Here the style is bold, somewhat harsh and full of decorative feeling, in contrast to the more sophisticated drawing. This fairground style, proper to wooden toys, makes one wonder what the draughtsman may have thought of his assistant's performance – if indeed he was permitted to see it. This division of labour, and consequent difference in quality, is apparent in many illuminations of this period as well as in later Italian fresco painting. Four hundred years later, we hear of Michelangelo's fury when his assistants failed to interpret the majesty of his 'sinopie', the red preliminary drawing, but perhaps this would have been thought pretentious by the artist craftsmen of an earlier period.

## TEXT

In the following text letters which are omitted in the abbreviated original are added in italics.

1. Cum aperuisset Agnus unum de vii$^{em}$ sigillis / avdiui unum de iiii$^{or}$ animalib*us* dicente*m* veni et vide. Agn*us* ero sigillu*m* soluit secundum an*imal* ait ven*i* et vid*e* Agnus iii sigillu*m* soluit Et audiui tertium animal /
dicens veni et vide /

2. Et exiit vincens ut vinceret. / Corona. Et ecce equus albus et qui sedebat super eu*m* habu*it* arcu*m*. Equus rufus et datu*m* es*t* ei ut sumeret pace*m* de te*rra*. Equus niger et qui sedebat super eu*m* habet / statera*m* in manu sua. vinu*m* et oleu*m* ne leseris. /

3. Quartu*m* animal ait veni et vide. Cu*m* aperuisset Agnus / quartum sigillu*m*. Equus pallidus et q*ui* sedebat desup*er* nom*en* illi mors. Vidi subtus altare animas int*er* / fe / ctoru*m* prop / t*er* uerbu*m* de*iet* testimoniu*m* / q*uo*d habebant. et date s*unt* illis singule stole albe. /

4. Cum aperuisset agnus sigillu*m* sextu*m* t*erre* motus factus es*t* / magn*us* et sol factus es*t* niger ta*m*qua*m* saccus cilicinus et luna tota facta es*t* sic*ut* sanguis. Et stelle celi ceciderunt et omnis mons et insule de / locis suis mote sunt. / Et reges t*erre* et principes et omnis seruus et liber. dicunt montib*us* et petris cadite sup*er* nos et abscondite nos a facie sup*er* thronu*m* sedentis et ab ira / Agni.

Revelation VI from the Authorized Version of the Bible.

1. And I saw when the Lamb opened one of the seals, and I heard, as it were the noise of thunder, one of the four beasts saying, Come and see.

2. And I saw, and behold a white horse: and he that sat on him had a bow; and a crown was given unto him: and he went forth conquering, and to conquer.

3. And when he had opened the second seal, I heard the second beast say, Come and see.

4. And there went out another horse that was red: and power was given to him that sat thereon to take peace from the earth, and that they should kill one another: and there was given unto him a great sword.

5. And when he had opened the third seal, I heard the third beast say, Come and see. And I beheld, and lo a black horse; and he that sat on him had a pair of balances in his hand.

8. And I looked, and behold a pale horse: and his name that sat on him was Death, and Hell followed with him. And power was given unto them over the fourth part of the earth, to kill with sword, and with hunger, and with death, and with the beasts of the earth.

9. And when he had opened the fifth seal, I saw under the altar the souls of them that were slain for the word of God, and for the testimony which they held.

12. And I beheld when he had opened the sixth seal, and, lo, there was a great earthquake; and the sun became black as sackcloth of hair, and the moon became as blood.

13. And the stars of heaven fell unto the earth, even as a fig tree casteth her untimely figs, when she is shaken of a mighty wind.

14. And the heaven departed as a scroll when it is rolled together; and every mountain and island were moved out of their places.

15. And the kings of the earth, and the great men, and the rich men, and the chief captains, and the mighty men, and every bondman, and every free man, hid themselves in the dens and in the rocks of the mountains. . .

## BIBLIOGRAPHY

O. Pächt and J. J. G. Alexander i.66 (with two bibliographical references)

P. H. Brieger *The Trinity College Apocalypse* (1967) pp.8, 13n, fig.2

Theresa Mroczko 'Genèse Iconographique de l'Apocalypse' *Wroclaw Rocznik Istorii Sztuki* vii (Warsaw, 1969). Reproduces 15 folios

Tilman Seebass *Musikdarstellung und Psalterillustration im früheren Mittelalter studien ausgehand von einer Ikonologie der Handschrift Paris Bibliothèque Nationale fonds Latin 1118* (Berne, 1973) p.51. He calls fol.6 the oldest Apocalypse illustration of musical instruments, but Seebass wrongly supposes this to be an English eleventh-century manuscript

Colour transparencies on Bodley roll 132B (22 frames)

# RANSHOFEN GOSPELS

1178, AUSTRIA [SALZBURG]

[PLATE 13]

St Matthew
MS. Canonici Latin Biblical 60 folio 14$^v$
318×230 mm / 12½×9⅛ in.
Canon Tables in gold on purple (eight pages), four evangelical
portraits, each facing a large decorative initial, and a Crucifixion.

## PROVENANCE

Ranshofen was a monastery in the diocese of Salzburg, whose archbishop was
sufficiently important to be, to all intents and purposes, a prince quite independent
of secular authority. These Gospels were written under Adelhard, the abbot of
Ranshofen, and Liutold, the treasurer, in 1178. A study of the Salzburg style of
painting was published with two plates reproducing this manuscript by G. Swar-
zenski as long ago as 1913, but these Gospels first became widely known in 1959
when they were shown at an exhibition of Romanesque Art in Manchester City
Art Gallery.

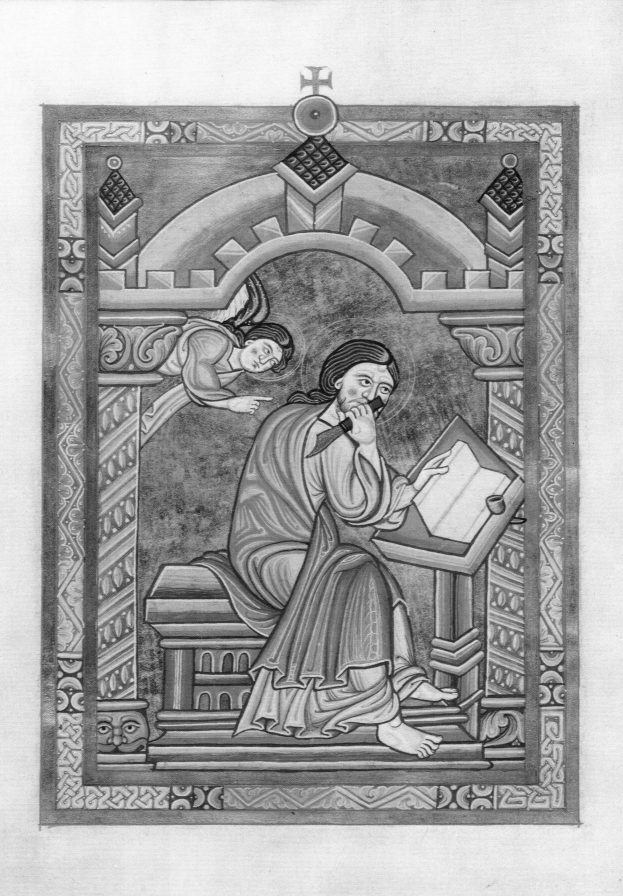

[PLATE 13]

## STYLE

The lavish use of gold background in many such Romanesque manuscripts is typical of central Europe in contrast to England. It reflects the Byzantine taste of eastern Europe but differs from Byzantine work in the surprising technical superiority of its application, for the gold on Byzantine manuscripts often flakes away badly. Apart from the Byzantine influence, a possible reason for the use of gold in manuscripts like this one was that before the Turks erupted into the Balkans, the Roman and the Orthodox Churches were rival claimants for the souls of men in the spiritual no-man's land where these two spheres of influence overlapped. The purpose of the gold would be to seduce any doubters away from the other side.

## FRAME AND COLOUR

Wide margins and a handsome frame surround the picture. The frame itself consists of two parallel stripes, the inner one of silver, the outer one of gold, enclosing a rich border of patterns mainly of geometric form, in pinks, blues, warm brown and orange. Each tint has various shades and all are highlighted with white. Fortunately the illustration is in superb condition, the tints notably fresh, the silver scarcely oxidized at all. The colours of the border, except for the silver, are those used throughout the rest of the picture.

## PORTRAIT

Against a gold background St Matthew sits on an elaborate stool ornamented with round-headed arches. On either side of him are two richly barbaric columns, whose capitals somewhat resemble the acanthus leaf, as does the base of that on the right hand. The left-hand column, however, rests upon a superbly executed frowning visage with a pair of curling moustaches. Above St Matthew's head is an arch adorned with castellations and turrets, each topped with a spherical form, and on the centre turret is a large orb surmounted by a cross in gold.

From the arch and behind the saint emerges an angel, admonishing the evangelist with his right hand. St Matthew frowns in almost painful concentration, presumably listening to the voice of the angel. His left hand holds open the blank pages of a book; his right elbow is bent so that he rests his right hand against his lips in a strikingly natural gesture. In this hand he holds a gold-bladed penknife. Saint and angel have long brown hair, wavy and painted in stripes, worn parted in the middle and fastened back. Both have fresh complexions with bright spots of red colour on the cheeks, and haloes indicated only by compass-drawn circles scratched on the clear gold background. St Matthew is bearded and has a pointed moustache. He wears a fawn-coloured undergarment, a blue mantle over his shoulders, and one of brilliant orange over his knees. His feet are bare and rest on the steps of his stool. As if to complement the graceful form of an L on the opposite page, he leans forward a little towards his lectern. His ink-horn has been thrust in a hole in this, but no pen is visible. This lack of a pen is probably no mere mistake of the artist, for this series of portraits of the evangelists is most unusual. As Miss Callard has pointed out, St Mark's ink-horn is fixed on the wrong side of his desk, St Luke has no parchment on which to write, and only St John, the apostle whom Jesus loved, is completely equipped for his task.

## BIBLIOGRAPHY

O. Pächt and J. J. G. Alexander i.82 (with three bibliographical references)

A. Boeckler *Abendländische Miniaturen bis sum Ausgang der Romanischen Zeit* (1930) p.83

Colour transparencies on Bodley rolls 130c and 167c (17 frames showing complete pages and 10 frames mostly details)

# THE ASHMOLE
# BESTIARY

[PLATE 14]

The whale or 'aspidodelone'
MS. Ashmole 1511 folio 5ᵛ
275 × 180 mm / 10⅞ × 7½ in.
This manuscript contains six full-page illuminations and
miniatures on 100 other pages, sometimes several on a page.

> Ye are mad, ye have taken
> A slumbering kraken
> For firm land . . .
> > Lowell, *Ode to France*, 1848

## BESTIARIES

A Bestiary is an illustrated and moralized natural history and, as M. R. James has
pointed out, although not originally an English compilation, seems to have assum-
ed a standard form in this country and was certainly more current here than else-
where. In *The Bestiary* he lists forty manuscripts, of which he considers thirty-four
to be certainly English. This popularity James assigns entirely to its pictures: 'its
literary merit', he says, 'is *nil*, and its scientific value . . . sadly meagre.' In fact, an
English translation has since won considerable popularity.

James finds four distinct families of Bestiary among those he has studied. Typical
of his first family is MS. Laud Misc. 247, a distinguishing feature of which, and
other members of the group, is that it supplements the *Physiologus* (the original
Greek source of the Bestiary) with extracts from the *Etymologies* of Isidore. Other
Bodleian Library manuscripts of this kind are MSS. Douce 167 and Bodley 602.

The second family is distinguished by the fact that the contents are classified
(into beasts, birds, etc.), beginning with the lion. Many more sources are inter-
polated into the texts, among them the *Liber memorabilium* of Solinus, the *Hexae-
meron* of St Ambrose, the *De Universo* of Rabanus Maurus, the *Pantheologus* of
Peter Prior and the *Aviarium*. Faced by the wide variation within this second family
James groups them in rough chronological order. Bodleian Library MSS. in this
group are: MSS. Ashmole 1511 and Douce 151 (a pair), Bodley 764 (paired with
BM. Harl. 4751, see plate 15), Bodley 533, St John's College 61 and 178, Univer-
sity College 120, and the first Bestiary in MS. Douce 88.

officium habeant. Amphi enim grece. utrumq; dr. i.
op inaquis intiris uuuunt. ut foce. cocodrilli ypota
mu. h. est equi fluctuales. De BALENA.

Est belua inmari qm grece aspido delone dr. latine ū
aspido testudo. Cete i dicta. ob immanitate in cor
pore. ē. enim sic ille qui excepit ionam. cuius aluus
tante magnitudinis fuit ut putaret infernus dicen

[PLATE 14]

Only one Bodleian Library manuscript appears in the third family, MS. Douce 88 (II). Characteristic of this group is a recasting of the Bestiary with an improved classification, the whole beginning with Isidore's account of the fabulous nations (*Etymologiae* xi.iii), and extracts from the *Megacosmos* of Bernardus Silvester. After the Bestiary proper, the final section includes the Seven Wonders of the World, an extract from Seneca (*De remediis fortuitorum*) and another on divination from the *Policraticus* of John of Salisbury.

The fourth family, based as much on Bartholomaeus Anglicus' *De proprietatibus rerum* as on Isidore, consists of only one manuscript, Cambridge University Library Cg.6.5.

## STORY OF THE WHALE

MS. Ashmole 1511, which belongs to the thirteenth century, is included in most surveys of English illumination as a matter of course, since it is illustrated in outstanding fashion. This particular plate illustrates the story of the whale, or 'Aspidodelone', as the book calls it. This lifts its back out of the water and lies at anchor, until, eventually, vegetation grows upon it so that it looks like an island. Sailors then land and light a fire, which causes the whale to submerge, dragging the vessel with it. The moral was that those who place their hope (or anchor) in the Devil go down to Hell. (In his *Book of Beasts, being a translation from a Latin bestiary*, T. H. White quotes the *Topography of Ireland* in which Gerald of Wales, a fascinating twelfth-century writer, tells how phantom islands appear and disappear off the Irish coast. If fire could be lit upon such an island it was possible to occupy it.) Unlike some Bestiary illustrators our artist fails to show the fire at all.

## ILLUSTRATION

In this case we are not concerned with an illustration, which, incorporated into the text, is an integral part of the design, for this picture is neatly framed in shades of pink with only the gilded cross and pendant at the summit of the mast trespassing into the text. The miniature itself is in a remarkably fresh condition, and the gold and the other colours bright and clean.

The fish bears some resemblance to a real whale, but numerous fins are fancifully dispersed over the body and the eye is large and circular; a round nostril is, presumably, the blow-hole. The whale is a clear grey hatched in black and white, very spirited in drawing. Two fish in shades of light and dark pinks are in the process of being swallowed by the monster, who swims in an area of green water with undulating black lines painted on it.

A gold background makes clear the motifs of the design – the sailors are on the point of landing on the whale's back but are evidently in some doubt as to the proceedings. One sailor, seated and wearing a loose shirt and a broad-brimmed hat in green with a point jutting out of the rounded crown, holds the steering oar in his right hand and points with his left while looking at his comrade at the other end of the boat. This man clutches the curved prow with his left hand and gestures, pointing upwards, with his right,

whilst turning his head and looking back at the man at the steering oar. He is dressed in an orange shirt and green hose, and has short yellow hair in tight curls. A third man pulls on one of the five ropes that support the mast – it runs over his left shoulder and he steadies it with his chin in a convincing manner. He, too, has tight blond curls and wears a shirt-like garment, this time in blue. The single pink sail, which is full of wind and is driving the boat onward, is attached at the stern, though the boat in fact has twin ends and so can be steered from either. There is an oar for steering, a steering board or 'stéorbord' (on the starboard side), as was customary before the popularization of the rudder in the late thirteenth century. The planks of the boat are gaily coloured in various tints.

The whole scene is full of vigour and action. The play of expression and action between the three sailors makes it very clear that they are consulting between themselves as to what course to take. The treatment of the whale is crisp and rhythmic and his evil gluttony as he gobbles the two fish is shown in masterly fashion with simple means.

## HISTORY OF THE MANUSCRIPT

The earliest known owner of this manuscript was William Wryght, vicar of Chepynge Wycombe (now called High Wycombe) who we know possessed it in 1550. Later William Mann gave it to Sir Peter Manwood (d.1625) and in 1623 it belonged to John Tradescant the Elder (d. ?1637), a traveller and gardener who founded the first 'physic garden' in England at South Lambeth. His son and namesake (1608–62) collected 'all varieties of flowers, plants, shells, etc', from Virginia for his famous early museum in South Lambeth, opened in 1637.

In 1650 the younger Tradescant was befriended by Elias Ashmole, a man of wide interests which included heraldry, local history, alchemy, astrology, and poetry. He had started life as a solicitor, becoming a commissioner of excise in 1644, but in 1647 a fortunate marriage with Lady Mainwaring enabled him to follow his bent as a collector. His support for the Royalist cause in the Civil War enabled him to enter the Office of Arms of Windsor Herald after the Restoration, and in 1672 he published his celebrated *Institutions, Laws and Ceremonies of the Order of the Garter*.

For his library he acquired various collections of papers, among them those of Simon Forman (d. 1611) and the astrologer, William Lilly (1602–81), and it was to him that Tradescant's 'Closett or Collection of Rarities', as catalogued in 1656 in the *Museum Tradescantianum*, passed in 1664 (and was seen a short time after by Izaak Walton). Thirteen years later Ashmole offered the collection to Oxford University on condition that it was housed properly. Accordingly, Sir Christopher Wren erected what is now called the 'Old Ashmolean' or 'History of Science Museum' in 1683, and 'the name of Tradescant was unjustly sunk in that of Ashmole' (cf. R. Poole's article). Finally in 1860 his manuscripts, together with those of Anthony Wood and William Dugdale, were transferred from the Ashmolean to the Bodleian Library.

[PLATE 14]

## TEXT

officium habeant. Anphi enim grece. utrumque dicitur. i[d est] quia, in aquis et terris uiuunt. ut foce. cocodrilli ypotami. Hoc est equi fluctuales. De Balena.

Est belua in mari que grece aspido delone dicitur. Latine uero aspido testudo. Cete etiam dicta. ob immanitatem corporis. est. enim sicut ille qui excepit ionam. cuius aluus tante magnitudinis fuit ut putaretur infernus dicen [te ipso iona].

. . . [The amphivia] have a function . . . In Greek 'both' is called 'Amphi'. That is because it lives both in the waters and on the lands like seals, crocodiles and hippopotamuses. That is river horses. About the whale.

There is a monster in the sea which the Greeks call Aspidodelone. In Latin indeed Aspido-tortoise. It is also called Ceta. Because of the immensity of its body it is like the one which took Jonah, of which the belly was of such enormous size that it could be regarded as Hell, as Jonah himself said.

## BIBLIOGRAPHY

O. Pächt and J. J. G. Alexander iii.334 (with twelve bibliographical references)

R. Poole 'A manuscript from the Tradescant collection' in *Bodleian Quarterly Record* vi (1931), pp.221 ff.

All illuminated pages are reproduced on Educational Productions coloured microfilm no.502 (70 frames). There are also select details on Bodley rolls 167G and 217.3

# BESTIARY

c.1225–50, ENGLAND

[PLATE 15]

Elephant and Castle
MS. Bodley 764 folio 12
292 × 197 mm / 12⅛ × 8¾ in.
This manuscript has 123 illustrated pages. It is a companion to
British Museum MS. Harley 4751.

## INTRODUCTION

This superb Bestiary was produced in England, perhaps as late as 1230–40, though
M. R. James considers it to be late twelfth century. Its numerous illustrations in-
clude two superb pages devoted to six of the beliefs about the lion – eating an ape for
medicine, sparing the humble, fearing the cock, fleeing the hunters, mothering its
cubs, and breathing life into them. In other scenes, the hunter deceives the mother
tiger with a mirror, the panther's breath attracts other beasts, hunters spear the
unicorn in a virgin's lap, the beaver castrates itself, the bonnacon fights its dis-
gusting rearguard fight, the fleeing ape jettisons its favoured baby, faithful hounds
protect Garamantes and – a peculiarity of two Bestiaries only – barnacle geese
hang from trees as described by Gerald of Wales.

## ELEPHANTS AND CASTLES

This particular illustration shows an elephant with an armoured howdah. The idea
of the elephant and castle as exemplified in the sign of a famous inn called the
'Elephant and Castle' in South London is often said to be a corruption of the In-
fanta of Castile. But long before an English prince married a Spanish princess, the
Bestiary had popularized the idea of the Persians and Indians fighting from towers as
if in castles on the back of elephants. Furthermore, the Book of Maccabees men-
tions this kind of warfare, and it is illustrated not only in Bestiaries but also in the
*Roman d'Alexandre* (twelfth century).

The large crew in our Bestiary is nothing compared with the one in Maccabees
vi.37 where the wooden tower on each elephant is said to contain thirty-two
valiant men who fought from above, and an Indian to drive the beast.

P. Bierowski reproduces various representations of elephants and castles from as
early as the fourth and fifth centuries B.C. in *Les Celtes dans les arts mineurs Greco-
Romains* (Cracow 1920) pp. 141–50, figs. 212–27. There is a famous terracotta
found at Pompeii in the Naples Museum and elephants and castles continue under
the Empire. Antique art illustrates the use of African and Indian elephants alike.
D. F. Allen summarizes the evidence in 'The Sark Hoard' in *Archaeologia* ciii (2nd
series liii, 1971), p.19.

[PLATE 15]

## ILLUSTRATION

This delightful scene, so full of inventiveness and activity, gives an impression of humour, whether intended or not. The elephant is rather like a creature drawn from an accurate description by someone who has never seen one – trunk, large ears (erect), bulky body, thick feet, and tusks all there, but the total is still not the elephant we know. The trunk grows larger at the tip, like a trumpet, and the tusks emerge from slits in the trunk. (The treatment of the elephant is in marked contrast to that by Matthew Paris, who actually studied from life an elephant given to King Henry III in 1255.) The tower is attached by three girths, complete with buckles, and a chestband. It seems to be made of planks, with criss-crossing external beams for extra strength, and is castellated and machicolated, the battlements complete with buckles being supported on curved brackets. Three round-windows provide openings and a castellated balcony for the pilot juts out behind the elephant's ears.

There is no serious attempt at naturalism; the background is blue, adorned with delicate x-shapes in white, and surrounds a golden rectangle, while the whole is framed in bands of red and green, over which the participants do not hesitate to obtrude so that a slingsman and swordsman stick out into the book's white margin. The two plant forms are of a purely decorative nature, resembling umbrellas in shape, the leaves depicted like fish-scales and arranged in rows without reference to the branches.

Of the figures defending the elephant, two faces, presumably of the officers, and one arm protrude from each of the three loopholes in the tower, the sleeved arm wielding a mace. These figures appear to be civilians. The five men in the turret and the pilot on the elephant's neck appear to be soldiers dressed in chain mail, three of whom wear surcoats of linen and four of whom wear metal helmets. Two of these helmets are of basin type, a third is pointed at the top and one covers the face completely and is flat-topped; two have nose-pieces. Of the figures defending the tower, that on the left has raised his arms to throw a stone, the next pokes with a long spear. The third, a moustached figure, has no room to wield his axe, and the fourth swings his right arm to throw a stone, an axe behind him. The fifth man aims his cross-bow.

The illustration is particularly interesting as a very early example of heraldic illustration. Beside the archer with the cross-bow is a small banner showing gules a chevron argent, and three shields adorn the castellations of the tower: or a bend cottised gules, azure a lion rampant argent, and or three chevrons gules (Clare). The surcoat of the stone-throwing man in the flat helmet is also heraldic in nature – gules three chevrons argent. The pilot bears a longer shield than those above, the heraldry of which is not immediately apparent, as the artist seems to have attempted to depict the shield in a sideways position, with only one-half showing. It would then be gules (or just possibly purpure), three chevrons argent not bends sinister.

Standing on the buff-coloured, undulating ground is a knight, the largest figure on the page, who wears a long red surcoat and wields a sword (the silver of which has oxidized) in his right hand, its handle stopped by a round gold knob. His shield seems to be on his right arm, but we cannot be too certain, because his torso faces the spectator while his feet walk sideways. The man on the balcony swings a mace-like whip with three flame-like lashes flowing from it, and the man at the back of the beast is wielding an axe, square-bladed like a carpenter's, unlike the more normal war axes being used by the soldiers in the tower. This axe-head, unlike the others, has been painted silver, which has oxidized, and would appear to be especially used to destroy the tower.

Of the attacking figures, the three civilians wear long-belted shirts and coloured hose, one being bare-headed and two wearing coifs; one carries a sling with its slingstone visible, one swings a curved axe over his shoulder, and one has just let fly an arrow. The faces are highly expressive, the three foot-soldiers being shown as rather coarse types.

## COLOUR

The colours are a clear blue, vermilion, a dull crimson, pale violet, and bright green. These are often shaded pale or dark, sometimes by means of dilution in true 'water-colour' technique – this is especially noticeable in the case of the head and ears of the elephant where a pale green wash has been partially reduced by another, much diluted wash of the more opaque blue.

## CONCLUSION

The total effect combines energy and oddity. The three objects floating in the air are stones in flight, and two loops beneath the elephant's tusks seem to be an aid to tethering him. On the other hand, there is plenty of contrasting movement: one figure at the upper window of the tower casts his eyes upward, while the man at the window below him looks out frightened at the fray. Those wielding heavy weapons grimace with effort, and the archer, who has just loosed his arrow open-mouthed with expectation, is very faithfully observed in his movements. In the midst of all this excitement stands the great beast, foursquare, brow furrowed, looking out with a large distressed eye.

RIpes uocatur: quod sit animal pen
natum & quadrupes. hoc genus sera
rum in hipboreis nascitur locis uel monti
bz. omni parte posteriori corpus leoni:alis
& facie aquilis simile. equis uehementer in
festum. nam & homines uisos discerpit.

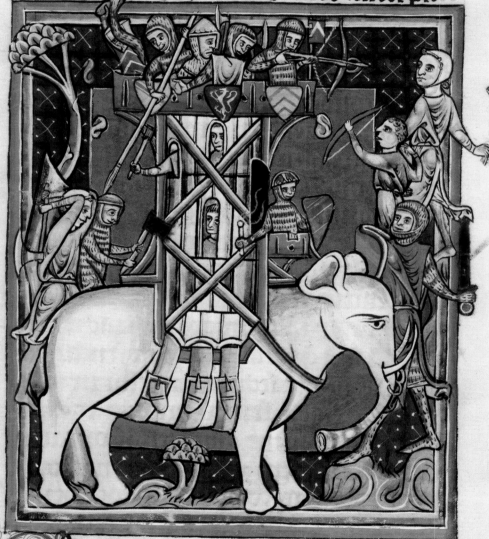

Est animal quod dr elephans in quo
non est concupiscencia coitus. Elephã

[PLATE 15]

TEXT

The end of the account of the griffin and the beginning of the account of the elephant:

-bus omni parte posteriori corporis leoni alis
et facie aquilis simile equis uehementer in-
festum nam et homines uiso discerpit.

Est animal quod dicitur elephas in quo
non est concupiscencia coitus. Elephan-

. . . resembling a lion in its hindquarters and an eagle in its wings and face, violently hostile, when it sees men it rends them.

There is an animal called an elephant which lacks desire to mate . . .

BIBLIOGRAPHY

O. Pächt and J. J. G. Alexander iii.372 (with nine bibliographical references)

Six of the pictures are reproduced in F. McCulloch *Mediaeval Latin and French Bestiaries* (1960), and four in 'English Rural Life in the Middle Ages' in *Bodleian Library Picture Book* no.14 (1965)

Colour transparencies on Bodley rolls 126 (18 frames), 136A (36 frames)

# BERNARDUS SILVESTER,
# LIBER
# EXPERIMENTARIUS

BEFORE 1259, ST ALBANS

[PLATE 16]

Socrates and Plato
MS. Ashmole 304 folio 31ᵛ
170 × 130 mm / 6⅞ × 5⅛ in.
This manuscript was illustrated by Matthew Paris and contains
four pages of 'portraits', thirteen pages with diagrams and
eighteen pages with pictures of birds. Fourteenth-century copies
of the pictures and of some which have been lost from this
manuscript can be found in another manuscript of Bernardus
Silvester, MS. Digby 46.

## MATTHEW PARIS

Apart from William de Brailes, Matthew Paris is the only thirteenth-century
English artist whose work can be identified. A monk who entered St Albans
monastery in 1217, Paris became one of England's greatest historians of contempo-
rary events, and these he illustrated with great care. He knew personally many im-
portant people, having travelled as far as Westminster, Canterbury, York, and even
Norway.

## FORTUNE-TELLING TRACTS

This particular manuscript, which he illustrated, contains a group of tracts on for-
tune-telling, called *Liber Experimentarius*, by Bernardus Silvester (of Tours), who
was at one time identified with Bernard of Chartres. In these, preliminary tables
direct the enquirer to a line of verse which forms part of the replies of twenty-five
'judges of the fates'. He finally can deduce his fate from the last column of the
fourth book. The second tract is a more complicated form of fortune-telling called
the 'Prognostics of Socrates'. Answers are derived from a series of circular dia-
grams representing the spheres which direct the reader to one of the responses of
the sixteen kings. In the 'Prognostics of Pythagoras' that follow, any of three-
dozen questions is answered by a number obtained by chance which refers to a
line of verses arranged opposite three-dozen different birds.

Plato.

Socrates.

Ey | of this there be to tables, oon above, q̄ theother be nethe.) An erit bonū ire extra domū nec non | As it appereth in the begynnyng above. and f̄is A in þ quaterne) þen loke for þ question in þ seconde table. and þ is A in þ quaterne) þen fynd þe lef and on þ hygh þte is A A. And if þo nombes þ þe toke in þ cerkel be ꝑ. þen agaynst it. descendyng. 10 ficus fruch) then seiche in Spera fructuū. for ficus. and þ þ he seith. Ite ad Regem hispanie.

And when ȝe com there, tell q̄ verses or Jugemētz. And the P shall tell yo Jugemēt. And aftr this way warke the residue. And on firste take þo nomber in the cerkel securly thynkyng on the question.

‖ Tabula questionū ꝑnosticoꝝ scdm Basileum Socrem

[PLATE 16]

## ILLUSTRATIONS IN THE MANUSCRIPT

As well as the 'portraits' of Socrates and Plato this manuscript contains a famous picture of Euclid and Hermannus of Carinthia, the author of, among other works, a commentary on Euclid and *Zael's Fatidica* or *Pronostica* and who helped transmit Arabic learning to Western Christendom in the twelfth century. In this scene Euclid holds a sphere and a dioptra to his eye with which he concentrates the light of the heavenly bodies. There are also pictures of Pythagoras writing, the sons of Jacob, diagrams representing the 'sphere of species' and the spheres of flowers, fruit, beasts, birds, and cities, and, for the 'Prognostics of Pythagoras', thirty-six varieties of birds – mostly quite unrecognizable.

## ILLUSTRATION

This picture is a line-drawing in sepia ink, lightly washed with diluted sepia, green, and blue, while the protagonists are named in red. It has a plain geometric frame, into which the right foot of Plato intrudes a little.

Seated on an elaborate throne, and eyeing the page on a lectern which his feet straddle, Socrates dips his pen in the ink-pot and steadies the empty page with a penknife held in his left hand. He wears a loose cloak, shirt, and an undergarment with long sleeves, neat little ankle-boots and a Phrygian cap that ends in foliage-like decoration. His pale blue beard and hair are long and curly, the bridge of his nose broken. The scabbard of a sword appears to protrude from under his cloak. The ink-pot has a lid attached by a cord to prevent loss. Paris has added two peculiar forms of a somewhat architectural nature for Socrates to rest each foot on. He is certainly the more important of the two figures for his name is written with a capital S and he is larger than Plato, who stands behind him and rests his right hand on a leafy carving on the back of the throne, and points with his left. He seems to be admonishing his companion, whose head is inclined to listen to him. Plato wears a flattish round cap, a toga-like cloak, and a shirt with a v-neck and gathered at the waist into a narrow belt. He floats in the air behind the throne and appears excited and alarmed, which, to judge by the calm expression on the faces in an earlier picture, is a deliberate effect. The rather comic effect of Plato, with his hunched shoulders and corrugated brow, is surely no accident, but reflects Matthew Paris's alert personality.

## TEXT

The text in English at the bottom of the page gives an example of how the two tables on the facing page should be used in conjunction with tables on the following pages: 'here be to tables, oon aboue. and the other benethe. An erit bonum ire extra domum vel non as it apperith in the begynnyng aboue and there is A in the quaterne then loke for the question in the second table and ther is E in that quaterne then turne the lef and on the hyer parte is AE. And if your number that ye toke in the cerkel be 9 than agaynst is descendyng ys ficus fructus. Then serche in Spera fructuum for ficus and there he seith Ite ad Regem Hispanie.'

This means that if an enquirer wants to know whether it is good to go outside the house or not he should look for the question on the opposite page. He will find it in the quarter marked A at the top and in that marked E at the bottom. If the number which he has obtained by chance is four he should look in the fourth section from the top on the following page in the column AE. This refers him to a diagram called the sphere of fruit (which comes between the sphere of flowers and the spheres of beasts and birds on the following pages). This refers him to various lines of prophecy grouped on three final pages under the names of various kings.

Sixteen possible questions (such as whether or not it is good to marry, whether a friend is loving, whether a prisoner will escape, etc.) are on the facing page.

## BIBLIOGRAPHY

O. Pächt and J. J. G. Alexander iii.437 (with eight bibliographical references)

R. Vaughan *Matthew Paris* (1958)

F. Wormald 'More Matthew Paris drawings' in *Walpole Society* vol. xxxi (1942–3), pp.109–12

Colour transparencies on Bodley roll 185D (44 frames)

# CODEX LAUD

THIRTEENTH CENTURY

MEXICO

[PLATE 17]

Mayauel and Cinteotl
'Codex Laud'
MS. Laud Misc. 678 folios 9 and 10
167 × 155 mm / $6\frac{1}{2} \times 6\frac{1}{16}$ in. each
This strip contains many pre-Aztec religious pictures on both
sides of a long strip of skin folded like a concertina into twenty-
four leaves, all illustrated. Given by Archbishop Laud, this
manuscript has come from the same source as 'Codex Bodley'.

## MEXICAN MANUSCRIPTS

Five of the few surviving early Mexican manuscripts came to the Bodleian Library
in the seventeenth century and four of these date from the period before the
discovery of America. All are the subjects of monographs complete with facsim-
iles and complete colour filmstrips.

'Codex Laud', as this manuscript is known to Mexican specialists, is the oldest and
also the most decorative. It consists of four strips of tanned skin. This is thought to
be deer-hide treated like European panel paintings with a layer of gesso. Detailed
'translations' have been ingeniously made but it is a painful duty to record that
A. R. Pagden points out that these 'translations' by the specialists in Mexican
codices depend on 'a good deal of imagination . . . unsupported by sufficient
evidence' and are 'subjective'. He agrees that the contents of this codex are religious.
This contrasts with 'Codex Bodley' and 'Codex Selden' which are physically made
in a similar way. All these three codices are Mintec but in 'Codex Laud' Pagden
says there are certain features which point to Mayan influence. It is generally
classified, unlike them, in the so called Borgia group of Mintec manuscripts,
resembling Vatican 'Codex Borgia' in a system of numerical progression.

[PLATE 17]

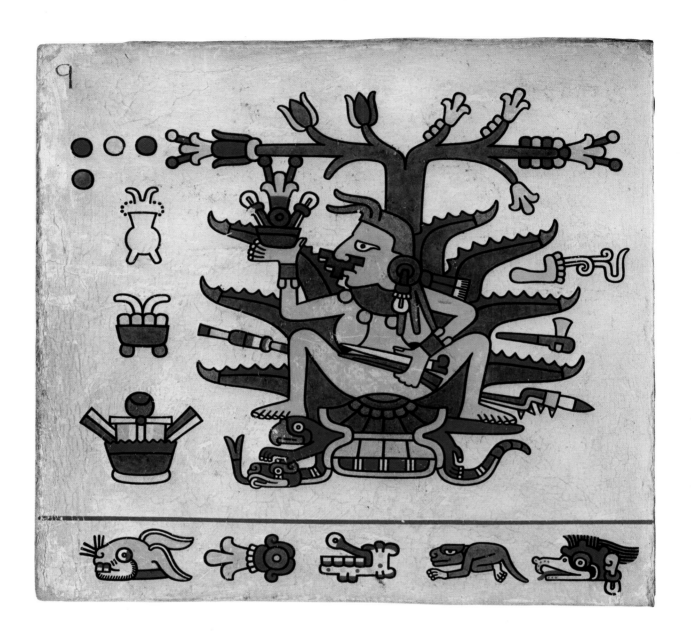

## LAYOUT

To those familiar with western European, or indeed Hebrew manuscripts, the arrangement of the contents in this Mexican manuscript causes some difficulty because the order is neither simply from left to right or right to left. For example the first section (folios 3 to 8) contains a series of pictures that apparently describe the passage of a man through life. It begins at the inner register of folio 8, running from right to left, ascends to the upper register and runs in the reverse direction. Folios 9 to 16, the second section, go from right to left. The meaning of the third section (folios 17 to 24) is uncertain, though many of the subjects are military. This series begins on folio 24 in the lower register and then proceeds backwards to folio 17 after which it runs along the upper register from folio 17 to folio 24. There is evidence that a further page containing a count of five days, painted on another skin, is missing. On

the 'concertina's' dorse or reverse side which forms the fourth section, those pictures that can be interpreted are concerned with death, marriage, the developments of an astrologer, an inspired shaman, and the four aspects of Tlazolteotl.

## ILLUSTRATIONS IN THE MANUSCRIPT

The second section, from which our illustration comes, shows eight deities, each enthroned in a personal 'house' composed of the proper attributes, with offerings next to each one (these pictures should be read in the reverse order of the folio numbers assigned by the Bodleian Library): Tlazolteotl on a bundle of reeds with a witch's broom, receiving offerings of bones and a human heart; Xochipilli, lord of flowers, on what appears to be an ocelot or jaguar skin; Tonatiuh, the sun god, on a plumed dragon throne; Itzcoliuhqui, eyeless and carrying weapons, on a stream of

[PLATE 17]

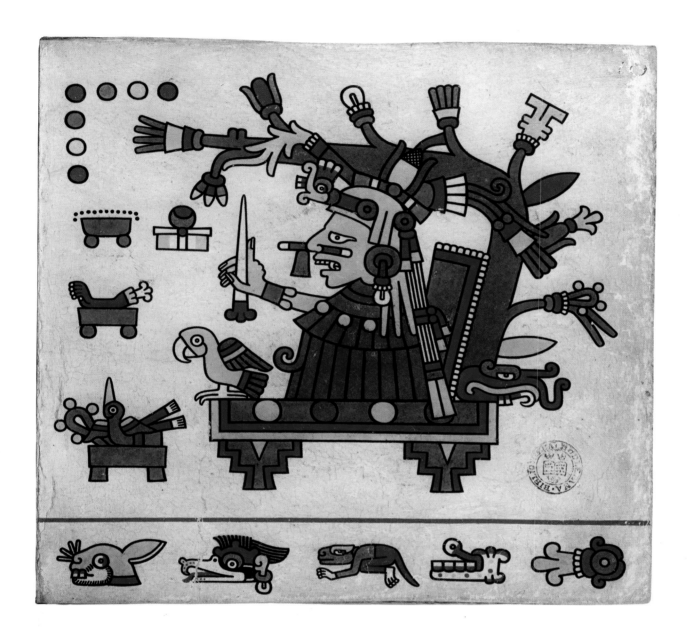

blood along which are three hearts; Tlaloc, the rain god, in clouds; the skeleton Mictlantecuhtli, god of death whose offerings include bones and a heart, holding a flaked flint dagger and a heart; Cinteotl, god of maize, and Mayauel, goddess of strong drink and childbirth, here reproduced.

### ILLUSTRATION

The yellow goddess Mayauel is seated in front of a great flowering maguey plant on a red, yellow and blue-green tortoise which serves as a throne. A stick pierces her nose and, naked except for a blue collar, she holds a maguey spine (for penance) and a bone awl in one hand, while in her right she lifts a bowl full of jewels, originally green and now brown. A serpent with a forked tongue passes through the tortoise throne. Mayauel is the lady of strong drink and, here, goddess of child-birth. A narrow panel at the bottom contains five standard hieroglyphs for five days. They are the same as those on the adjoining folio described below, but their order is not the same. The four dots arranged in the shape of a knight's move in chess signify numerals.

Cinteotl, lord of maize, also with a yellow head and a stick through his nose, sits in front of a flowering tree, hands raised, on a large stool. He wears a pleated robe made of feathers, which was green but has now faded to a golden brown, and he holds a dagger. A parrot, mainly yellow, with green and red wings, shares the stool with him, while another small bird perches on a separate stool and two other stools are unoccupied. There is also a brown tree, bearing flowers of red, yellow, and blue.

Five signs in a row are at the bottom of the page, a rabbit, a vulture, a lizard, a crocodile, and a flower, which signify five day signs: Tochtli, Cozcacuauhtli, Cuetspallin, Malinalli and Xochtli.

[PLATE 17]

## LAUD MANUSCRIPTS

Books given to the Bodleian by Archbishop Laud of Canterbury, who was executed in 1645, came in four great donations between 1635 and 1640 and are all kept together on the Library's shelves. They are divided mainly into three, MSS. Laud Greek 1–93, MSS. Laud Latin 1–118, and MSS. Laud Miscellaneous 1–761, in addition to which there are some in eleven different Oriental languages. Laud's Western manuscripts were described in detail in volume two of the old Bodleian Library *Quarto Catalogues*, which appeared in 1858 and is being reissued in facsimile with corrections. In each Laudian manuscript there is usually a fly-leaf with an inscription of ownership followed by a date, evidently that on which he acquired it. The whole collection is analysed by date in *Summary Catalogue of Western MSS* pp.128–141. (E.B.W. Nicholson hoped in vain in 1901 to recatalogue the Latin and miscellaneous manuscripts according to provenance – the oldest section came from St Kylian's, Würzburg.)

The Laudian Collection contains many of the Bodleian's most important texts, including the *Anglo-Saxon Chronicle* and a manuscript of the Acts which may have been the one used by the Venerable Bede. By October 1971 the Bodleian had published twenty rolls of coloured filmstrips devoted to sixteen of the manuscripts, but this only scratched the surface as Pächt and Alexander's *Catalogue of Illuminated Manuscripts* lists thirty-six Laudian manuscripts from Italy and 141 from other European countries.

## BIBLIOGRAPHY

Cottie A. Burland 'A 360 day Count in a Mexican Codex' in *Man* vol.247 (1947) no.114, pp.106–8

Cottie A. Burland 'Some descriptive notes on MS. Laud Misc. 678, a Pre-Columbian Document in the Bodleian Library' in *International Congress of Americanists* vol xxviii (Paris, 1948), pp.371–6

Cottie A. Burland *Magic Books from Mexico* (King Penguin, 1953) plates 14–15

Cottie A. Burland *Codex Laud* (Akademische Druck-u. Verlag-santalt, Graz, 1966)

Lord Kingsborough *Antiquities of Mexico* vol. ii section 2 (1831) facsimile

Carlos Martínez Marín *Codice Laud, Introdúccion, Seléccion y Notas* Instituto Nacional de Antropológia, Serie Investigaciones 5 (Mexico, 1961)

Karl A. Nowotny *Tlacuillolli: Die Mexicanischen Bilderhandschriften, Stil und Inhalt. Mit einem Katalog der Codex-Borgia-Gruppe. Monumenta Americana* iii (Berlin, 1961). With diagrammatic commentaries. Nowotny's plate 50A is MS.Laud Misc. 678, fo.9 (which he calls page 8)

A. R. Pagden *Mexican Pictorial Manuscripts*, Bodleian Picture Books, Special Series no.4 (1972)

# APOCALYPSE

c.1250–60, ENGLAND

[PLATE 18]

Abaddon and the locusts
Two illustrations to Revelation IX. 7, 11 and 13–15
MS. Auct.D.4.17 folio 5ᵛ
230 × 160 mm / 11 × 8 in.
This manuscript contains ninety-two miniatures, two on each
page. Every leaf is illustrated; some leaves are bound out of order.

## INTRODUCTION

This is another example of the fashion for illustrated Apocalypses that made itself
so apparent in thirteenth- and fourteenth-century England. Though not as magni-
ficent as the one at Trinity College, Cambridge or the Bodleian's Douce Apo-
calypse, both executed in the second and third quarters of the fourteenth century,
it is still quite famous for its fine miniatures and coloured drawings. One of five
that deal with the life of St John, as well as his vision, it follows a model of the St
Albans school and has a sister manuscript in the Pierpont Morgan Library,
M.524; Dr Bing has shown that it in turn served as a model for a block book after
the invention of printing. Its style resembles that of *La Estoire de Seint Aedward le
Roi* in Cambridge University Library (MS. Ee.3.59). H. O. Coxe published a
superb facsimile of it in 1876 for the Roxburghe Club as *The Apocalypse of St John
the Divine.*

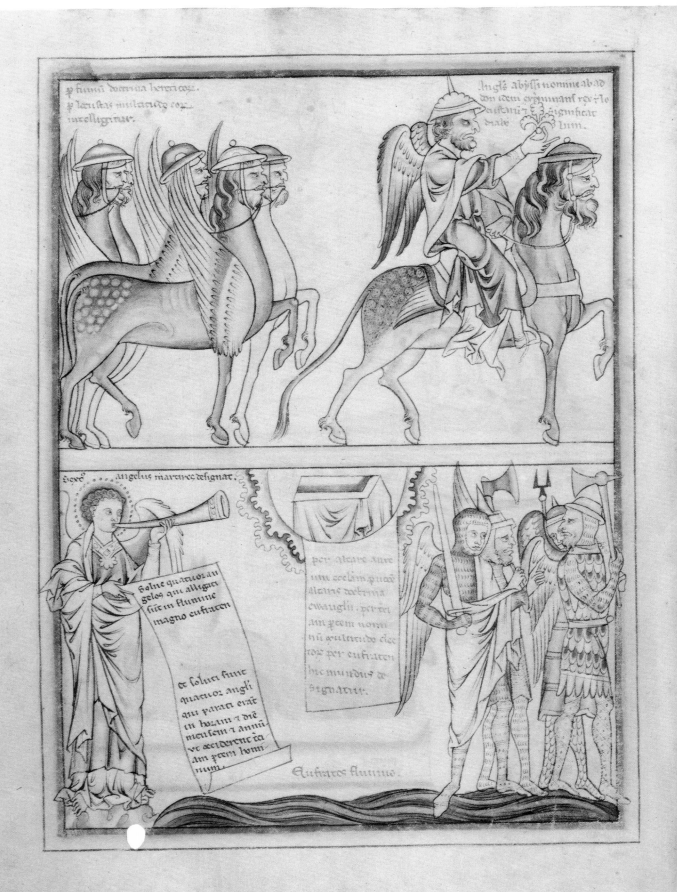

[PLATE 18]

## ILLUSTRATION

It is not easy to clothe a vision in visible form; terrifying words have a way of losing their fire when they are thus pinned down. The interest in a vision of a world overrun by locusts was intensified by the very real threat from the advancing Mongol hordes, but even so, though our artist does his best with hooked noses and portentous frowns to provoke us to terror, the 'locusts', part horse, part man, who are prancing forward in perfect time together in the upper picture, wear an air of caricature. To assist the horse image, they have been given thread-like bridles and, to hint at supernatural powers, they carry wings, but the crowns that they ought to wear have been transformed into cheerful basin-like helmets of red, green, buff, and blue. They are dappled blue and sepia in colour, with long tails, tufted only at the tip. All glare as they march forward, close-ranked, steady and breathing defiance. The text says that locusts signify heretics and their king's name means destroyer. Riding before them is their king, astride another man-horse-locust, which lifts its front leg in time with its fellows. As it is being ridden, it wears a heavier bridle than the token ones of the others, and, like them, but with more reason, its mouth is pulled back cruelly by the bit, causing a grimace of agony. It, too, wears a basin and a wing is visible tucked neatly beneath the saddle cloth. Abaddon, its rider, dressed in loose robes and with wings, wears a spiked basin helmet, while his boot has a pointed, claw-like tip to it and carries a prick spur. Hook-nosed, he too frowns and grimaces. His left hand clasps the reins, but the positioning of the left arm has given the artist trouble. The right arm is raised, and held between thumb and forefinger is an orb from which springs a three-leaved trefoil plant.

On the other hand, the lower picture reveals the slender, elegant figure of the sixth angel, wrapped in loose and ample robes, heavily embroidered at the neck. His hair is in tight golden curls, his face youthful, his halo a piece of pretty decoration in yellow and blue. Raising his trumpet, in his left hand, and with his right holding the corner of a large scroll, he stands upon a rock, washed by the rolling, ribbon-like waves of the River Euphrates.

In the centre is the altar, shaped like a house and covered with a cloth. It is enclosed in a semi-circle beyond which are the very formal scalloped forms of the clouds of heaven.

On the right the four winged angels from the River Euphrates stand dressed in armour for their task of slaying a third of mankind. One is clothed in chain mail from head to foot, wearing a loose cloak and carrying a sword. Another, with an exotic, pointed hat, carries a battle-axe, while a third, wearing a pointed helmet like the old Prussian type, carries a two-pronged weapon. The fourth angel, who also carries an axe, wears a basin helmet over a mail bonnet, and has body armour of overlapping 'fish-scale' pieces of mail. One of the other angels wears this sort of armour on his legs underneath a long surcoat, while another has mail to protect his legs; two appear to be cross-gartered. Two of the angels have hooked noses and grimaces like the 'locusts' above, but two are milder and younger, with a more benevolent look. They gesticulate and seem to be arguing among themselves.

## DRAUGHTSMANSHIP

This is a tinted drawing in the English manner of elegant linearism, avoiding 'body' and weight of tone. Indeed, the colour is almost everywhere transparent, as in true water-colour. The paint, when moist, has been removed here and there with the brush as in the dappling on the blue and brown 'locusts' and has everywhere been handled in washes of various strengths. A darker wash is superimposed upon a lighter (notably on the body of the blue horse) – the classic watercolour technique.

## TEXT

Per fumum doctrina hereticorum
Per locustas multitudo eorum intelligitur

Sextus angelus martires designat

Solue quatuor an-
gelos qui alligati
sunt in flumine
magno Eufraten

Et soluti sunt
quatuor angeli
qui parati erant
in horam et diem
mensem et annum
vt occiderent terci-
am partem homi-
num          Eufrates fluuius

Angelus abyssi nomine ab ad-
don idem exterminans rex lo-
custarum et significat
diabolum

per altare aure-
um ecclesiam per uocem
altaris doctrina
ewangelii per terci-
am partem homi-
num multitudo elec-
torum per Eufraten
hic mundus de-
signatur

The smoke means the propaganda of dissidents. Their number is signified by locusts.
The angel of the abyss by name Abaddon, the same is the destroyer the king of the locusts, and he signifies the devil
The sixth angel signifies the martyrs
By the golden altar is signified the church, by the voice of the altar the teaching of the gospel and by the third part of men the multitude of the elect by Euphrates the world.

Revelation IX. 7, 11 and 13–15
7 And the shapes of the locusts were like unto horses prepared unto battle; and on their heads were as it were crowns like gold, and their faces were as the faces of men . . .
11 And they had a king over them which is the angel of the bottomless pit, whose name in the Hebrew tongue is Abaddon, but in the Greek tongue hath his name Apollyon.
13 And the sixth angel sounded and I heard a voice from the four horns of the golden altar which is before God.
14 Saying to the sixth angel which had the trumpet, Loose the four angels which are bound in the great river Euphrates.
15 And the four angels were loosed, which were prepared for an hour, and a day, and a month, and a year, for to slay the third part of men.

[PLATE 18]

BIBLIOGRAPHY

O. Pächt and J. J. G. Alexander iii.438 (with thirteen biblio-graphical references)

Dr Gertrud Bing 'The Apocalypse block books and their manu-script models' in *Journal of the Warburg and Courtauld Institutes* v (1942), p.145

G. Henderson 'Studies in English manuscript illumination' in *Journal of the Warburg and Courtauld Institutes* xxx (1967), pp.104–37

Colour transparencies on Bodley roll 1671 (36 frames)

# BIBLE
# MORALISÉE

MID THIRTEENTH CENTURY

FRANCE

[PLATE 19]

Eight miniatures in medallions about Noah
MS. Bodley 270ᵇ folio 10
419 × 292 mm / 16½ × 11½ in. (Here reduced slightly)
This manuscript contains 1,785 miniatures on 225 leaves. After a
full-page picture of the Creator, each coloured page, showing
eight miniatures in medallions, alternates with a blank page.

## INTRODUCTION

Except for illustrated manuscripts of Genesis, the Psalms and the Apocalypse, long
series of Biblical illustrations are rare in the middle ages. Of this kind, the twelfth-
century Pamplona Bibles, the thirteenth-century *Bible Moralisée* (presented by Sir
Thomas Bodley in 1604), the fourteenth-century Holkham Bible Picture Book
and the rather similar Picture Bible of Velislaus are among those which have been
reproduced wholly in facsimile. The pictures in others, like the Bible of the Anti-
Pope, Clement VII, formerly Holkham MS. 7 and now British Museum MS.
Add. 47672, are still relatively unknown.

## PARIS BIBLES

The *Bible Moralisée* is the climax of artistic activity satisfying a great demand for
small portable Bibles, written in abbreviated Latin on thin vellum, and in which
artists 'historiated' or decorated the initials marking the beginnings of the various
books and their prologues. The unrivalled centre for these illuminated Bibles was
Paris whither came artists from the Low Countries, Italy, and the Rhine. Their
supreme achievement was the *Bible Moralisée*, produced in about 1250 in the royal
workshop of St Louis (King Louis IX), for here their skills were deployed in illus-
trating not only the text but also the commentary accompanying it. This they did
with brilliance and care.

The book consists of so many miniatures because underneath each picture from
the Old Testament itself, another illustrates the lesson a preacher might draw from
it – sometimes this is a moral lesson, sometimes it prefigures an event in the New
Testament. (The intellectual basis of this work is the *Postillae in Bibliam* of the
Dominican, Hugh of St Cher who died in 1262.) The first of four volumes, the one
in the possession of the Bodleian, illustrates the Old Testament as far as Job XL.
Two of the others are in the British Museum and one is in the Bibliothèque Nat-
ionale in Paris. In addition, three copies were made, of which one is in Toledo
(with part in the Pierpont Morgan Library in New York). A French translation
is in Vienna.

[85]

[PLATE 19]

## FRAMES

Folio 10, illustrated here, tells the end of the story of Noah (Genesis VIII.13, 15–16 and IX.20–21, 22–3). Narrow, vertical bands of text separate the two sets of four roundels, which are each placed against a diapered panel. The blue and white one has ornaments, at the corners and between the roundels, of gold line-work on a pink ground, and the roundels themselves are framed with a pink band. The panel diapered in pink and white has similar ornaments of gold on a blue ground and its four roundels are framed with blue.

## COLOUR AND DRAUGHTSMANSHIP

In each roundel the background is a clear, rich gold, well padded. In addition to black and white, the colours are various tints of pink, blue and green, a red-brown and carrot colour, and a blue grey. Although on certain other pages the drawing is a little coarse, here it is delicate and minute, and the gestures expressive and dramatic. Figures sway, garments blow in the wind, waves undulate. Characteristic of the artist of this page is a considerable interest in naturalistic folds of cloth, deeply gathered and full of rich shadow. The flesh of the bodies is painted a very pale pink, with bone structures and tendons picked out in white.

## ILLUSTRATIONS

In the first roundel on the left-hand side, Noah's dove returns with the olive branch and then departs. The ark is shown as a three-tiered structure set upon a curved ship, which has a dog-like figurehead and a forked stern with a net thrown across it. Noah, in a red cap, stands in the prow, hands raised to catch the returning dove, above which may be seen the bird on its outward journey. Seven birds sit in the top storey of the ark, a pair in each window, and one odd one – perhaps the mate of the dove, which departs. In the middle storey are three pairs of animals, a pair to each window, one of which may be identified as horses, while the others could be deer, or perhaps camels. Below, in the bottom storey, sit the five members of Noah's family, gesticulating and conversing.

The second roundel interprets the dove's departure as the good men reconciled to God and then retiring from the world. Under an arched building stands the Church and before it a crowned figure, who carries a chalice in the right hand, while his left seizes by the wrist a figure who is naked but for a breech clout. This is presumably the reconciliation, though it suggests that force is being employed. To the right of the scene, a tonsured figure in black, holding a paper in the left hand and gesticulating with his right, enters a cave. He is a hermit renouncing the world.

The third scene shows the departure from the ark and is somewhat cramped. Noah and his wife step forward with confidence, but their family – depicted on a much smaller scale – seems to be kneeling in prayer. A ladder, flung awkwardly across the foreground, supports departing pairs of cattle and horses. Birds perch on the roof of the ark and trespass beyond the margin onto the patterned background. A miniature God, who has permitted the departure, bends down in approval from a small, formal cloud.

The fourth panel interprets this scene as God's salvation of the good from peril. A rather fish-like boat rocks on the waves, its prow grasped by a mitred bishop with his right hand, who, like the bishop St Nicholas of Bari, seems to assist those in peril on the sea. Three figures stand in the boat and gesticulate violently before the small, single sail. A conventional cloud is painted on the upper left-hand margin of this scene, and from it issues the muzzle of an evil and threatening monster.

The right-hand group of roundels begins with the illustration of the drunkenness of Noah. He is seated, upright, clutching a wine jar in one hand and tipping a goblet towards his mouth with the other, the lips drawn back to denote his greed. A very formal vine, with a few leaves, twists and twines in and out amongst the persons in the picture, and one of Noah's sons, pick in hand, stoops to cultivate the earth around its roots.

The sixth complementary roundel illustrates Christ's cup of punishment which He must drink whilst buffeted blindfold by His enemies. He is seated amongst His tormentors, one of whom displays the Tablets of the Law; they wear long cloaks and the exotic pointed hats typical of mediaeval Jews. Behind Christ's halo there seems to be a raised club.

The seventh roundel shows Noah's sons, Shem and Japhet, covering the naked legs of their drunken father with a cloak, while he lies in the foreground, asleep. The top of his body is decently clad and he retains his hat. One son turns modestly away, the other raises his hand in a gesture of concern. Ham, the third son, also gesticulates, but presumably he mocks his helpless father.

The eighth and last roundel interprets the drunken Noah mocked by Ham as the wicked humiliating Christ crucified, and the more modest sons as converted Gentiles preaching the glory of the Crucifixion. Christ here droops from the Cross, which is tinted a fresh green, symbol of the living tree. On either side of Him are the sun and the moon typifying Church and Synagogue. To the left of the picture, the wicked mock Him – one pokes Him with a heavy stick, another, grinning evilly, chucks Him under the chin. As in the sixth roundel they too wear pointed hats. On the right side of the composition, a Dominican, in dark blue and white habit, preaches with an impressive gesture to two blue-clad monks who listen with inclined heads. Here 'left' and 'right' would be symbols of the 'bad' and the 'good' respectively, as in the scene of the shipwreck.

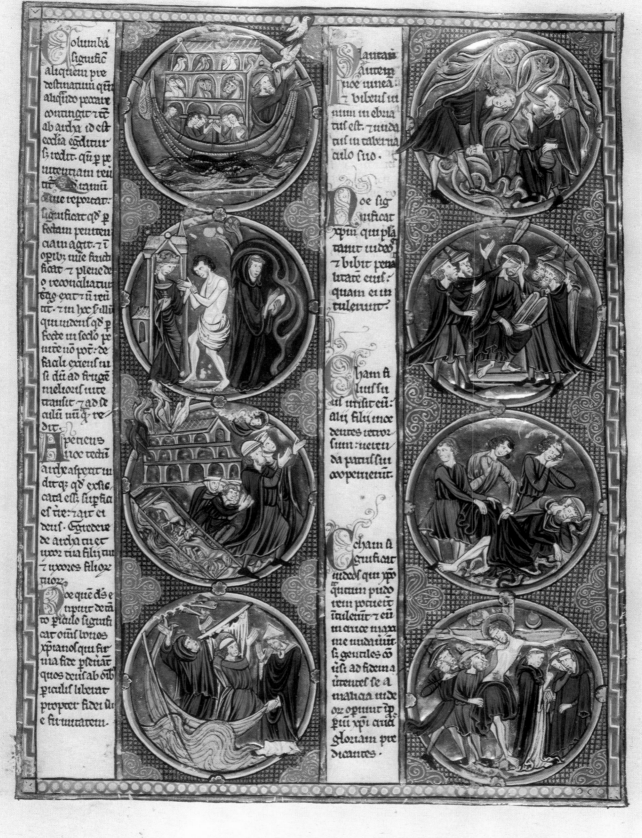

[PLATE 19]

## TEXT

Columba
significat
aliquem pre-
destinatum quem
aliquando peccare
contingit et tunc
ab archa id est
ecclesia egreditur
sed redit. Qui per pe-
nitentiam reuer-
titur.

The dove signifies anyone
predestined who at some time
happens to sin and then goes
forth from the ark, that is to say
the Church, but returns. The
return is through penance.

Quod ramum
oliue reportat
significat quod per-
fectam peniten-
ciam agit et in
operibus misericordie fructi-
ficat et plene de-
o reconciliatur
Tercio exit et non reuer-
titur et in hoc significat illum
qui uidens quod per-
fecte in seculo pe-
nitere non potest de
facili exiens ni-
si dum ad frugem
melioris uite
transit et ad se-
culum numquam redit

That it brings back
the branch of the olive
means that it acts through
penance that has been completed
and it yields fruit
in works of mercy
and is fully reconciled
to God. On the third [day]
it goes forth and does not return
and this means the man who
sees that he cannot live perfectly
in the world. He goes forth
readily and crosses over the fruit
of a better life. And he never
returns to the world.

Aperiens
Noe tectum
Arche aspexit ui-
ditque quod exsic-
cata esset superfici-
es terre et ait ei
deus. Egredere
de archa tu et
uxor tua filii tui
et uxores filiorum
tuorum.

Noah opens the roof of the
ark. He looks and sees that
the surface of the land is dry.
And God says to him: "Come
forth from the ark, thou, and
thy wife and thy sons and thy
son's wives."

Noe quem deus e-
ripuit de tan-
to periculo signifi-
cat omnes bonos
Christianos qui fir-
ma fide perseuerant
quos deus ab omnibus
periculis liberat
Propter fidei su-
e firmitatem

Noah whom God plucked from
so great peril signifies all good
Christians who with a firm
faith raised up those whom
God frees from perils because
of firmness of faith.

Plantans
autem
Noe uineam
et bibens ui-
num in ebria-
tus est et nuda-
tus est in taberna-
culo suo.

But Noah planting a vine and
drinking the wine becomes
drunken and naked in his
tent.

Noe sig-
nificat
Christum qui plan-
tauit iudeos
et bibit pena-
litatem eius
quam ei in-
tulerunt.

Noah signifies Christ
who planted the Jews and
drinks the punishment
which they brought upon
him.

Cham fi-
lius su-
us irrisit cum
alij fillij uide-
dentes retror-
sum uerend-
da patris sui
cooperierunt.

Ham his son mocked him.
The other sons saw him,
turning themselves away,
and they covered the
private parts of their
father.

Cham si-
gnificat
iudeos qui Christo
quantum pudo-
rem potuerunt.
intulerunt et eum
in cruce maxi-
me nudauerunt
Set gentiles con-
uersi ad fidem a-
uertentes se a
malicia iude-
orum operiunt impro-
perium Christi crucis
gloriam pre-
dicantes.

Ham signifies the Jews
who brought as much shame
on Christ as they could,
and they made him utterly
naked upon the Cross. But
the Gentiles converted to the
faith and, turning away from
the malice of the Jews, cover
the shame of Christ's cross
and preach the glory of it.

---

## BIBLIOGRAPHY

O. Pächt and J. J. G. Alexander i.524 (with two bibliographical references)

Colour transparencies of details from this MS. on Bodley rolls 155 (44 frames), 198c (14 frames), 207c (17 frames), 207d (19 frames), 210c (36 frames) and 211e (19 frames)

Colour transparencies of every page (except fol. 65ᵛ) with notes on each miniature by W. O. Hassall published by Educational Productions, East Ardsley, Wakefield (nos.536–42)

# DOUCE
# APOCALYPSE

BEFORE 1272, ENGLAND

[PLATE 20]

The Merchants' and Mariners' lament over Babylon
Illustration to Revelation XVIII.9–20
MS. Douce 180 (Arch.F.c.36) page 76
310 × 203 mm / 12¼ × 8 in.
This manuscript contains one page with a heraldic historiated
initial and ninety-seven pages with miniatures in panels occupying
the top portion of each page.

## PROVENANCE

The historiated initial letter S, which opens the Douce Apocalypse, harmonizes
with the subsequent illustrations and text neither in intention nor style. Belonging
to the world of chivalry and of the court, it is busy with small figures and bright
with colour and burnished gold, and is linked to the text which it introduces by long
flourishes. At the top it shows the Trinity, worshipped by two kneeling figures,
the Lord Edward (1272–1307), son of Henry III, and later Edward I, and his wife
Eleanor of Castile, each with a shield of arms. For heraldic reasons the illustration
can be dated to between 1250 and 1270, during the reign of that highly cultivated
king and generous patron of the arts, Henry III. The thirteenth century, celebrated
for its sculpture and stained glass, saw the growth of a court school of painting
centred round Henry's palace at Westminster and linked with the noble families
and monasteries on either side of the Channel. We are not certain of its exact
provenance, but there is a hint in the words on the paintings, whether as labels or
scrolls indicating spoken words, of Anglo-Norman speech which would suggest
that the work was done in England. Certainly this Apocalypse has qualities of
delicacy and sophistication that raise it from the mass of Apocalypse manuscripts
and few such accomplished masters of the thirteenth century have survived in such
quantity.

Qui diuites facti sunt ab ea
longe stabunt ppter timo
rem tormentorum eius flentes
et lugentes et dicentes. Te ciui
nitas illa magna que amicta e
rat bisso τ ppura τ cocco et inaura
ta auro et lapide pcioso et mar
garitis. quoniam una hora desti
tute sunt tante diuicie. Et om
nis gubernator et omnes qui in
locum nauigant et naute qui in
mari operantur longe steterunt
et clamauerunt uidentes locum
incendii eius dicentes. Que si
mul ciuitati huic magne τ mi

serunt puluerē super capita sua
flentes et lugentes τ dicentes. Ve
nie ciuitas magna in qua diuite
facti sunt omnes qui habent na
ues in mari de preciis eius. quoni
am una hora desolata est. Exulta
super eam celum τ sancti apostoli
et pphete. quia iudicauit deus iu
dicium uestrum de illa.

ui diuites facti sunt ab ea. et c.

Portuinus per mare hic seculum per gubernatores
uero principes iniquos intelligere. per eos autem qui
de loco ad locum nauigant τ p nautas qui in mari
operantur. eos qui diuersa officia ad depredationes
pauperum τ ad peccata sua condie agenda inmun
te excercent. Ista ergo flebunt τ lugebunt uidentes
locum incendii babilonis. Ipi namqz erunt babilo
et ipi flebunt τ lugebunt. Videbunt autem incen
dia babilonis. quia sua incendia prferendo uidebt.

[PLATE 20]

## ILLUSTRATIONS IN MANUSCRIPT

The illustrations, of which a hundred seem to have been intended, but only ninety-seven remain, have outgrown the jewel-like brilliancy of colour and the lavish use of gold on the initial page. Instead, they reveal, especially when half-finished, all the gracefulness of the best period of Gothic drawing and a sense of remote and spiritual power. The text of this Apocalypse, thought by experts to have been written in its entirety by one unknown scribe, is followed by the picture-book, in which each illustration embodies a portion of the text and is roughly contained within its simple frame, though sometimes a foot or a finger will be seen to trespass beyond it. Each picture, horizontal in format, occupies the top of the page while the words are written below, but because court people were little likely to read them, they are evidently considered so unimportant that they are sometimes incomplete or even in part repeated in order to fill the page with a solid block of handsome Gothic script. There are also labels, for example, 'C'est le hysle de pathmos' indicates where John sits writing, and scrolls that give the words of a speaker somewhat in the manner of a modern comic strip.

## TEXT

On occasion the biblical text is supplemented by the commentary written by Berengaudus in the ninth century, normally in letters half the scale of the text it explains, but sometimes this ratio is reversed. This commentary interprets St John's vision in terms of early Church history, without seeking allusions to modern politics in the manner of commentators of the thirteenth and later centuries – although it should be said that some students of heraldry have seen in the banners of Satan's hosts the arms of Prince Edward's enemies.

## DRAUGHTSMANSHIP

The book was never finished: spaces are left blank waiting for their coloured initial letters, and some remain only as line-drawings. This is less frustrating than one might think, because while the coloured pictures exhibit a quiet but brilliant harmony, the finesse and sureness of the draughtsman's line is a supreme feature of this manuscript, and we are fortunate to be able to see it in all its purity. Projected and enlarged upon a screen, the paintings resemble less the finest wall-paintings, now lost to us, than the strong line and clear colour of stained glass.

## STYLE

The artist is observant but not the slave of nature, and certain traditions persist to give the illustrations that mediaeval look: he still treats clouds purely symbolically as scalloped fabric hanging from the sky. Nor is there any striving after 'correct' proportion between tree, building and man, and although we can recognize the vine and the oak-leaf the ground plants are the merest formal sprigs. The trees in general still retain traces of the old barbaric interlace among the branches, yet in such sophisticated

hands they partake of the nature of *art nouveau*. The figures themselves sway and undulate like some Gothic Virgin carved from an ivory tusk. Fingers are boneless, the little finger often held straight out like a genteel lady at a Victorian tea-party – no mean handicap when one is holding a sword. The heads are those in fashion in this century, the cheeks are concave and haggard and the foreheads bulge. Ears are studied carefully, but sometimes lie flat on the cheek, as a child would draw them, instead of behind the line of the jaw.

These general observations hold less true of the more dramatic illustrations. The withdrawn elegance of the poses is replaced in the battle scenes by writhings suited to supernatural disasters, and dragons and demons appear, descendants from an older world. In one picture, that of a hailstorm, the colour is a mass of 'atmospheric' paint, instead of being contained, as normally, within clearly drawn outlines.

## ILLUSTRATION

This picture illustrates the passage from Revelation, 'The merchants . . . which were made rich by her, shall stand afar off for fear of her torment weeping and wailing and saying, "Alas, alas that great city that was clothed in fine linen and purple and scarlet and decked with gold and precious stones and pearls" . . . and every shipmaster and all the company in ships and sailors, and as many as trade by sea stood afar off and cried when they saw the smoke of her burning, saying, "What city is like unto this great city!" and they cast dust on their heads and cried weeping and wailing saying, "Alas, alas that great city wherein were made rich all that had ships in the sea by reason of her costliness, for in one hour is she made desolate."'

The usual method of the artist seems to have been first to draw finely in ink the principal outlines of the picture, then the gilder would add a discreet portion of gold. The painter, probably, but by no means certainly, the same man as the draughtsman, would add rather pale, flat washes of colour, which would be deepened for shadow or overpainted with light sprigs and individual details later. This picture has been selected deliberately incomplete to demonstrate the superb line before it is muffled with painted detail and the sober and subtle basic tints.

On the left, the 'Whore of Babylon' holds a sceptre with a trefoil head, with her face and neck modestly muffled in a kerchief while she seems to be beckoning the crowd to advance. She is seated beneath an arch, cusped and roundheaded, and above her stand two little houses behind an embattled parapet: next to these is an arcade of two roundheaded Norman arches and two pointed Gothic arches, an arrangement together with its colour such as might have been seen in life. A buttress below and other architectural features are not completely painted, though a little turret has zigzag patterns on the roof. This is the splendid town of Babylon.

A small green tree with three formal fan-shaped heads of foliage – that in the centre displaying oak-leaves, those on

[PLATE 20]

either side of it a sort of pattern like the fish-scale tiles on roofs – sways in front of the shipmen and merchants. The passage below the tree with its loosely scrubbed outline is unpainted and may have been going to develop into 'the smoke of her burning' or perhaps into a grassy bank. One horizontal and one vertical scroll indicate the speech of the distressed crowd, whose members are busily casting dust on their heads, which may be perceived peppering the bottom of the picture. (This would, presumably, have to be painted right over and added on top of the paint.)

The speakers indicate their scrolls with long flexible fingers. The scrolls are written in the script used in charters of the last half of the thirteenth century and for the earlier decades of the fourteenth. The text above runs 'Li quel est semblable a cele grante cyté' and that below has 'Allas, allas i cele grant cyté en ki tuz ki auoient nefs en la mer sunt fet riches de ses pris kar a un hour'. 'What city is like unto this great city! . . . alas, alas that great city, wherein were made rich all that had ships in the sea . . . for in one hour . . .' (Revelation XVIII. 19–20)

Two little men, out of scale with the rest, grovel in front among the dust, which they cast on their curly hair: both are bearded and wear long gowns and mantles. The compact crowd of merchants and seamen behind them is larger in scale and they wear, in some cases, the little male bonnet tied beneath the chin, customary among the burgher classes at this time, and in others, hooded cloaks; all have curly hair and the older ones have flourishing beards. The drawing of several of the faces is lively and

piquant and although the attitudes are rhythmic, they display considerable variety. One is reminded here, in this little-known but beautiful passage, of the crowd of Sienese in Ambrogio Lorenzetti's *Allegory of Good Government*, painted for the town hall of his native city seventy years later.

## COLOUR

The colour here, uncomplicated as it is by later glazes, is outstandingly lovely – greys, sober blues, soft pinks, rust reds, and a rich khaki tint form a sophisticated scheme of great appeal to the modern eye. M. R. James has reproduced every page in monochrome for the Roxburghe Club, but selected colour reproductions have been done by Averil Hassall.

## BIBLIOGRAPHY

O. Pächt and J. J. G. Alexander iii.469 (with twenty-one bibliographical references)

G. Henderson 'Studies in English manuscript illumination' in *Journal of the Warburg and Courtauld Institutes* XXX (1967), pp.86–7, 88, 90, 104, 123, 126, and *ibid* XXXI (1968), pp.113–29 and plates XLIId, XLVa, and c

G. Henderson 'An apocalypse manuscript in Paris' (B. N. MS. Lat.10476) in *Art Bulletin* LII (1970) pp.22–31 and figs.2, 4, 5, 7, 14, 18, 21

Averil Grafton Hassall *The Douce Apocalypse* (Faber & Faber, London, 1961)

Colour transparencies wholly devoted to this MS. on Bodley rolls 139C, 166J, 166L, 167J and 196T

## TEXT

Qui diuites facti sunt ab ea longe stabunt propter timorem tormentorum eius flentes et lugentes et dicentes. Ve. ue ciuitas illa magna que amicta erat bisso et purpura et cocco inaurata auro et lapide precioso et margaritis. quoniam una hora destitute sunt tante diuicie. Et omnis gubernator et omnes qui in locum nauigauit et naute qui in mari operantur longe steterunt et clamauerunt uidentes locum incendii eius dicentes. Que simul ciuitati huic magne et miserunt puluerem super capita sua flentes et lugentes et dicentes. Ve ue ciuitas magna in qua diuites facti sunt omnes qui habent naues in mari de preciis eius. quoniam una hora desolata est. Exulta super eam celum et sancti apostoli et prophete. quia iudicauit deus iudicium uestrum in illa.

[Q]ui diuites facti sunt ab ea, etc.

[Small letters]
Possumus per mare hoc seculum per gubernatores uero principes iniquos intelligere. per eos autem qui de loco ad locum nauigant et per nautes qui in mari operantur. eos qui diuersa officia ad depredationes pauperum et ad peccata sua cotidie agenda inmunde excercent. Ista ergo flebunt et lugebunt uidentes locum incendii babilonis. Ipsi namque erunt babilon et ipsi flebunt at lugebunt. Videbunt autem incendia babilonis. quia sua incendia perferendo uidebunt.

[The merchants . . .]
which were made rich by her, shall stand afar off for the fear of her torment, weeping and wailing. And saying, Alas, alas that great city, that was clothed in fine linen, and purple and scarlet, and decked with gold, and precious stones and pearls!
For in one hour so great riches is come to nought. And every shipmaster and all the company in ships and sailors and as many as trade by sea, stood afar off. And cried when they saw the smoke of her burning, saying, What city is like unto this great city! And they cast dust on their heads, and cried, weeping and wailing saying, Alas, alas, that great city, wherein were made rich all that hath ships in the sea by reason of her costliness for in one hour is she made desolate. Rejoice over her thou heaven and ye holy apostles and prophets; for God hath avenged you on her.

[The MS. then repeats the first line for the sake of the spacing of the page.] 'which were made rich by her, etc.'

Translation of Berengaudus' commentary
We can understand this world by the sea, and wicked princes by the shipmasters; but by those who sail from place to place and by those who work by sea [we can understand] those who indecently exercise their different offices to the spoliation of the poor and to their evil actions day by day. Therefore they will weep and bewail these things when they see the place of the burning of Babylon. For they will be Babylon and they will weep and wail, for they will see their burnings in bearing them.

# PORTABLE

# BREVIARY

EARLY FOURTEENTH CENTURY

EAST ANGLIA

[PLATE 21]

Descent into Hell
MS. Gough Liturgies 8 folio 62ᵛ
203 × 140 mm / 8¼ × 5½ in.
A series of fourteen fine (but partially damaged) full-page
miniatures of the life of Christ are added to a psalter from Hyde
Abbey, Winchester, which has many decorated initials.

## BREVIARIES

The words 'breviarium' and 'portiforium' mean, respectively, a compendium and 'vade mecum' of any sort. Such a book contains, in one compact and convenient volume, prayers, canticles, collects, hymns, biblical passages, and other excerpts taken from various religious books such as collectars, hymnals, antiphoners and psalters, so that services could be conducted at a distance from a church.

This psalter, whose style is related to that of Queen Mary's Psalter, was probably once part of a breviary from Hyde Abbey (MS. Rawl. Liturg. e.1*) as both manuscripts have identical early eighteenth-century bindings. (The asterisk is an essential part of the shelfmark as the Bodleian Library has another liturgical manuscript from the library of Richard Rawlinson which is also referenced MS. Rawl. Liturg. e.1.)

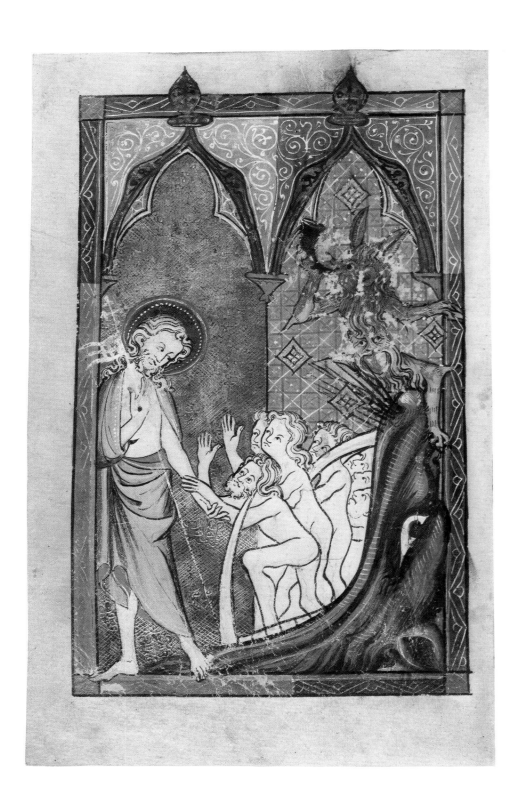

[PLATE 21]

## ILLUSTRATION

In this illustration Christ, after the Crucifixion, is in the act of descending into Hell to rescue those souls worthy of salvation. This theme known as the Harrowing of Hell was popularized by the Gospel of Nicodemus, of which there was a number of English translations, by alabaster carvings and by plays (Mrs. M. D. Anderson has discussed the popularity of this theme in Norman sculpture). In a simple frame of blue and pink, delicately patterned in white line-work, stands the Saviour, smiling, gentle, and gracious. A pale blue mantle lined with vermilion covers only the lower half of His body, revealing a black, sickle-shaped scar on His right-hand ribs. His right hand, with a nail-mark clearly visible, rests on His breast, but a banner, in the form of a long, shafted cross with a pendant, itself bearing a cross, has been lightly indicated in white paint in the position it would take were He clasping it. It is evidently an afterthought, for the shaft runs across the back of His hand. Long wavy hair flows over His shoulders, and His beard is neatly parted in the middle. His halo is blue, embellished, like His mantle, with a border of white dots. He inclines His head towards the anxious souls, and grasps the front one amongst them, firmly but lightly, by the forearm.

In contrast to the smiling elegance of Christ, the souls, symbolized by wholly naked human bodies, show signs of agitation and distress. Four of them stand and gaze up at Him anxiously. The foremost, a bearded man, smiles at his rescuer and clasps the arm that is stretched to seize him, whilst waving his free arm in excitement. The other three – a woman, identified by her hanging breasts, and two young men – anticipate their rescue, but three faces behind them, crushed back into Hell's mouth, can only peep at what goes on.

Christ and the naked souls are painted a clear white and outlined in black, quite without tint or shading. Five of the souls are shown, like Christ, three-quarter face, but two of them at the back are shown in profile, with somewhat coarse faces and beaky noses.

Hell's mouth is in a savage, fish-like face painted in grey and black, with an evil eye and gaping, bristled jaws, from which protrude sharp white fangs. It occupies the bottom right hand of the illustration, symbolically placed to the left, or 'evil', side of Christ Himself.

Perched on the uppermost lip is a grotesque and evil demon, clawed and hairy, with long ears and grey pelt. His arms and legs, which have elbows, end in thorn-like points. He turns his head aside to blow a horn – and seems to have a round eye, a third ear, and a comic nose; a beard hangs down onto his chest, and from under this peers a second evil face, likewise bearded, its mouth stretched in

yelling. The effect is nightmarish in the extreme, like Hell's mouth itself, and very lively – the suggestion of noise and hideous brute energy contrasting with Christ's graceful pose. A porter in Hell with a horn features in English art and literature. In the York and Towneley Miracle Plays of the Judgement he is called Tutivillus, or 'all vile' – a specialist in silly mistakes such as clerical errors. As late as Shakespeare (*Twelfth Night* II.iii and *2 Henry IV* II. iv) 'Tilly-vally' or 'Tilly-tally' is an expletive.

The background is divided into fanciful Gothic arches, on which the metal paint has deteriorated somewhat, as elsewhere in the book. They are cusped and topped with rather clumsy finials. The gold panel containing Christ has been enriched with a cross-hatching of fine, diagonal lines broken at intervals by grotesque beast masks. Behind this golden arch is a background of pink, delicately painted with linear scrolls in white. On Hell's side of the page is a blue background, similarly adorned, and the span beneath the arch is filled in with pink overlaid by a grid of horizontal and perpendicular lines in a deeper pink, and a white diaper pattern. At intervals, the lozenge shapes formed by these diaper lines are filled in with gold touched with black and white. Although these are intended to embellish the background, the lowest of these has been painted over Hell's fierce bristles – another instance, like the banner of Christ, of an afterthought added without reference to the drawing beneath. The painter has also forgotten to paint in the pink background behind the lower part of the group of souls.

## DRAUGHTSMANSHIP

There is a good deal of black line-drawing throughout, but shadow on Christ's mantle, the wrinkled jaws of Hell and the hornblowing demon's fur are reinforced with dark paint. Hell's mouth has received a final highlighting with touches of white. The paint is opaque and has fallen off in some places – notably so in the case of the demon.

## CONCLUSION

The whole picture is drawn with the curvilinear feeling typical of its period, balance and contrast, whether of form or mood, being most skilfully employed. Christ and demon sway inwards towards each other; the arc of the gaping mouth is closed by the curve of the two terrible fangs.

## BIBLIOGRAPHY

O. Pächt and J. J. G. Alexander iii.545–6 (with six bibliographical references and references to three manuscripts executed in a similar style)

Colour transparencies on Bodley rolls 171E (19 frames) and 175E (12 frames)

# THE

# ORMESBY PSALTER

c.1310, EAST ANGLIA

[PLATE 22]

Christ at the right hand of God
MS. Douce 366 folio 147ᵛ
375 × 254 mm / 14¾ × 10 in. (Here slightly reduced)
The manuscript contains eleven pages with large initials and
decorative borders. The first of two 'Beatus' pages was taken
from another psalter and inserted. The initials for the psalms and
for the collects are mostly historiated. The contemporary binding
is white leather and boards with a white chemise.

## PROVENANCE

The celebrated Ormesby Psalter has been discussed by every writer on English
illumination, Cockerell, Millar, Pächt, and Rickert all being contributors to the
fame of this page. An East Anglian masterpiece of around 1300, it commemorates
the name of Robert of Ormesby, a monk who gave it to his priory (Norwich
Cathedral) to lie in the choir before the sub-prior. Heraldry associates its produc-
tion with the families of Foliot and Bardolf.

## ILLUSTRATIONS IN MANUSCRIPT

Apart from the ten chief illuminated pages for the main divisions of the psalms,
there are numerous historiated initials and decorative line-endings, while the
borders of the main pages are occupied by numerous creatures, leaves, flowers, and
grotesques. There are also some half-finished pages, that tell us a great deal about
the way the manuscript was illuminated.

ccrra a persequentibz animam meam.
Inice obsecrationis dñe deus. qui
maledictioni subiacere dignat⁹
es. ut nos a maledicto legis erucris. z fa
ceres nobcum misediam: wt noii tuii
digneris nos z a pseqntibz uictis. et a
malorum obtrectationibz liberare. pcr.

domino meo: sede a dextris meis.

[PLATE 22]

ILLUSTRATION

The plate shows folio 147ᵛ and introduces the psalm 'Dixit Dominus Domino' (Psalm 110 for Anglicans but 109 in the Vulgate). The splendid design is based round the capital D of 'Dixit Dominus', which is written vertically by it. Above, the decorated U of 'Unice' is of a smaller size. Against a diapered background of dark blue, patterned with black, white and vermilion, is set the great initial D. The terminal lines of this develop into twining tendrils that bear leaves, mainly of an ivy-like nature, in blue, pink, green, and carrot colour, and having buds and flowers amongst which a cornflower and pea form can be recognized. Close to the D itself, these tendrils curl into roundels, the upper one of which is being bitten by a flying, dragon-like beast, whilst a small naturally-drawn bird perches within the circle. Beneath the lower roundels crouches a frowning, curly-haired figure in a long grey robe with a red-lined hood, stockings of blue and black shoes. This roundel contains another lively little bird, facing in the opposite direction to its fellow, with left claw raised and left wing opening as if for flight. Within the letter itself upon 'the likeness of a throne' (Ezekiel) sit God the Father and God the Son, in formal frontal positions, their hands raised in the ancient 'orans' position. They look straight ahead with solemn gaze. Almost identical ('for he who hath seen me hath seen the Father also'), they are dressed in long blue robes, tied with plain, knotted girdles, and long pink cloaks each fastened in the centre with a brooch of almond shape. Their long curly hair and neat beards are brown, a paler tint of which is used to indicate modelling on their faces and hands and in the anatomy of other figures in the scheme. Immediately behind these figures is gold leaf, pricked into patterns – a decorative effect which is added to this page wherever there is a large enough gold surface. Behind the gold runs a curly strip of cloud, with a miniature sun and moon. An elaborate Gothic building, with battlements, turrets, cusps, crockets, and other ornaments, surrounds the figures, and, in the right-hand turret, a round-headed door with hinges of elaborate type and keyhole is shown quite convincingly as half open. Five enemy warriors, in surcoats and chain mail, struggle together under a footstool, as suggested by verse 1 ('. . . until I make thine enemies my footstool').

The D is bordered with a simple strip pattern of vermilion circles, each centred with a black and white dot; the vertical portions of the letter are diapered in pink, black and white and in each is a six-winged cherub, haloed and with short curly hair, bare feet, feathered arms, and hands in the 'orans' position. Round the neck of each is tied a scarf-like kerchief and they stand upon golden wheels which symbolize speed. The six wings of each are scattered with eyes – in Ezekiel 1 'the eyes are in the rims of the wheels' – that signify God's omniscience.

On the right hand of the D at top and bottom are two beautifully observed greenfinches and a vertical strip of letters, while on the left side stands a most lively figure. He is naked but for a cloth flung over him which drags on the ground, and round his short curly hair is tied a scarf, knotted and with the ends blowing out. Although his bare buttocks face towards us, he has swung round so that we see his left profile. His hands hold a long 'buzine' or trumpet, bearing a white pendant with a red cross and his cheeks are rounded in the effort of blowing it. Perhaps this figure portrays the majestic, rushing sound which accompanied Ezekiel's vision. Although a close inspection suggests that the pose is strained beyond probability, yet the effect is lively and even appears convincing anatomically.

The page contains seven lines of text above the D. The gold-filled U, in pale vermilion delicately scribbled with a patterned line of white, contains the portrait head of Christ, His blue halo bearing a cross, and His hair formally curled. This U is linked to the border by a fretted pattern of blue and pink, delicately painted with formal flowers in white.

FRAME

A similar device runs right round the text like a frame, sometimes partly hidden under the rich and diverse embellishments. These include at each corner a geometric pattern of bands, often interlaced, in pink and blue, enriched with gold. Three are based on a circular layout, and that in the bottom left-hand corner on a grid design. None is alike. The top one contains a circle in the centre, from which peers a man's face; it is backed with an elaborate design in blue, and acorn-forms alternate with fairly convincing oak-leaves. It also appears to develop out of a blue and gold stalk, twined with leaves of ivy. The two interlaced patterns at the bottom each have a band which grips the neck of a formal beast in grey, having long waving ears, a dog-like face, a bird's body and dog's paws; that on the right has opened his mouth to reveal a long red tongue.

All sorts of patterns enrich these borders – any pointed form is apt to bear a flower such as cornflower, pea, or carnation, or a golden disc. Leaves, whether of oak, ivy, or buttercup, run riot all over the place, and the right-hand border bears, in the centre, an interlaced pattern, with two winged insects and a ladybird above, whilst two ladybirds and a wasp lie in the lower portion.

The upper and lower borders show scenes of great liveliness. At the top, a hare runs off to the left, an owl, facing backwards, borne on his back. He is pursued by a greyhound, ears laid back, who is ridden by an ape. The latter is unclothed, save for hawkers' gauntlets and a belt, which bears an open bag. In one hand he holds an object in red, perhaps the hawk's jesses, and in the other a pair of wings tied to a string, which blows out behind him – undoubtedly a lure used in hawking.

The owl prefers the darkness to the light and so typifies the Jews who reject the light. Riding backwards is a mark of humiliation and a symbol of evil. For this Ruth Melinkoff suggests numerous parallels in *Viator: Mediaeval and Renaissance Studies* IV (1973), pp.153–76.

At the bottom margin is a savage scene of combat. Two nude men are riding beasts. The lion, on the right, springs

[PLATE 22]

open-jawed to bite the bear's neck, clawing him at the same time. The men fight without weapons: the figure on the bear pulls his adversary's rather long hair, and swings his right arm with knotted fist to deliver a hard punch. The other has got his thumb in his opponent's mouth and is pulling the face about. The disorderly violence of these creatures contrasts with the calm dignity of the Lord above.

## CONCLUSION

It is hard to do justice in words to the quality of this superb page – the drawing at once delicate, but boldly planned, and diversified by action, wit, lively observation, and majestic calm. The figure blowing the trumpet has been compared to a similar one in late Roman depictions of a triumph. Although the mediaeval world of dream and fantasy is with us still, a new world of nature is beginning to unfold in insects, leaves, flowers, birds, and well-observed anatomy.

## A NOTE ON THE TEXT

Once each psalm used to be followed by a prayer or 'collect' more or less inspired by the psalm. However, psalters which contain them are of such relative rarity that collects occur in only twenty-four of the 472 psalters studied by Leroquais in *Les psautiers manuscrits Latins des bibliothèques publiques de France*. M. R. James has pointed out that the Ormesby Psalter is one of five East Anglian psalters which differ from the others in having a collect after each psalm or canticle, and furthermore in all five the series of collects is practically the same. This series, in part at least, cannot be before the eighth century when many occur in Alcuin's 'Officia per ferias'. The series also occurs in Continental manuscripts of various dates.

## TEXT

[Ut saluam fa–]

–ceret a persequentibus animam meam
Unice obsecrationis domine deus qui
ma勒ediccioni subiacere dignat*us*
es. ut nos a maledicto legis erueris et fa-
ceres nob*is*cum misericordiam p*ropter* nom*en* tuu*m*
digneris nos et a persequ*entibus* uiciis. et a
malorum obtrectationibus liberare . per.
DIXIT DOMINUS
domino meo. 'sede a dextris meis . . .'

[To save him] from those that condemn his soul
O God of a pity without peer Thou who
hast deigned to undergo condemnation that Thou mightest
pluck us out from the condemnation of the law,
have mercy upon us for Thy name's sake and
deign to deliver us from the vices which beset us and from
the slanders of the wicked.
The Lord said unto my Lord, Sit thou at my right hand, [until
I make thine enemies thy footstool.]

## BIBLIOGRAPHY

O. Pächt and J. J. G. Alexander iii.499, 536 and 581 (with sixteen bibliographical references)

M. R. James and S. C. Cockerell *Two East Anglian Psalters at the Bodleian Library* (Roxburghe Club, 1926). The caption under plate xiv wrongly describes this as Psalm 126

P. Lasko and N. J. Morgan (ed.) *Mediaeval Art in East Anglia 1300–1520* (1973), pp.18–19. (Discusses work of two artists postulated for our page on eight other leaves and in two other MSS. They associate the solid figures with Bolognese illumination)

Colour transparencies on Bodley rolls 139D (12 frames), 195G (28 frames), 195H (15 frames) and 195I (24 frames)

# THE ROMANCE OF

# ALEXANDER

1338–44, FLANDERS

[PLATE 23]

Alexander confronts Porus and assaults city
MS. Bodley 264 folio 51ᵛ
490 × 295 mm / 16 × 11¾ in. (Here slightly reduced)
This manuscript of the *Roman d'Alexandre* and other French
poems contains twelve full-page miniatures and lesser ones on
most of the 207 leaves, sometimes several on a page. There are
also scenes of daily life or drolleries in the lower margins of most
pages. It also contains nine English miniatures of about 1340–70,
illustrating the English verse *Romance of Alexander* (folios 209–17),
and thirty-eight English miniatures of about 1400, illustrating
Marco Polo's travels.

## THE ALEXANDER LEGEND

This illustration comes from the first part of the volume, Alexander of Paris'
version of the *Roman d'Alexandre* in the Picard dialect. This page follows pictures
of Alexander at Tyre and Jerusalem, of his confrontation with the Persian army's
elephants, the death of King Darius, Alexander's descent in a submarine and his
slaying of Porus (folio 75), in fact the story of Alexander the Great as developed in
the Middle Ages. As was customary perhaps all the scenes are modernized into
Gothic rather than shown as Classical events, which tends to take the story into
fantastic realms: Alexander is shown not only with a glass bathysphere but also
with a spaceship powered by griffins motivated by meat on a pole. (These two
items were still further elaborated by German artists, who added new details and
new adventures.) One event that grew into popular legend was the story of
Alexander's duel with Porus, whom he defeated on the River Hydaspes, or Jhelum,
in 326 B.C. (for fuller details see *Alexander the Great* by W. W. Tarn). For example,
illustrations in other manuscripts show the use of heated copper balls to repel
Porus' elephants, and the single combat between the two kings in a 'champ-clos'
like a boxing ring. The text requires that Porus have his back turned when he is
finally stabbed, but the various illustrations do not always show this.

Conment alixand auoit danen le roy dire.

[PLATE 23]

## CONTENTS OF MANUSCRIPT

This manuscript is amplified by various other French poems: *Le Duc Melcis* or *La Prise de Defur*, *Le Vœux du Paon* of Jacques de Longuyon, *Le Restor du Paon* of Jean Brisebarre, *Voyage d'Alexandre au Paradis Terrestre*, and Jehan le Nevelon's (Venelais) *Venjance Alixandre*. This volume also contains a mid-fourteenth-century English verse *Romance of Alexander* and Marco Polo's *Livre du Graunt Caam*, the latter including a famous view of Venice executed in England about 1400.

## OTHER ILLUSTRATIONS IN MANUSCRIPT

A particularly intriguing feature of this book is its numerous marginal illustrations with many scenes from daily life, including a wide range of sports and pastimes such as a Punch and Judy show, stilts, blindman's buff, cockfighting and mummers, one of whom has an ass's mask like Bottom the weaver in *A Midsummer's Night's Dream*. One page has a sportsman shooting a hare, while another, as in *Struwelpeter*, shows the great hare shooting the little man. It has been assumed that these marginal pictures seldom have any relevance to the story, but S. K. Davenport has shown that in a number of cases they are in fact highly relevant.

## ILLUSTRATION

This illustrated page shows how Alexander conquered King Porus; the mediaeval caption inaccurately reads: 'Comment Alixandre auoit vaincu le Roy doire.' The full page is divided into four rectangles, all with the diapered backgrounds which were so popular in fourteenth-century illumination. The background of each rectangle is identical with the one diametrically opposite, like the charges on a quartered coat of arms. That on the top left hand and bottom right hand consists of alternating squares – one of gold, bearing a lion rampant in vermilion, the other divided into nine smaller squares in gold, pink and blue, the two latter lightly decorated in white line. The other two rectangles have diaper patterns laid out on a diagonal plan to form lozenge-shaped spaces which have been filled in alternately with a series of animal masks, apes in pink and lions in blue, and a pattern based on nine rectangles in violet-pink and gold.

The two upper panels show the confronted armies of Alexander and Porus, Alexander's being in the upper left, where three horses are part visible, but the green and yellow legs of many more can be seen advancing over rocky ground behind, a pattern which is continued in the picture opposite and repeated below. The soldiers either wave swords or carry banners attached to spears. The one nearest to us draws his sword with his right hand, elbow facing us, and has gathered the reins together in his left. All save one have their faces exposed, including the king, who rides in front and wears his crown. Details, like coloured surcoats – the one worn by a young man who brandishes his sword above his head appears to be made of overlapping red

plates like a tiled roof – and rowel spurs, are well shown. Throughout this illustration can be seen helmets with the latest movable visors, whilst others are basin or nut shaped; all the warriors have their necks, and sometimes their legs and arms, protected by chain mail, but in other illustrations plate armour is used. The banners fixed to the spears have backgrounds of gold, silver or a pale violet-pink, and though most are drawn as flat rectangles some are foreshortened and droop convincingly.

The two generals are picked out by the fact that their horses alone wear armour over the front of the head and splendid caparisons, and they also carry shields with their respective heraldic charges. The arms assigned to Alexander are a lion rampant on a gold background, which appears on shield, horse-cloth and banner, as well as on the diapered background. Porus' arms show three boars' heads in black on gold, but this rectangle also contains a knight, with white beard and basin helmet, bearing a lion rampant in black on silver facing the opposite direction to Alexander's lion; this he carries on shield and banner.

Porus' corner contains nine men and three horses in pale grey, dark grey and sand-colour with white spots, whereas Alexander's are white, fawn and a purplish brown. One horse, seen in full frontal view, has involved the artist in the difficulties over the angle and position of the eyes which are usually experienced in this period. Both armies share the same saddles and equipment, and all the men have a pink complexion. Most of them are clean shaven, but each army contains one older man with a neatly parted white beard.

The two lower panels show the advance of Alexander's army and the siege of a city. On the left the cavalry advances, led by an infantryman with drawn sword who marches behind his shield. Somehow the rocky ground has created less room than its opposite number so that the legs of the horse nearest to us are too short and the whole animal rather awkwardly drawn. It wears a golden band across the breast, a saddle of gold on a blue cloth patterned in white and, like the other horses, a single, patterned girth. Its rider seems to wear a prick spur. Its head is covered by cloth with the red lion on gold, which also appears on a banner at the back. However, another device, a gold lion rampant on a blue ground, is visible on another warrior's shield, banner and horse-cloth.

The bottom right-hand picture shows Alexander, distinguished by his crown and surcoat with his arms, halfway up a scaling ladder in front of the city gatehouse with drawn sword and still wearing his spurs. An archer with a crossbow gives covering fire from the rear and one man is starting to undermine one of the corner towers with a pick. The defenders wave banners or throw stones from behind the crenellations of the building, and the silver banner with the lion rampant is once more in evidence together with that of the boars' heads. On either side of the red door of the citadel are two towers with golden conical roofs.

[PLATE 23]

## FRAME

Surrounding the four pictures is an architectural frame. Along the top runs a roof-line in gold of three gables and two cones, the latter carrying banners and resting on blue turrets. The gables are supported by three designs in pink stone decorated with gold, and vaulted underneath in blue, with touches of red and gold. Among the roof-tops are six musicians busy with wind and stringed instruments: trumpets, portable organ, fiddle, hurdy-gurdy and psaltery. The sides of the frame consist of decorative buttress-like forms, bearing elaborate pairs of pinnacles, windows, and twisted columns from which spring sprays of golden foliage with delicate tendrils.

This frame is a good example of the respect in which architecture was held at the time, truly the mistress of the arts, and in this case forms a fitting surround to the noble warfare. On the other hand the base reveals a frivolity that sets off the main picture. Two small stooping people link the bottom of the illustration to a border of delicate leaf work and a narrow band of blue and gold with a central plant motif. To the left of this five lads, wearing hoods, short gowns, long hose, and linked by short cords, stamp about in lively fashion in a sort of Morris dance. To the right, one archer shoots a crossbow whilst another loads, and a hooded figure capers in front of another who is pouring a drink from a jar into a bowl.

## CONCLUSION

In conclusion, this ambitious and splendid decoration reveals that mixture of fantasy and visual truth characteristic of the period. The artist seems affected by a desire to include everything that appeals in the one design – leaf forms of a well-known contemporary type spring from the architecture, and the homely scenes of musicians and dancers are put beside an epic tale of world conquest.

## HISTORY OF MANUSCRIPT

The manuscript was in the possession of several English families. In *Annals of the Bodleian* W. D. Macray suggests that it is 'the great book in French, very well illustrated, of the *Romance of Alexander*, which is described in the inventory of the library of Thomas of Woodstock, Duke of Gloucester (d.1397) at Pleshy'. Professor Manly similarly put forward that this book might have been 'the curiously illuminated book of *Romance of King Alexander* in verse, value £10', which William Walworth, the famous Londoner who killed Wat Tyler, obtained from a burgess of Bruges in satisfaction of a debt of £180. A later owner was certainly Jasper Fyllol, who was actively engaged in the dissolution of the monasteries in 1535 although he himself was a friar in the house of the Dominicans in London. It also belonged to the Rivers family at one time, and was probably presented to the Bodleian by Sir Thomas Bodley himself.

## BIBLIOGRAPHY

O. Pächt and J. J. G. Alexander i.297 (with four bibliographical references including the facsimile edition of M. R. James)

Details are reproduced in scores of publications, notably J. Strutt *Sports and Pastimes of the People of England* (1801) and its pictorial plagiarists

S. K. Davenport, 'Illustrations direct and oblique in the margins of an Alexander Romance at Oxford' in *Journal of the Warburg and Courtauld Institutes* xxxiv (1971), pp.83–95

M. R. James *The Romance of Alexander* (1933) (complete facsimile)

Colour transparencies on Bodley rolls 79A (12 frames), 79B (37 frames), 79C (15 frames), 97D (32 frames), 79E (9 frames), 93 (28 frames), 168B (10 frames), 172B (15 frames), 189D (12 frames), 190C (6 frames), 203G (14 frames), 203H (20 frames), 203I (12 frames), 203J (7 frames), 211D (14 frames)

# FRANCISCAN MISSAL

MID FOURTEENTH CENTURY

FRANCE

[PLATE 24]

The Crucifixion
MS. Douce 313 folio 4
273 × 216 mm / 10¾ × 8½ in.
This manuscript contains six important grisaille miniatures with
coloured tints. There are smaller pictures on almost every one of
the 433 leaves.

## MISSALS

A missal is a combination, with or without music, of a sacramentary (see introduction to plate 5) and a gradual or grail, which contained both the variable parts of the mass, such as the introits, and the fixed parts (Kyrie, Gloria, Credo, Sanctus and Agnus Dei).

There are over seventy missals in the Bodleian Library, about half of which contain pictures; over a quarter belong to the Canonici Collection. Also in Oxford at Trinity College (MS.75) is another part of the missal which was found at Abingdon Abbey 'amidst a heap of rubbish removed in the year 1807 from a room adjoining the chapel'. Other handsome fifteenth-century missals, illuminated in England, are those of Buckland and Closworth, the latter containing a Crucifixion picture with a hilly background thought to resemble the Dorset coast.

This particular Franciscan missal is an immense storehouse of interesting biblical iconography, because the artist was not obliged to confine himself, as in most manuscripts, to only a few scenes. Indeed many missals have no illustrations at all except the Crucifixion and a priest celebrating Mass at the opening of the 'canon of the Mass', but here, although it is rather unusual to find representations of such scenes, there are well over twenty miracles of healing and almost as many parables.

The passages which the pictures illustrate are, of course, arranged in the order of the Church services and not, as in an illustrated Bible, in Biblical order, let alone historical order. References to pictures in this volume are difficult to pursue as the preliminary pages are in arabic numerals and the following pages, which form the bulk of the book, are in roman numerals, contrary to normal Bodleian practice. Furthermore, the arabic numerals are not those normally used, but are arranged by 'scores'; thus ninety would be represented as four score and ten.

[PLATE 24]

## ILLUSTRATION

The beginning of this book, from which our picture comes, contains illustrations in the modern sense, 'scenes' within a plain frame, but here, although the Crucifixion is the main theme within a simple linear frame, a series of medallions suggests a link with the old decorative arrangements. They are of two kinds: in each corner are scenes from Christ's Passion and Resurrection, while the ones in between display symbolic ideas connected with the Crucifixion. At the top, the pelican with her nest full of young pierces her own breast to sustain them, a common emblem of Christ's sacrifice for us – the story is told in mediaeval bestiaries, and Dante even calls Christ 'nostro pelicano'. In the medallions to left and right both Church and Synagogue are shown as female figures. At the right hand of the crucified, the 'good' side, the Church is shown as a crowned woman, dressed in a purple robe and brown cloak: her hair flows down her back and she wears a halo. Her right hand holds the book, her left the cloth-covered chalice from which the faithful partake of the blood of the Redeemer. On Christ's left is the traditionally elegant and seductive Synagogue, blindfolded, for the truth is veiled from her, and carrying a broken lance and the Tables of the Law. Finally, in the centre of the bottom margin, the patriarchs rise from their tombs, including Adam and Eve, whose sin has been redeemed by Christ, the new Adam, and Mary, the new Eve. This medallion is below the foot of the cross where, traditionally, the body of Adam lay.

At the top corners, the left-hand medallion shows the Entombment, with Mary on the floor clasping to her lips the dead hand of Christ, and on the right is the traditional Resurrection composition of Christ, holding a cross, in the act of stepping from the tomb. While three soldier guards lie sleeping at the foot, the lid of the tomb has been knocked away to enable Christ to rise and an angel kneels on it somewhat precariously. The bottom left-hand medallion shows a dignified Jesus clad in grey being pushed by Jews and soldiers in front of Pilate, who wears, as often, an exotic hat. In the right-hand medallion is the Flagellation: Christ, stripped of all save a loin-cloth, receives the blows from two energetic figures wielding knotted whips.

The central picture shows the traditional Crucifixion scene. Christ, His head inclined to His right, is nailed to a high cross and bleeds freely; an especially vicious nail secures His feet. On His right the 'good' thief bends his bowed head towards Christ, while the 'bad' thief on His left turns away. Below, the ground is shown as sharply rocky, like fretted steps. At the foot of the cross, to the right, the Virgin swoons and the two Marys attend her, grieving; to the left of it, St John kneels on the ground, wringing his hands as he looks up at Christ. Next to him two spectators discuss the affair, one of them pointing upwards with a strong gesture.

## DRAUGHTSMANSHIP

Throughout the book, the grisaille drawing has a curiously 'modern' look, due perhaps to an emphasis on shading the drapery, and not a little to the absence of matt, brilliant colouring. In most of the smaller illustrations, the only colour other than the different dilutions of the black ink is an opaque mauve, somewhat insensitively applied and out of harmony with the blue and red initial letter. In this picture where the mauve has been applied more subtly in various dilutions, from a deep violet to a pale transparent lavender, and there is also a bright green and a warm brown both varying in strengths, we see a technique approximating to water-colours. A few touches of red, on the wounds of Christ, on lips, and in places on the cheeks of living people, completes the range of tints.

In general the decorative surrounds, the crosses, the naked limbs, heads, hands, tombs, the pelican's nest, and the bird and her young, with details like armour, crowns, the chalice, and so on, are drawn in black with a very fine pen. The robes and coloured portions are generally painted direct, not over line-work; and this is especially clear in the scene of the Flagellation, where the green colour has faded, so that the ink drawing stands out strongly. In fact, the green has flaked off or faded in many places in the book, while the delicate mauves and the subtle grisaille shading remains unspoilt. This further emphasizes the role played by shading, the sensitivity of which this picture demonstrates, though not as forcibly as elsewhere in the book.

## BIBLIOGRAPHY

O. Pächt and J. J. G. Alexander i.603 (with three bibliographical references)

Colour transparencies on Bodley rolls 158B (140 frames), 172G (24 frames), 172H (19 frames), 219.3 (12 frames), 219.4 (32 frames), 219.5 (13 frames), 219.6 (17 frames)

# THE ROMANCE OF THE ROSE

SECOND QUARTER

OF THE FOURTEENTH CENTURY

FRANCE

[PLATE 25]

The dream of the lover
MS. Selden Supra 57 folio 1
237 × 175 mm / 9⅜ × 6⅞ in.
This manuscript contains fifty-three miniatures (some damaged)
with backgrounds in gold, pink, and blue diaper, sometimes
solid gold.

## THE *ROMANCE*

The *Romance of the Rose* is the work of two authors. The first part of the poem was written by Guillaume of Lorris (which is between Orléans and Montargis) sometime during the years 1225–40, and consists of a well-worked-out psychological allegory. Unfortunately, the poet who continued it, Jean Chopinel (d.1305) of Meung-sur-Loire, added little to the story. Instead he gave a compendium of mediaeval knowledge with long examples from classical mythology which is interesting in itself, but diverges widely from the point of Guillaume's poem. It occupies over eighteen thousand lines.

That the *Romance* was extremely popular throughout the Middle Ages is some indication of how mediaeval literary taste differs from ours. After the invention of printing a new edition of the poem was one of the first illustrated books to be printed in France, but its popularity had vanished by about 1540.

The story of the poem is as follows: the lover has a dream that walking forth one May morning beside a stream he finds a garden. Outside its walls he sees statues of Hate, Wrath, Villainy, Covetousness, Avarice, Envy, Sadness, Old Age, Hypocrisy, and Poverty. However, the door to the garden inside, signifying the courtly life from which such evils are barred, is opened to him by Idleness. He enters, but as he gazes into the fountain of Narcissus, the God of Love shoots him with an arrow so that he falls in love with a rose. When he is repelled by the rose's hideous guardian, Reason and a friend give lengthy advice. However, it is only with the help of Venus that he at last attains the rose.

Illuminated copies of the *Romance* are very numerous (this one belongs to Kuhn's sixth group), and often contain a large range of illustrations. This plate shows the first page of one produced in France in the second quarter of the fourteenth century.

[PLATE 25]

## FRAME

Enclosing text and illustration is a straight, right-angled frame to the right and bottom of the page. A few leaf-sprays spring from it at intervals, richer at the right corner and at the top. On the left hand, this straight margin curves away from the binding and turns into a winged, dragon-like beast from whose open mouth issues a run of round dots. A charming and delicately-drawn scene rests on the lower border, wherein a hooded hunter on foot, and wearing a short tunic, blows his horn; his greyhound, leaping through a curled frond of the ornament on the margin, pursues a rabbit, who, while making for his burrow, turns his head as if to measure the distance from his pursuer. The hill with the burrow, a few trees and leafy plants, the pole carried by the hunter, and a part of his horn are all touched in a transparent green. The rest is drawn with minute delicacy so that we can perceive, with the aid of a magnifying-glass, the hunter's tip-tilted nose (a sign of humble origin), the quiff of hair under his hood, and the slightly odd fact that the cord which would normally support his horn when hanging from his belt remains upright in the air as he blows. The marginal decoration is in gold, blue, and pink, but, this being the first page, the colour is somewhat rubbed and the gold dull from much handling.

## ILLUSTRATION

The brownish text is neatly written in two columns with capitals in gold on a blue and pink ground covered with a fine white filigree design. There are four scenes, each enclosed in a separate but adjoining square somewhat like postage stamps. Each square has a ruled frame of blue, pink or blue and pink, adorned with fine white arabesques and a narrow gold outer margin from which spring sparse plant-sprays.

In the first scene the lover, who is the author of the tale, is shown as a naked young man with a tonsure, lying dreaming of the rose-tree which springs up just behind the middle of his bed. Although his eyes are closed, he looks uncomfortable in his semi-recumbent position, for while his bare right arm rests upon the tunic, his left is wrapped in the bedcover. Beside him stands Dangier, making a gesture with his raised right hand and carrying a heavy club in his left. He wears a blue tunic and red hood and has a grey beard, somewhat reminiscent iconographically of old Joseph beside the Virgin at the Birth of Christ. The dreamer lies in a narrow upholstered bed, like a chaise longue, on a pile of cushions; these and the draped undersheet are white, the top cushion ornamented with stitchery and tassels. The bed-cover is striped in transparent blue and orange so that the red and black drawing of its folds is clearly seen underneath. The dreamer's clothes, a brown tunic and white cloak, lie across the bed. There is no indication of place here, the background being simply of gold.

In the next square, the dreamer has woken and is putting on his clothes. Against a blue background decorated with gold arabesques he sits in a round, rather barrel-like chair,

cut away at the base in a cusped trefoil. He wears the white cloak seen formerly lying across the bed, and a camail or elbow-length, hooded cape which reveals the narrow sleeves of a red undergarment. He leans forward to pull on his red hose. A golden lamp and roller are suspended from the ceiling, and from the latter hangs a long towel, the shadowed underside of which blows over the golden wash-basin, supported by an elaborate stand of column form.

In the third square, the author stands between two formal trees. He wears a blue hooded gown, with white undergarment visible at the neck, and red hose, the points of which overlap the lower frame. He stands in the swaying attitude fashionable in the fourteenth century, his right hand engaged in sewing his left sleeve. The thin thread, red to match his narrow sleeves, may be perceived with the aid of a magnifying-glass. Although the green ground is somewhat naturalistically shown, the artist is still satisfied with a background of deep pink, covered with a delicate patterning of gold.

In the fourth scene, the author and lover, now dressed in a white camail with blue sleeves below, raises both hands in wonderment as he enters a garden, surrounded with white crenellated walls and towers. These have narrow slit windows and 'fish-scale' tiles adorn the turrets. Inside, a few trees crowded together indicate the horticultural nature of the area. The background is plain gold. Here we have an excellent example of an art lying halfway between the fully naturalistic and the formal. In the figures and their stage properties, there is a real endeavour to copy nature, but the setting remains an ornate back-cloth.

## TECHNIQUE

The colours are limited to gold, pink, blue, an orange vermilion, green, and white. The lover has the palest of aristocratic complexions and sandy curls, clustered round his tonsure. The microscopic delicacy with which line is drawn, or the sureness with which colour is applied, as in the minute whites of the lover's eyes in the third picture, is hardly to be appreciated by normal vision.

## OTHER DEPICTIONS OF THE *ROMANCE*

The first page, the one over which the artist usually expends most trouble, always includes the lover in bed dreaming, but all six illustrated copies of the text in the Bodleian (all illuminated in France in the fourteenth and fifteenth centuries) differ in their treatment.

The earliest of the Bodleian copies of the *Romance of the Rose*, a production of about 1300, shows the dreamer with the rose-tendrils of his dream rising from his coverlet rather in the manner of a Jesse tree. In the latest manuscript, one of between 1485 and 1495, he is first portrayed reading Macrobius's commentary on the *Dream of Scipio* and later, as usual, dreaming.

Bodl. MS. e. Mus. 65 and MS. Douce 332 both of about 1390, include the poet's dream of the stream and the walled garden. In MS. Douce 188 of the early fifteenth century,

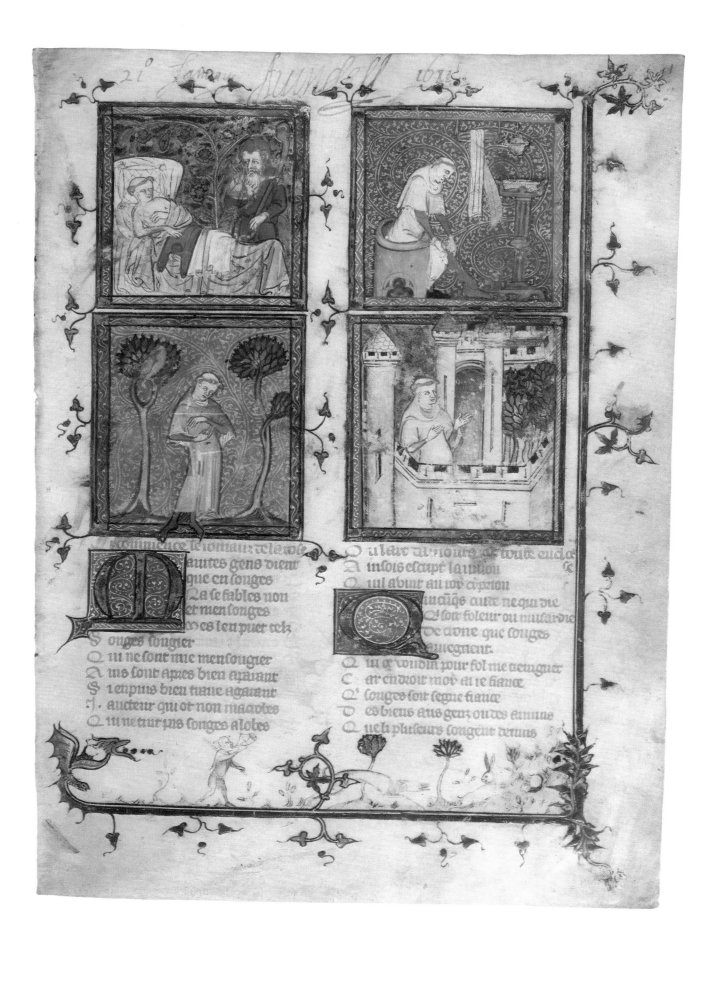

A ce commence le romaut de la rose
S autres gens dient
Q ue en songes
N a se fables non
E t mencongies
C es len puet teiz
S onges congier
Q ui ne sont mie mensongier
A ins sont apres bien aparant
S i enpuis bien tume agarant
J. aucteur qui ot non maaubes
Q ui ne tint pns songes aloies

O u lan anoure est toute cuelos
A insois escarpe la million
Q ui auint au roy cyprion
L ancns autre ne qui die
Q i son toleur ou misardie
D e aune que songes
A uiegnient

Q ui ce voudit pour fol me tietngier
C ar endroit moy en te fiance
Q i congres sont segne fiance
D es biens aus genz ou tos ennine
Q ui li pliseurs congent deniis

[PLATE 25]

the author is shown washing his hands. In MS. Astor A.12, produced in France in the second half of the fifteenth century and now deposited by Lord Astor in the Bodleian, the poet not only washes but also pulls on his hose. MS. Douce 364 (c. 1460) shows his valet pouring water over his hands. In the different manuscripts, the details of the ideal bachelor bedroom vary from picture to picture. The dreamer may, or may not, wear a white or black skull-cap. He may lie on a chaise longue, the bed may have a canopy and bed-curtains may be attached to a pelmet. The coverlet may be white, striped, green, or green with gold stars. There is sometimes an additional truckle-bed, and there may also be a small round armchair, a bedside chair with perhaps a cushion, or no chair at all. In one illustration there is a dog on the floor, and in another a carpet of neatly plaited straw. Windows can be shown, glazed or unglazed. Walls may be covered with gold and blue tapestry, or decorated with red and white flowers on scrolls. There is often a reading-desk, or a cupboard with jug and plates. A brush may be seen on the servant's bed or, as here, a gown and cloak. The most striking and common details are the varying arrangements for running water. A ewer like a kettle sometimes hangs on a chain, often with a towel on a rail, though in one instance the towel is draped over the valet's shoulder as he pours water over the hands and catches it in a basin. In pictures of Pontius Pilate washing his hands it is customary to use this method of running water, and some Orientals, for instance in Outer Mongolia, still follow the practice of washing the hands of an honoured visitor only in water poured from some kind of kettle.

## SELDEN MANUSCRIPTS

John Selden (1584–1654) left Oxford without a degree and became a lawyer. Elected a Member of Parliament in 1621, he opposed the crown and represented Oxford University from 1640 to 1653. He was one of the most learned Englishmen of his day and formed a vast library. In 1659 over 8,000 volumes came to the Bodleian where a special wing at the west end of Duke Humfrey's library (called 'Selden End') was prepared for them. His collections include the famous *Codex Mendoza* (see plate 36).

## TEXT

First column
[Cy] commence le romanz de la rose ou l'art d'amour est toute enclose
Maintes gens dient
que en songes
N'a se fable non
et mensonges
Mes l'en puet telz songes songier
Que ne sont mie mensongier
Ains sont apres bien aparant
Si en puis bien traire a garant
l'aucteur qui ot non Macrobes
Qui ne tint pas songes a lobes

Second column
Ainsois escript la vision
Quit avint au roy cyprion
Quicunques cuide ne qui die
Qui soit foleur ou musardie
De croire que songes auiegneur
Qui le voudra pour fol me tiemguet
Car endroit moy ai ie fiance
Que songes soit segne fiance
Des biens aux genz on desennuis;
Que li pluseurs songent de nuis.

The translation here given is of the text on the first page of another *Romance of the Rose* as the lines on the page illustrated here do not go far enough to explain the four pictures.

Five years ago when I was twenty, I went to bed and slept soundly. I had a sweet dream which has been fulfilled in my life . . . I dreamt that it was day and I rose hastily, dressed and washed my hands . . . I took out a silver needle from its case and threaded it with silk. I walked out into the country basting my sleeve as I went and listened to the birds singing among the branches that had just come into bloom . . . I came to a garden of Mirth the wall of which was sculptured with figures of Hate, Felony and other undesirables excluded from the garden [they are described at length]. Idleness unlocked the gate . . . I was very happy when I had entered what seemed to me an earthly paradise. The scenery made it like Heaven and better than Eden. A multitude of various birds thronged this orchard and sang like angels or sirens as if well trained. I was never so merry before as when I saw this verdant place and heard the tunes. The birds sang part-songs about love. I went to see Mirth and his fair company. Having turned down a little path bordered with mint and fennel I found them dancing.

## BIBLIOGRAPHY

O. Pächt and J. J. G. Alexander i.597 (with five bibliographical references)

J. V. Fleming *The Roman de la Rose, a Study in Allegory and Iconography* (Princeton, 1969)

A. Kuhn 'Die Illustration des Rosenromans' in *Jahrbuch der Kunsthistorischen Sammlungen des Allerhochsten Kaiserhauses* xxxi (1912), p.46

E. Langlois lists over two hundred manuscripts in his edition, but though most are illustrated he ignores pictures as editors of Dante and Piers Plowman have done

Colour transparencies on Bodley rolls 179D and 179E

# ST BERNARD, SERMONS

EARLY FIFTEENTH CENTURY

FLORENCE

[PLATE 26]

St Bernard preaching on the Song of Songs
MS. Canonici Pat. Lat. 156 folio 1
394 × 254 mm / 15½ × 10 in. (Here slightly reduced)
In addition to this opening page, this manuscript contains fine
initials on some 109 leaves. These contain floral foliage but no
figures.

## ST BERNARD

When St Stephen became abbot of Cîteaux in 1113, Bernard (1090–1153) with a
group of young nobles sought to join his house of reformed Cistercian monks,
and he was soon sent to found a new monastery, which he called Clairvaux. Des-
pite, or because of, its austerity it throve and new houses had to be founded so that
eventually he set up no less than 163 monasteries. In 1119 a general chapter of the
order, much under Bernard's influence, adopted a body of rules called the Charter
of Charity, and in 1120 Bernard composed his *De Gradibus Superbiae et Humilitatis*
and *De Laudibus Mariae*. Thereafter his influence throughout France and all West-
ern Europe grew enormously. His most famous triumph was the defeat of Abelard
for adopting a rationalistic attitude and his success in preaching a crusade to save
Jerusalem. He was canonized in 1174.

[PLATE 26]

## PROVENANCE

Between 1135 and 1153 St Bernard preached eighty-six long sermons on the *Canticum Canticorum* (Song of Songs), or the Song of Solomon, as it is called in the Authorized Version of the Bible, which amounted to some 170,000 words in all, mostly on the first two chapters. Recorded at the time, they became famous enough to be copied out in Florence early in the fifteenth century probably by the Camaldolese monks in the Florentine convent of Santa Maria degli Angeli; they may be found in Migne's *Patrologia Latina*. Although there is, by modern standards, much repetition and a certain amount of obscurity in argument, St Bernard's thought is simple and his Latin prose terse and poetical.

## SONG OF SONGS

Ever since the time of Origen in the third century A.D. Christian thinkers have seen this Song of Songs, a poem of the lover and his beloved, as an allegory either for God's love of Israel, or the love between Christ and the Church. For example, in discussing the first verses ('The song of songs, which is Solomon's') St Bernard points out the suitability of Solomon's name, for it means 'peaceful'. He explains that the book opens with the sign of peace, a kiss, and only the peaceful who control their passions and are free from care should study it. The title is not just 'a song' but the 'Song of Songs' which distinguishes it from the many songs in the Bible, such as Israel's hymn to the miracle of vengeance and deliverance at the Red Sea, or the songs of Deborah, Judith, Samuel's mother, and certain prophets. They all sang their own triumphs, but God inspired Solomon to hymn the love and marriage of Christ and the Church. It is therefore called the 'Song of Songs' because it stands alone and hails the King of Kings. In the second chapter, St Bernard goes on to explain the second verse: 'Let him kiss me with kisses of his mouth', and in chapter three discusses the breasts both of the bridegroom and of the bride.

It is important to remember the seriousness of this allegorizing, a point which had to be made even to Bernard's fellow monks, for in his preface he tells them that it is proper for him to discuss different things from those suitable for a lay audience, or at least to have a different approach. 'The laity are like babies needing milk, as the apostle has it, but the religious need solid food. Prepare then to eat the wonderful bread of Solomon's *Canticum Canticorum*. Ecclesiastes has already taught you by God's grace to despise the vanity of the world; Proverbs has taught you discipline. You have nibbled both these loaves

and thereby you have routed the two chief threats to the soul, love of earthly things and of self. Hither then to sample the third loaf, the best of the three. But who shall break the bread for you? The Master of the House is here and it is God who breaks it. I am unworthy, but like you seek food from Him. O most merciful, break the bread by Thy power for us in our hunger if it please Thee.'

## ILLUSTRATION

Although this illustration is an advanced work in matters like the use of shading to achieve a modelled effect, as we should expect from its time and place, its naturalism is still limited: thus St Bernard is too squat, and his disciples, as less important, are painted on a slightly smaller scale, in the old childlike way. The expression of the faces is lively and varied, yet the hands are carried out in a perfunctory fashion. The artist wishes to show us that the shelves of St Bernard's delightfully castellated bookcases are seen from below, but he has got into difficulties with his placing of the books upon them. Then the lectern too with pen, penknife and ink-bottle neatly laid out upon it, slopes violently up to the horizon.

Two young monks, perhaps Camaldolese, peer forward towards the preacher, avid for his words, one of them following the lines of a book with pointed finger, while an old bearded monk is absorbed in some text. The saint also clutches an open book and seems to have fallen silent, for his mouth is closed and his glance searches his two eager young hearers in a questioning way.

## FRAME

In the frames which form part of the border, Dominican friars read, gesticulate or glance about them in lively fashion. The border, consisting of barbed quatrefoils and panels of ornament in numerous colours resembling the 'cosmatesque' work of marble inlaid with coloured glass, famous in thirteenth-century Italy, here includes touches of silver and gold, and demonstrates various decorative traditions. The handwriting of the text is impeccable throughout the book.

## BIBLIOGRAPHY

O. Pächt and J. J. G. Alexander ii.212
M. Etienne Gilson *The Mystical Theology of St Bernard* (1940)
*Saint Bernard on the Song of Songs: Sermones in Cantica Canticorum* ed. and trans. a religious of C.S.M.K. (R. P. Lawson) (1951)

Colour transparencies on Bodley rolls 184E (Florentine scribes, 41 frames), and 229.1 (European culture, 37 frames of which this is frame 25)

# BOOK OF HOURS

c. 1440–50, NORMANDY

[PLATE 27]

Noah's Ark
MS. Auct. D. inf. 2.11 folio 59ᵛ
290×200 mm / 11½×7¾ in.
Forty-three full-page miniatures are preceded by twelve calendar
pages with the occupations of the months and the signs of the
zodiac, all on rectos. The outer margins are illuminated
throughout.

## PROVENANCE

This Book of Hours is the work of an artist known as the Master of Sir John Fastolf, who was responsible for several other Bodleian manuscripts: the Christine de Pisan *Epître d'Othéa* (see plate 29), a psalter (MS. Hatton 45), a heraldic treatise (MS. Ashmole 764), and *Alain Chartier* (MS. University College, Oxford 85). It is a sumptuously produced work, but illustrates a technical trick used in many French manuscripts of the fifteenth century to speed up production and satisfy demand – a demand that the invention of printing was destined to meet with greater efficiency. This is to make the marginal patterns of the verso the mirror image of the patterns of the corresponding rectos.

The present binding is in silk and velvet of bluish purple with embossed gilt clasps and gilt corner pieces in the centre of which are plaques bearing the heads of kings. This was executed in England in the sixteenth century.

The text of this Book of Hours was planned for export to England as it follows the use of Sarum, i.e. the liturgical customs of Salisbury and the places that adopted them; as is normal, it is in Latin, though the 'Fifteen Joys' and 'Seven Requests' are in French (for further information on these books see plate 34). It is possible also that the book belonged to Kings Henry VII and VIII successively to judge by the appearance of St George and St Christopher (folios 44ᵛ and 48ᵛ) among the many popular saints illustrated in the manuscript. In the foregrounds of these two pictures are two figures kneeling in prayer on tasselled green cushions, both wearing 'houppelandes' (long cloaks with high collars) and black hose; both have 'basin' haircuts. One might suppose that these are portraits of the patron for whom the volume was destined. However, it should be added that the prayers on folios 61ᵛ, 232, and 247ᵛ suggest a female owner.

Memoie delapaix. antiphona

Da pacem domine in diebus

nostris quia non est alius qui pu

[PLATE 27]

## NOAH'S ARK IN MANUSCRIPTS

We have several representations of Noah's ark in mediaeval manuscripts. In the *Caedmon Genesis* (see plate 4) it is represented as a Viking ship with a steering-board, a dragon's head on the prow and a Saxon sky-scraper with wooden slats on the roof to house the animals; Noah's wife, as in the later miracle plays, is rebuked for her lateness in embarking. In a 'Bible Historiale' of the thirteenth century the ark resembles a nut-shell, while in this manuscript the ark is a new yellow wooden box like a modern packing-case. Indeed, the word 'ark' simply means box or chest. Chests were used for storage before wardrobes and chests of drawers were invented – the surname Arkwright signifies a joiner who specialized in their production.

To mediaeval preachers the ark which saves mankind symbolizes the Church of Christ and the water recalls the purifying water of baptism. The white dove and the black raven may typify either Christians and Jews or the good and the bad thief at Calvary. Although the very ancient *Vienna Genesis*, like ours, depicts the bodies of the drowned, this feature is relatively uncommon, as is the entry of the animals into the ark.

### FRAME

The picture is enclosed, except at the top, by a golden border, approximately half an inch wide, on which are painted acanthus-like foliage forms in a great variety of colours. These twist and curl to reveal the contrasting tints of their undersides – green with vermilion, vermilion with blue, green with crimson, and so on. They are placed as if arranged in a pattern on the lower and right-hand margin, but the left-hand margin is treated somewhat differently, the leaves appearing to spring from a slender, pole-like stem. To right and left at the top, these plant forms are continued beyond the golden borders, that on the left away from the binding being especially rich and fantastic. Outside the borders, at the bottom, are the stems from which these leaves spring, formally represented and cut across at the base. Again, that furthest from the binding is more elaborate, as is true also of two plant decorations which escape from the centre of the upright golden margins since on the left it terminates in two crossed, prickled stems and leaves completed by deep-red flower heads of 'Tudor rose' appearance, ably foreshortened. Beyond the golden borders, on all four sides, is a riot of spray forms with tiny golden leaves in great varieties of shape and with edges often decorated with hair-like prickles in black. Tendrils spring from the curved stems and the whole area forms a margin of finely executed, thickly clustered decoration in black and gold, typical of the age in which it was produced and here especially sumptuous. Points of colour are provided by the flower and fruit terminals which include cornflowers, forget-me-knots (possibly), herb-Roberts and strawberries, as well as flowers of sheer fantasy.

### ILLUSTRATION

Within this enriched border, God presides in an attitude of benediction, His left hand resting on a rainbow arc and His glance directed at the praying Noah beneath. While pointed fleecy clouds ray out behind Him, He is shown in half-length before a blue sky which shades to a lighter tint towards the horizon and is spangled with the stars, resembling golden asterisks, throughout the book.

The ark itself is set on a little tub-like hull, which is nailed together from small pieces of wood and has four portholes. The method of manufacture suggests a log cabin, and its seaworthiness is rendered even more suspect by the fact that no means of steering or of propulsion is indicated. At the top of the ark on the right is an opening like a skylight through which the head of Noah may be seen. With long grey hair like God's, rolled back in the fashion of the epoch, he has a long beard and moustache, wears a red gown, and has set his hands together in prayer.

While God looks tenderly down at Noah, he himself directs his glance along the top of the ark towards the dove which flies towards the open hatchway, the olive branch in its beak. Through another opening may be seen two human heads, inclined towards one another and looking out. One is that of a young man with the 'basin' haircut of the period, the other a woman wearing a white wimple that covers head, neck and the lower part of the face up to the mouth in the fashion of the time.

The waves around the ark are indicated with white curled lines on a blue background resembling the treatment of water in a picture of the crossing of the Red Sea in the *Krumlov Miscellany* of about 1420 in the National Museum at Prague. Where the boat lies beneath the water line, the background is brown and furthermore, close examination reveals that below the furrows float bodies of the drowned, clad in gay colours and differentiated in sex, attitude, and scale.

### CONCLUSION

The sensitive naturalism of this passage in which the dead bodies, tossed about, float as it were behind a veil, contrasts strikingly with the rich and formal borders. There is a similar contrast between the convincing foreshortening of the ark, the roof or lid of which is an ambitious and successful exercise in perspective, and the spiritual conception of the large form of God above it and the formal pattern of the sky. We have reached a stage here, where observation and scientific study of visual facts has not yet wholly driven out the older painting in symbols, but the two exist together in the same manuscript.

### TEXT

Memore de la paix. Antiphona
Da pacem domine in diebus
nostris quia non est alius qui pu[gnåt . . .

Prayer for peace. Antiphon
Give peace in our time O Lord
for there is none other that [fightest for us
but only Thou O Lord

[PLATE 27]

BIBLIOGRAPHY

O. Pächt and J. J. G. Alexander i.670 (with two bibliographical references)

Colour transparencies on Bodley rolls 169G (13 frames), 173B (12 frames), 173C (22 frames)

# MIROUER

# HISTORIAL ABREGIE DE

# FRANCE

BEFORE 1472, FRANCE

[PLATE 28]

The Battle of Hastings
MS. Bodley 968 folio 173
365 × 250 mm / 14½ × 10⅛ in. (Here slightly reduced)
There are fifteen large miniatures (two retouched, folios 1 and
89). The edition printed in 1531 has woodcut illustrations.

## INTRODUCTION

The *Mirouer Historial Abregie de France* was compiled between 1443 and 1461 for
Charles d'Anjou, Count of Maine, who died in 1472, this copy being executed for
his second wife, Isabel of Luxembourg, whose arms and motto 'Si mieulx non pys'
occur in the borders. In three parts, the first part deals with the Fall of Troy, the
second with Pepin and the third covers the period from Hugh Capet to Charles V
in 1380. Fifteen large miniatures illustrate the story of Mohammet, the Emperor
Constantine IV, Pope Stephen II crowning Pepin, the sons of Pepin, the monks of
St Martin of Tours being punished by an angel for embracing ladies, Charle-
magne, Bishop Turpin, the Emperor Louis the Pious, the battle between the sons
of Louis at Fontenay, Hugh Capet, the Battle of Hastings, and the King of France
embraced by the Holy Roman Emperor.

[PLATE 28]

## FRAME

Although these illustrations each have a page to themselves, none fills the page completely. The broad margins are filled with decorations in the new fashion of flowers such as cornflowers, roses, columbines, strawberries, and clover; amidst these are incorporated mottoes, coats of arms, birds, insects, and miniatures. At times, indeed, the more naturalistic pictures seem to lack a certain delicacy of outlook compared to the designs that frame them. However finely drawn, however microscopic in detail, there is a largeness and fullness about them, that, in the figure drawing, especially in the more conventional part of people and poses, becomes very like an empty blankness, a merely mechanical technique. However lacking in delicacy of spirit though they are superb examples of expert painting.

The border of this picture is no exception to those in the rest of the book. Decorative acanthus scrolls, varied with recognizable plants treated formally, appear at intervals against a hairline growth of tendrils and minute gold trefoils. Roses and pinks have place here, as well as winged insects and one lovely white-breasted bird that stretches its brown wings and raises its head. The rich capital letter, blue, gold, pink, and white, belongs to the border in feeling.

## ILLUSTRATION

The battle scene, by contrast, though superbly decorative, is naturalistic in feeling and intention. We seem to be looking through a depressed arch or window, at a scene of mediaeval chivalry, a deadly tournament, of great richness. This naturalism may be found, for instance, in the depiction of the meadows, the stream and woodlands, all rendered with delicate affection, or of the painted architectural interiors which put our stripped Gothic stone to shame. The artist has his own personal quirks – he likes his more important personages rendered larger, in the ancient fashion, than the mere spectators. Matters of visual perspective are approached without inhibition, without study, and sometimes with good luck, naturally, after the fashion of a child. He is also so passionately absorbed in dress that some figures, especially his splendidly robed kings and priests, seem merely well-filled robes, free-standing, to which rather small limbs and heads have been added, as it were as an afterthought. This produces an almost Eastern sense of decoration at times, and a richness of dress which reminds us that personal adornment at this period was a great art, only surviving today in a few such things as ecclesiastical robes or military uniforms.

In the background Hastings is shown as a many-towered town, built of white stone, with roofs and spires of gold or slate blue. The blue sky behind it fades to white at the horizon and is sown with small golden clouds and very curious dark grey ones, wriggling like Chinese dragons, and perhaps presaging storm. The town is set by green fields and pale water, in which cockleshell boats sail or row, while a peasant in grey works over the green meadowland with a grey mule. At one point the water flows past a delicious island, with jagged precipices and young trees. In the far background another group of towers may just be discerned. In the middle distance neat groves of young trees, all of an age, suggest careful planting, as the painter has drawn them all alike with a slender trunk forked into the main branches which bear a truss of green, shadowed at its base and overpainted with a spray or two of outsize yellow leaves. The trunks of the nearer trees are gold. Three birds perch in the tree tops almost as large as the trees themselves; although white-breasted with pale brown wings, their proportions differ as if to show different species.

Too large for natural proportion and set among the trees is a white building. We see only enough of it outside to note a plain round-headed window with leaded glass and a simple moulding, because the side nearest the spectator has been done away with to reveal the scene within. On a throne, covered in a pink cloth, sits the Pope in triple tiara, gloves, and blue and gold cape lined with green. Though young in face his ample red-robed body suggests a considerable paunch. His right hand makes a sign of benediction, while his left makes a gesture with the palm displayed. To his left stands a cardinal, his hand on the shaft of a banner; at his feet kneels a soldier, bareheaded, revealing a basin haircut, but otherwise in full armour; his right hand too closes round the shaft of the banner – no lazy feat, as the cardinal who shares it with him stands behind him, a little distance away. The group is shown against a green carpet and the wall behind them is painted black with formal leaf sprays in gold. A portion of a barrel-vault is visible, and the opening through which this scene is observed is a depressed Perpendicular arch. This incident has been interpreted as the Pope sending a consecrated banner to William of Normandy, but as the dead Harold of England wears a surcoat of the same device elsewhere in the picture – three gold crowns on a background of brilliant blue – it should more properly be interpreted as the presentation by the Normans of Harold's banner to the Pope.

This engaging scene is cut off from the Battle of Hastings by another river. Compared with the still rural peace of the background all is movement, even if of the frozen kind. The battle is envisaged in three registers with the Saxons on the left and the Normans on the spectator's right. In the distance is the Norman mailed infantry, a crowd of silver pebbles, from which emerge long floating pennons of red and gold. A few only have their visors up to reveal round, sallow faces. A group of bowmen go before them, tensed, having just let their arrows fly. On the left, a smaller group of Saxon knights stands in the background, but they appear to be conferring rather than supporting the Saxon bowmen who go in front, some in the act of shooting their arrows. The next range, the middle register, shows the emotional climax of the picture – two horsemen, leaders of their troops, charge at one another. On the right is Duke William, shown clean-shaved and middle-aged with grey 'bobbed' hair and a soft hat so that his face and head are

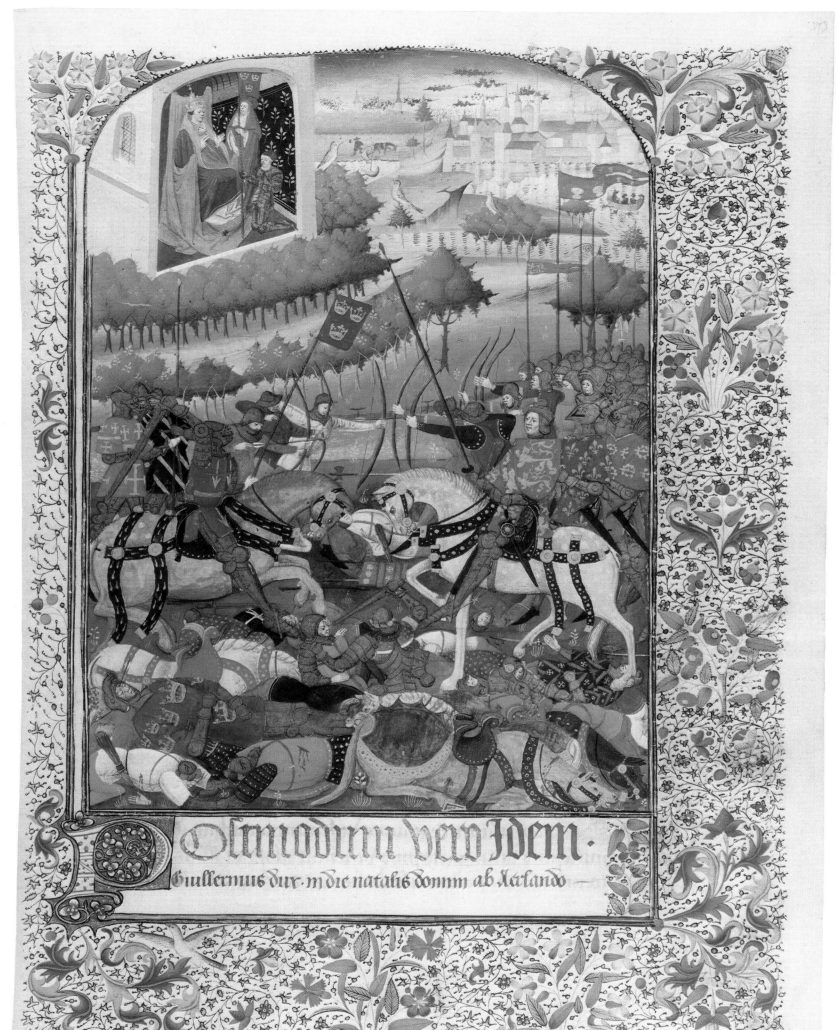

Olim odium vero idem.

Guillermus dux. in die natalis domini ab Arelando

[PLATE 28]

unprotected (we know that at the battle he had to lift his helmet to reveal his face and stay a momentary panic at the rumour of his death among his men). He sits on his horse very calmly, holding a long lance in his right hand, and a single rein in his left. He wears a small shield of two lions in gold on a vermilion ground, and a surcoat in the same design. His legs are heavily clad in plate armour with long pointed shoes and a gold spur; he also carries a shortish sword. Leaning backwards, he has thrust his feet forward well into the stirrups, as if to sustain the shock of meeting the enemy. He rides a grey horse spotted with white, richly caparisoned, but not armed. It seems to be at a halt, the front nearside leg very stiff and straight, the offside one pawing the air. Both the Duke's horse and that of his opponent are of rather light graceful build, although the Saxon one, because both feet are in the air, seems to show the more fury and fire, and they arch splendid necks thus lowering their heads as if they are going to butt each other. The Saxon standard-bearer, whom Duke William is charging, wears a blue surcoat with a red cross upon it and golden arrows pointing downwards. His bared left hand holds the standard of three gold crowns on a blue ground such as we have seen William's man presenting to the Pope. In contrast to William, his helmet completely covers his face and neck and is of a rather squat, ape-like form, but sitting upright he too has his leg thrust forward to take the shock of the meeting. His horse is buff in colour and is also nobly dressed in saddlery of black and gold.

Between and beneath the two main antagonists are strewn the dead and the dying, painted in a strikingly graceful and rhythmic manner, despite the grim subject. For example, although the buff horse in the foreground bleeds from a wound in the flank, it carries a small rug on the rump and a curved saddle and lies with a curious, unreal grace, reminiscent of a Persian manuscript. The whole drawing of this sinuous animal is a pattern of arcs. We also notice bleeding wounds amongst the brilliant clothing of the corpses: a dismounted man raises his sword to give another the *coup de grâce*. One has a heavy bludgeon still swinging at his side, while on the ground close by lies a single detached hand.

Before a beautiful white charger, proudly dressed in leather trappings of red and gold, its head buried, but distinguished by a curly saddle of fantastic shape, lies King Harold, with eyes closed and his dead face only partly coloured. As befits a king he is taller than the rest, lying stretched out, his mailed arms across his body. His visor is raised and upon his helmet he wears an elaborate gold crown; he also wears the blue surcoat with gold crowns. He is shown as wounded in two places – on his right side and in the middle of his forehead, where a short-shafted arrow may still be seen, sticking out between and above the eyes. This would seem to be evidence in favour of those who believe that the tradition that Harold died from an arrow in the eye is based on a misreading of his death scene in the Bayeux tapestry.

## CONCLUSION

It is interesting, indeed inevitable, to compare this scene, made 400 years later, with that famous wall-hanging that was made shortly after the Battle of Hastings. The emotional idea of war has obviously changed in the interval. Instead of the stark, bare facts of battle in the tapestry, presented in so lively a fashion without setting and stage properties, we have here the idea of battle as a stately pageant, a richly accoutred tournament, taking place in a delicious rural scene and presided over by the Pope.

## TEXT

Postmodum vero idem Guillermus dux. in die natalis domini ab Aerlando

But afterwards the same Duke William [was crowned] by Aerland [Aldred, Archbishop of York,] on Christmas day

## BIBLIOGRAPHY

O. Pächt and J. J. G. Alexander i.724

Colour transparencies on Bodley roll 159A (the chief pages of the manuscript, 17 frames)

# CHRISTINE DE
# PISAN,
## EPÎTRE D'OTHÉA

### 1450, EXECUTED IN ENGLAND
### IN THE FRENCH STYLE

[PLATE 29]

Christine de Pisan presenting her book to the Duc de Berry
MS. Laud Misc. 570 folio 24
266 × 190 mm / 10½ × 7½ in.
MS. Laud Misc. 570 contains several fine half-page miniatures
(approximately 105 mm square) with border decorations on
three sides of the page, three for the *Livres des Quatre Vertus* and
seven for *Christine de Pisan, Epître d'Othéa*. Another miniature at
the beginning of the manuscript, probably showing Justice, is
lost. There are many decorated initials.

## CHRISTINE DE PISAN

Christine de Pisan, who in 1369, at the age of 25, became a widow, took to writing
to help maintain her household, even to the extent of enjoying foreign sales. She
was the author of various works, which were dedicated to her patrons, John the
Fearless, Duke of Burgundy at Dijon and her uncle, John, Duke of Berry at Bour-
ges and Poitiers, who, like the King of France, both patronized such leading illum-
inators as the De Limbourg brothers. Her best work was written late in her life,
between 1400 and 1403, a long autobiographical and allegorical poem on the
changes of Fortune, a popular theme exemplified in the wall-paintings of Henry
III's palaces, and in the *Romance of the Rose*.

[PLATE 29]

## PROVENANCE

This manuscript was made in England in about 1450 for Sir John Fastolf, whose motto, 'Me fault faire', appears in the book, and was done by the same artist as executed plate 27. It contains two works, a disquisition on the four cardinal virtues, and a letter from the Goddess of Prudence to Hector when he was aged 15. This latter was translated in about 1440 by Stephen Scrope as *The Epistle of Othea to Hector* or *The boke of Knyghthode*, and dedicated to Sir John Fastolf, which was edited for the Roxburghe Club in 1964 by G. F. Warner. Another translation was made about a hundred years later and is ascribed to R. Wyer; yet another, attributed to Anthony Babyngton, who died in 1537, was edited by J. D. Gordon and printed at Philadelphia in 1942.

## FRAME

In this plate, a small square illustration is surrounded on all sides except that of the binding by an enriched margin whose delicately drawn running sprays of fantastic plant forms may be compared with the decoration in plate 27. The small golden leaves, of eccentric shapes, with tendrils and prickles drawn in black ink with a fine pen, are a commonplace of the period, as are the acanthus leaves and other plant forms in brilliant tints, twisted to show the undersides in contrasting colour. The pole-like form to the right of the illustration, which bursts into acanthus at either end and in the middle, and the Tudor roses seen foreshortened, blooming on stems which cross each other, also afford a close parallel with plate 27.

## TEXT

Because the eight lines of verse are written in black ink, where two letters in the first line trespass into the bottom margin of the illustration, they have been touched up in white in order to clarify them against the gold – an example of the detailed care with which the manuscript has been produced. The L with which the verse begins is painted in white designs on a blue ground arranged in little squares on the shaft of the letter, within which is a plant spray in pink and blue.

## ILLUSTRATION

A plain, narrow margin of gold and pink surrounds the illustration, which shows the Duke of Berry, seated, receiving the book from its kneeling authoress, Christine de Pisan. Such courtly pictures of authors presenting books to patrons are quite common, and often show the Burgundian court, many of the courtiers being recognizable. Here, for instance, the rather stocky Jean de Berry is much the same as in the celebrated opening page of the *Très Riches Heures du Duc de Berry*, and although he had long been dead, the tradition of so great a patron of the arts no doubt survived from many pictures. He is seated on a high-backed wooden chair, upholstered in green, with a rug, back-drop and canopy of blue, patterned in the golden fleurs-de-lis that mark his connection with the royal house of France. The canopy is fringed in green, white, and red, with red borders to the backdrop and carpet. The Duke wears a heavy, much-gathered robe of rose, turned back at neck, sleeves and front to show the lining of light-brown fur; this also adorns the turned-back brim of his red cap from which protrudes his grey hair. Tight blue undersleeves are visible, and a short neck chain serves to hold closed the Duke's collar. His invisible feet rest upon a green cushion tasselled in white and gold.

Christine kneels on the Duke's carpet, holding up her book with both hands. She has strong features, and her skin is paler than the Duke's tanned countenance. She wears a black gown and an elaborately draped head veil and white wimple, with the neck cloth drawn across the chin; on the left side of her gown is a slit pocket, faced with white, and its sleeves, also lined with white, hang at the elbows to reveal a narrow fitting undergarment. Her costume, though sober black and white, as befits a widow, is elegant and beautifully cut, and quite appropriate to the ceremony. With his right hand the Duke receives the book, which is bound and strapped in green, with gold clasps and edges. His left hand is raised, palm outwards, to indicate astonishment as he looks down at its woman author.

The room in which the presentation takes place is painted grey, with a floor of bright green tiles patterned in yellow; in the back wall are four tall windows with round arches painted white, which has caused some inconsistency in the perspective, as the one on the left seems to have a white surround while with the rest only the inner edge is white. Just visible is the black lattice-work over the silver which has unfortunately oxidized. To the right and left, close to the margins, shafts of slender Gothic columns support the flat grey roof, and next to these are two round-arched doorways. Above the back wall may be glimpsed a barrel-vaulted roof in brown wood, adorned with red and green, which appears to cover the passage to the right-hand doorway.

Through this steps a courtier in red who clasps a mace. Almost blocking his view is a group of figures near the Duke; some are dressed in mauve and green, one has his hands on his belt, another is tonsured and wears a blue robe, cowled and lined with white fur, over a red tunic. All these courtiers look down at the Duke, while the two front ones raise a hand to copy his gesture and one lays his hand on another's shoulder in order to see better. Another group enters from the left – the man in front, in red tunic carrying a white staff, raises his right hand in the same gesture. All the courtiers wear short tunics, touched at neck, wrist, hem and centre opening of the skirt with brown fur. Underneath these they wear a shirt, either black or coloured and often visible at the neck, long black hose and close fitting black shoes. They also wear patterned belts, which in one case is gold, and have 'basin' haircuts.

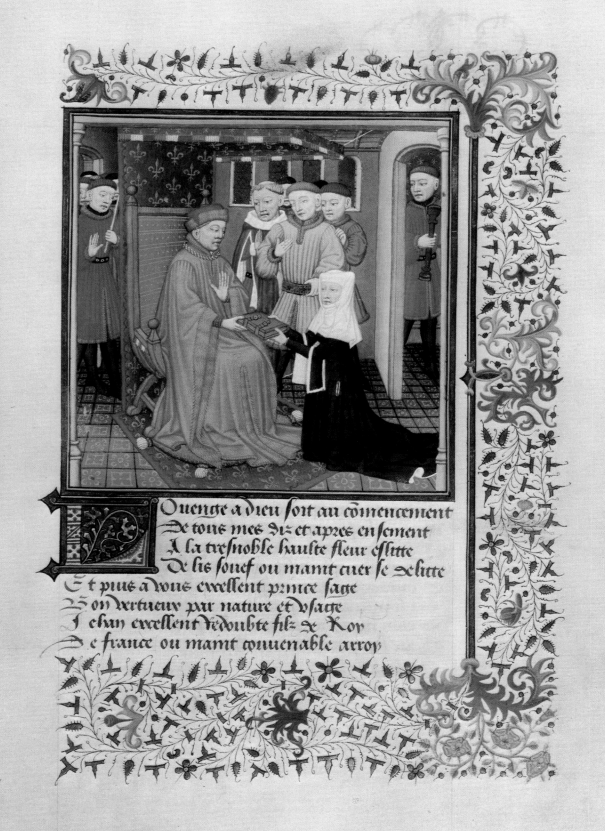

Ouenge a dieu soit au commencement
De tous mes dis et apres ensement
A la tresnoble haulte fleur eslitte
De lis souef ou maint cuer se delitte
Et puis a vous excellent prince sage
Bon vertueux par nature et dusage
Jehan excellent redoubte filz de Roy
De france ou maint convenable arroy

[PLATE 29]

## CONCLUSION

To this delicate and beautifully finished miniature the glimpse of blue sky sprinkled with the asterisks that indicate formal stars adds a touch of mystery. The fair perspective and the great regard for natural appearances make this a good example of that artistic outlook which the Duke's own preferences had done much to promote.

## TEXT

| | |
|---|---|
| Louenge a dieu soit au commencement | Praise be to God at the beginning |
| De tous mes diz et apres ensement | of all my sayings and afterwards also |
| A la tres noble haulte fleur escrite | to the very noble and high fleur- |
| De lis souef ou maint cuer se delicte | de-lis the sweet wherein many hearts delight |
| Et puis a vous excellent prince sage | and then to thee, excellent prince, wise, |
| Bon vertueux par nature et usage | good, virtuous by nature and by custom, |
| Jehan excellent Redoubte filz de Roy | John, excellent and bold son of the |
| de France ou maint conuenable arroy | King of France |

## BIBLIOGRAPHY

O. Pächt and J. J. G. Alexander i.695 (with four bibliographical references)

Rosamund Tuve 'Notes on the Virtues and Vices' in *Journal of the Warburg and Courtauld Institutes* vol.26 (1963)

Colour transparencies on Bodley roll 186G (11 frames)

# THE ABINGDON ABBEY
# MISSAL,
## BENEDICTINE USE

1461, ENGLAND

[PLATE 30]

The Crucifixion
MS. Digby 227 folio 113ᵛ
358 × 240 mm / 14 × 9½ in. (Here slightly reduced)
The manuscript contains one full-page picture, thirteen
historiated initials and marginal drawings on two folios. About
one quarter of the leaves are decorated with single sprays in the
margin springing from decorated initials. The part of the missal
for winter ('pars hiemalis') is in Trinity College, Oxford (MS. 75).

## INTRODUCTION

This folio contains the only full-page illustration in the manuscript, though it does
have eleven 'historiated' initials at the commencement of the various offices. As is
customary in illuminated missals, the illustration of the Crucifixion precedes the
canon of the mass which opens on the facing page with the words, 'Te igitur'. In
this case the initial T (not reproduced here) shows the intended sacrifice of Isaac –
the sacrifice of an innocent being that foreshadows Calvary.

The artist was William Abell, who was paid for illuminating the Eton College
charter of 1447, and the manuscript is dated 1461.

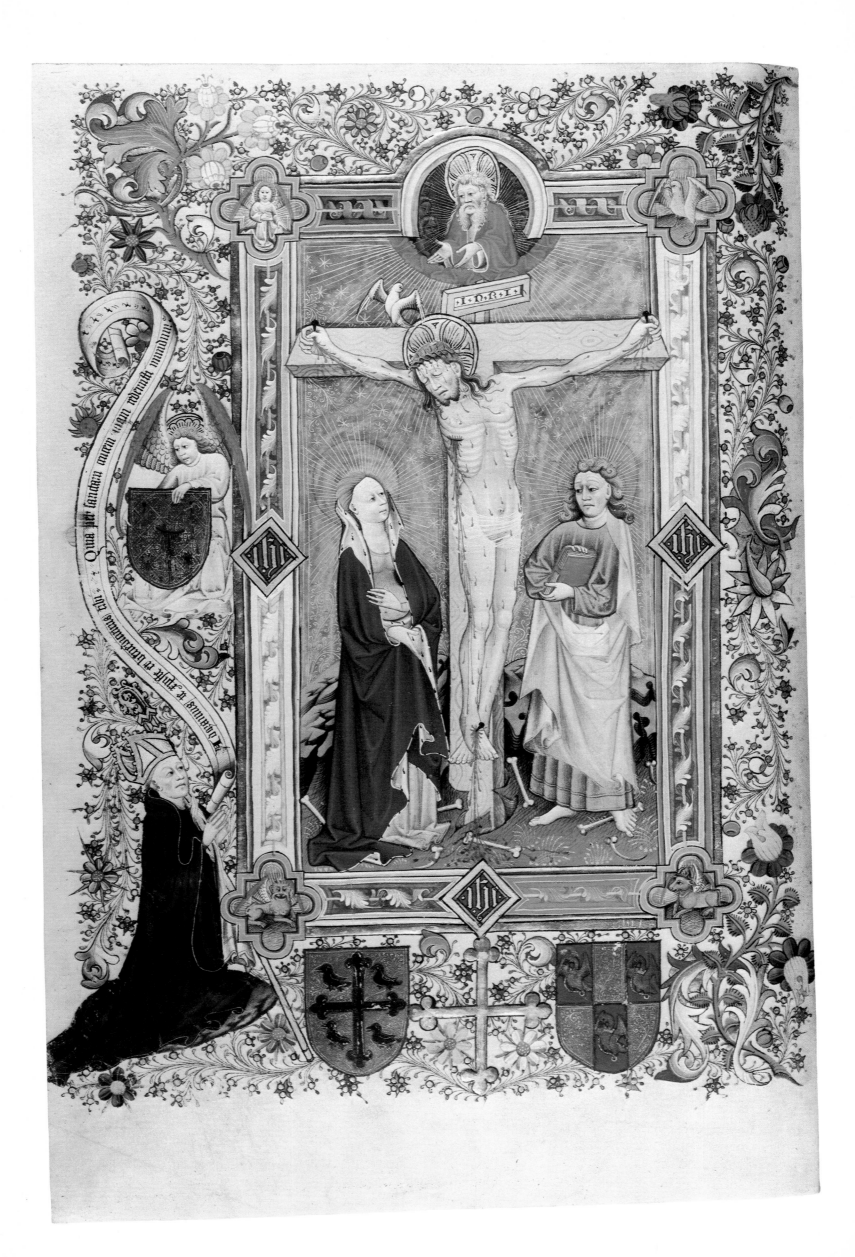

[PLATE 30]

## FRAME

The border of the illustration is exceedingly rich; the background is of curved sprays of fine pen-work bearing various fantastic flowers and leaves in gold and colour. This serves as a setting for various motifs, the most striking of which is that of the manuscript's donor, William Ashenden, who kneels in the bottom left-hand corner. (He was Abbot of Abingdon from 1436 to 1468 and built the Abbey gateway which still stands.) He wears a mitre trimmed with gold and white, applied in solid spots; his black robe is edged with gold; the golden crozier, pressed against his body, is swathed in a napkin. Out of his praying hands runs a scroll, inscribed 'Adoramus te Christe et benedicimus tibi. Quia per sanctam crucem tuam redemisti mundum.' ('We adore Thee O Christ and bless Thee, for by Thy holy cross Thou hast redeemed the world.') Within the curve of the scroll, an angel, with curly brown hair and wings of red and grey, holds a shield of (oxidized) silver, diapered with a delicate white arabesque pattern and pierced with the five wounds of Christ, which bleed freely.

In the centre of the lower border is the golden cross of St John. To the left a shield bears the arms of Abingdon Abbey, to the right those of the Abbot. Both shields are covered with an almost microscopic light arabesque patterning. The arms of Abingdon are 'argent a cross flory between four martlets sable', and resemble, except for a change in tincture, those attributed to Edward the Confessor. The monks of Abingdon claimed that the Royal House of Wessex, ancestors of Edward the Confessor, had founded them. The arms of the Abbot, which are Ashenden's personal ones, are 'on a field of six pieces azure and argent three swans rising silver gorged with a crown and chained or'. Mr Osmond Smith states that this formation is contemporary and points out that in 1456 a coat with six pieces of similar tinctures was granted to the Tallow Chandlers Company but with doves instead of swans for the charges.

The three other corners of the border bear rich sprays of acanthus leaves and large fantastic flowers. The total effect is one of opulence, and exemplifies that 'horror vacui' for which the fifteenth century is famous. A ruled frame surrounds the picture, divided into areas of green, blue, red, and a pale brown; these are painted with a running pattern of acanthus leaves curling round a rod and are nearly monochrome. In the centre of the two sides and the bottom of the frame, a lozenge in blue framed with gold bears the letters IHS (Jesus), also in gold. At the four corners, in Gothic frames of geometric design, are the symbols of the evangelists – an angel (Matthew), an eagle (John), a winged lion (Mark), and a winged calf (Luke). At the top, in the centre of the frame, God presides over all. A grey-bearded personage, with long curly grey hair, He holds His hands out before Him, palms facing inwards, as if to send forth or to receive back the Dove of the Holy Spirit, which perches on one arm of the cross, wings outspread, and head turned towards God. He wears a gown of deep red, ruched to form a cloud-like border below the circle which contains Him, and a golden halo, patterned in black lines of petal shapes and set against a deep blue sky, in which may just be perceived the close-packed faces of His adorers. Rays of gold stream from Him.

## ILLUSTRATION

Below is enacted the Crucifixion. The cross is T-shaped, clearly marked with a wood grain, and somewhat oddly cut about at the base. At the top, on a framed panel, it bears the customary inscription, in Lombardic letters in this case, INRI (Jesus Nazarenus Rex Iudaeorum), which has caused the artist considerable perspective difficulties. Christ wears the crown of thorns painted in green, the colour of hope and new life, and His golden halo is decorated with petal shapes, drawn in black outline. His wavy locks are long and grey, His head lies on His right shoulder. His eyes are closed, His expression showing the pain and suffering which preceded unconsciousness while blood flows freely from the big black nails driven into His hands and crossed feet, and from the wound in His right side. Little, flame-like drops of blood pattern the pale corpse all over. The rib-cage indicates a spare frame, the stomach and navel – the latter somewhat resembling an eye – suggest stress and strain. The loin-cloth is transparent but there is no indication of male sex organs. The hands are somewhat large and coarse.

To the left the Virgin Mary leans slightly away from the cross making a formal gesture with her right hand. With her left she clasps the edge of her cloak which is blue and lined with ermine, traditionally the fur of noble ladies and forbidden to common women. Her sepia robe is adorned with stars, her hair is pale brown. This Virgin has a somewhat prosaic expression, and raises her brows with no more emotion than a woman out shopping, considering a choice of goods.

The artist has managed to imply somewhat more concern on the face of the curly haired St John, who stands to the right of the Cross, clasping a red-bound book in both hands. His gown is pale brown, with a mantle thrown across it, and his bare feet come into uncomfortable contact with one of the bones that strew the ground (the old Adam was traditionally buried at the Place of the Skull).

The background is a warm sepia, enriched all over with fine gold line work. Rays stream from the holy personages, sprinkled with asterisks and fine spray patterns, the haloes of John and Mary being indicated only by a slight change of tint. The distant horizon is formed of green rocks, cut by deep chasms so as to leave the upper surface somewhat like the pieces of a jigsaw puzzle, flat and tilting forward towards the spectator. This ancient formula for depicting rocks persisted long after other Byzantine visual traditions had vanished – whether in the plains of Lombardy or the Low Countries. To the front of the picture, grass is indicated by formal yellow sprays against the green.

## CONCLUSION

This rich page, whose borders are so exquisitely drawn, is

[PLATE 30]

the work of a highly accomplished, if not perhaps very spiritual, artist, a master of naturalistic detail in such matters as highlight and shadow, or the folds in the Virgin's robe, but less certain of his ground when it comes to tackling the perspective of the Cross. He also uses gold sparingly but to brilliant effect. Characteristically he is unable to leave any painted surface without a network of subsidiary ornament, which, in the case of the shields of arms, is a highly untraditional innovation of the period.

## THE DIGBY MANUSCRIPTS

Sir Kenelm Digby (1603–65) was the son of Sir Everard, one of those executed as a Gunpowder Plot conspirator (1605). In 1632, his tutor, Thomas Allen, left him a collection of scientific and historical manuscripts, which Archbishop Laud then persuaded him to give to the Bodleian. In 1634 five chests arrived containing 238 manuscripts. Sir Kenelm was also the donor of thirty-six of the Oriental manuscripts wrongly attributed to Laud. (He was a great traveller.)

Their present order mostly dates from 1641 when they were placed in 'Selden End'. The pictures in thirty-six of them have been indexed, and transparencies of twenty-one manuscripts have been included in various rolls of film. Four Bodleian Library filmstrips have been devoted to Digby manuscripts: geomantic tracts (MS. 46), mid-twelfth-century astronomical tracts (MS. 83), late thirteenth-century French Arthurian Romances (MS. 223) and a fifteenth-century copy of Aegidius de Columna (MS. 233).

### BIBLIOGRAPHY

O. Pächt and J. J. G. Alexander iii.1065 (with seven bibliographical references)

Colour transparencies are scattered on Bodley rolls 80, 101A, 108F, 161D and 184G

# BOCCACCIO, FILOCOLO

c.1463-4, MANTUA OR FERRARA (?)

[PLATE 31]

Amor and Venus
MS. Canonici Ital. 85 folio 25
350×230 mm / 13⅞×9⅛ in. (Here slightly reduced)
325 pages exhibit strapwork initials and there are also five
miniatures.

## PROVENANCE

We are lucky in being able to date this manuscript fairly precisely, as the letter
from one Andreas de Laude to Duke Ludovico asking for payment for copying it
still exists and is dated 30 January 1464. As regards its provenance, the arms on
folios 1 and 25 belong to Ludovico III (1444–78) of the Gonzaga family of Mantua.

## THE GONZAGAS

Although they are one of the great families of the Italian Quattrocento, who
owned a remarkable library, its importance has been overlooked, possibly, as
Cecil H. Clough has argued, because Vespasiano da Bisticci omitted it from his *Le
Vite* out of pique that the Marquis employed a copyist instead of continuing to buy
books from Vespasiano's shop in Florence. U. Meroni's catalogue for an exhibi-
tion of the Gonzaga manuscripts at the Communal Library at Mantua made some
amends and listed the whereabouts of some hundred manuscripts; the collection
is certainly comparable to that of the Sforzas at Milan, the Aragonese King of
Naples and King Matthaeas Corvinus of Hungary.

As early as 1407 the library, under the care of Cardinal Francesco Gonzaga,
contained 392 manuscripts, of which thirty-two were in Italian, and it was im-
proved by his successive heirs in the humanistic spirit of Renaissance Italy. In
keeping with this spirit the illumination is possibly the work of the celebrated
Guindaleri of Cremona, the most important miniaturist at the Mantuan court; the
miniatures are by the same hand as BM. Harleian MS. 3567, and the borders and
initials match a manuscript of Plautus in Madrid. Guindaleri worked for the
Gonzagas right up until his death in 1506, designing brocades as well as painting
miniatures. Unlike ours, the Harley MS. was copied by the famous calligrapher
Matteo Contugi for Cardinal Francesco Gonzaga.

[PLATE·31]

## HANDWRITING

The script exemplifies an important reform in handwriting which took place in Quattrocento Italy, when the pointed letters of the Gothic period were superseded by a preference on the part of Italian scribes for the rounded hand of ninth- to twelfth-century manuscripts. The date of its introduction, however, is a little problematical: Miss Albinia de la Mare regards the earliest book in this roman script, which was executed by Poggio in 1402–3, to be slightly untypical of the latest taste because it is not written in Latin. However, Poggio's successors, mainly in Florence, developed the careful roman and the more rapid italic scripts, which so greatly influenced modern typography.

## BOCCACCIO

It is fitting that the new script was used to transcribe another Italian humanist, Giovanni Boccaccio, one of the earliest writers of Italian prose, who like Dante and Petrarch wrote both in Latin and in Italian. He was born in Paris, the son of a Florentine merchant. His *Filocolo* was translated into English as early as 1566 as 'a pleasant disport of diuers noble personages, written in Italian by M. John Bocace, Florentine and poet laureat, in his boke which is entituled Philocolo, and now Englished by H. G. London, Imprinted by A. Bynneman for Richard Smith and Nicholas England, 1566'. Two later editions appeared in 1571 and 1587. There was a reprint in 1927 and a modernized version in 1931. *Filocolo* is a version, in prose, of the metrical romance of Flores and Blanchefleur.

## OTHER ILLUSTRATIONS
## IN MANUSCRIPT

In this manuscript, there are five important illustrated pages, showing Juno in a chariot drawn by peacocks; a flaming altar with the arms of Gonzaga, Amor and Venus (this plate – from book 2, chapter 1); four courtiers, one with a hawk, another with a little dog; horsemen before a portico in a city square, with a seafront in the background; and a landing stage with the retinue of Fleure and Blanchfleur. These pictures reflect the influence of Mantegna in their sculptural qualities but they are also closely related to some of the frescoes for the month of June by the school of Cossa in the Schifanoia Palace at Ferrara.

## FRAME

A border of elaborate strapwork in blue, green, and pink against a gold ground surrounds the miniature on three sides, the top and the side nearest the binding being narrower than that at the outer margin. The straps are painted to suggest a depressed margin at either side and the 'raised' middle portion is decorated with white dots. At the bottom, the marginal decoration consists of an enrichment of four blue masses of strapwork, surrounding the coat of arms of Gonzaga against a gold ground.

## ILLUSTRATION

The space within the margins is divided into two nearly equal rectangles, each approximately five inches square. The lower one contains the text, written in a pale sepia ink, the lines of capital letters divided by delicate bands of monochrome pattern, three in pink and one each in blue and sepia. The natural tint of the skin is used to make a second colour in these patterns by the device of painting in the applied colour as a background only. Cusps and semicircles, painted by the same method, in pink, serve to give interest to the outline of a gold square at the left-hand side of the text, occupying the position normally given to a large capital letter. Indeed, the golden ground is decorated with a sort of mock capital – an elaborate triangle of strapwork which is painted in the form of a twisted blue rope. This is highlighted in white and a suggestion of shadow is given in a dark blue. To left and right the rope develops into acanthus-leaf forms, blue but curled to display undersides of pink and green. A curled frond issues from the top of each of these upper leaves, in gold, highlighted with white, a fantastic conceit which appears also to be made of rope.

In the miniature, against a very blue sky which pales towards the horizon, three mountain peaks are seen. Even at this late date, and when the passion for naturalism is so strong that the very ropes or straps of the decoration are painted with highlights and shadows, the stratified rocks slide flatly towards the spectator in the old Byzantine way. The two rocky mountains on the left are brown and from them grow woody or bushy trees, individual trees with bare branches and solitary conifers which appear to be blown hither and thither. The mountain on the right, representing Mount Cithaeron, is of grey rock, and seems to be formed of diminishing ovals, grey at the sides and with flat grassy tops, set one above another to form a sort of cone which bursts into a steep peak at the top. Woods, stones, and bushes spurting with greenery are scattered thickly on the green grass. The mountain is surrounded by a grey road, strewn with stones, and there are fields and forests in the valleys around.

In the upper right-hand corner Venus herself stands on a bright, flat cloud of yellow, red, and gold, wearing the mantle of 'inviolate purple' – here a sort of stole of very dark blue, highlighted in gold and draped so as to cover her left hand and arm but reveal her right arm, legs, and torso, which are bare and muscular. She is looking at her son below, inclining her head towards him, and pointing with her right hand at his bow. Her face, most delicately painted, is plump and prosaic, with a pronounced double chin. Her hair, in gold paint, hangs down her back and over her forehead in a sparse fringe, while alternate red and white roses form a wreath for her hair.

Cupid looks straight forward and has struck a muscular pose, his legs wide apart, standing near the base of the mountain which is but little taller than himself. His left hand is supported on the bow, ready strung, while his right hand holds the arrow. Completely nude, Cupid has wings

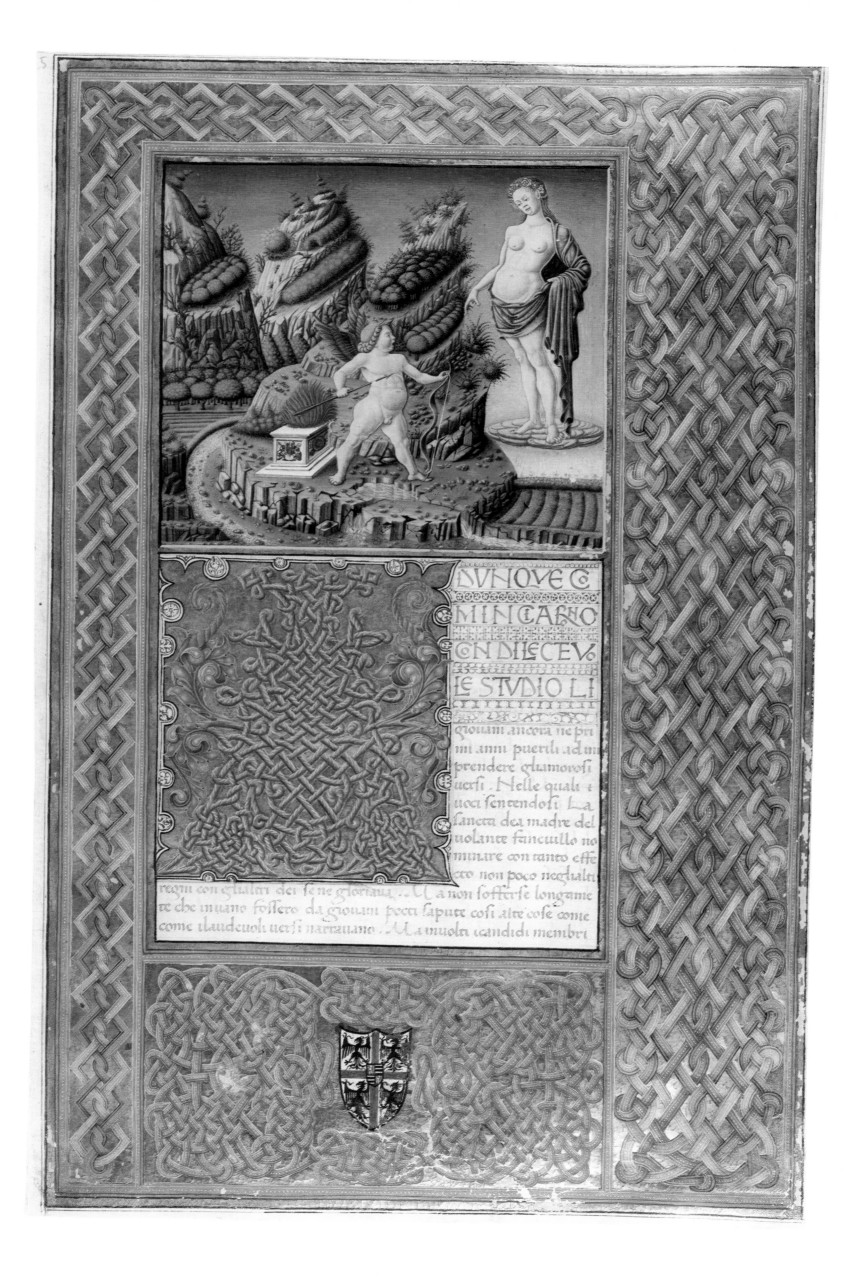

DVNQVE CO
MINCARNO
CON DILECE VO
LE STVDIO LI

giouani ancora ne pri
mi anni puerili ad im
prendere glamorosi
uersi. Nelle quali e
uoci sentendosi. La
sancta dea madre del
uolante fanciullo no
mirare con tanto effe
cto non poco neglialtri

regni con eglialtri dei se ne gloriaua. Ma non sofferse longame
te che inuano fossero da giouani pecti sapute cosi altre cose come
come ilaudeuoli uersi narrauano. Ma inuolti icandidi membri

[PLATE 31]

of green, crimson and blue and his yellow hair, flat at the top, has been curled all round his head as was fashionable at the period. His mouth is open so that he appears to be shouting. Behind him is a stone table altar of classical type, bearing on one side a wreath carved in relief, and on the other a shield with arms, in black and red, two figures supporting it on either side. Like the large shield in the bottom margin, it bears a red cross, but the charge here looks more like black lions rampant than spread eagles. From the top of the altar bursts the fire in which the arrow can be heated and at Cupid's feet is a small basin-shaped spring of water in which he can temper the steel tip. The water flows away in two directions through the rock.

## DRAUGHTSMANSHIP
The artist is clearly highly trained and most able: he applies his paint delicately and is a master of the art of using highlight and shadow to suggest form. Yet the trees and rocks are executed to a formula, and the nudes are rigid and frozen as a result of the artist having been trained to 'draw from the Antique'; he has a Mantegna-esque delight in bunches of foreshortened toes. The traditional mediaeval colours appear rather harsh on the whole, but a most satisfying passage is Venus' beautiful stole with its many folds. This mixture of natural form and archaic proportion marks the transitional period before the complete flowering of technical mastery in the High Renaissance.

## ITALIAN MANUSCRIPTS IN THE BODLEIAN
Italian illuminations occur on over a thousand Bodleian manuscripts and in over 150 early printed books in the Bodleian Library. Of these, over 600 have been reproduced, albeit only in black and white on a reduced scale. The total of Italian manuscripts is 930, but only six are of the fifteenth century. Most of the manuscripts are from northern Italy, and over half were in the collection of Matteo Luigi Canonici. He had acquired many of them from the library of Jacopo Soranzo (d.1760) who had, in turn, acquired a large number of manuscripts from Bernardo Trevisan (d.1720). Some of Trevisan's other manuscripts now form part of the Earl of Leicester's library at Holkham.

A selection of the most beautiful Italian illuminated manuscripts in the Bodleian was exhibited in 1948 and described by Otto Pächt in his *Italian Illuminated Manuscripts from 1400 to 1550, Catalogue of an Exhibition held in the Bodleian Library, Oxford, 1948.*

Plates 26 and 31 are alone reproduced to represent this vast treasury of Italian illumination.

---

## TEXT
Dunqve Co-
minciarono
con dilectevo-
le stvdio li
giouani ancora ne pri-
mi anni puerili ad im-
rendere gli amorosi
uersi. Nelle quali i
uoci sentendosi La
sancta dea madre del
uolante fanciullo no-
minare con tanto effe-
cto non poco ne gli alti
regni con gli altri dei se ne gloriaua. Ma non sofferse longame[n]-
te che in uano fossero da giouani poeti sapute cosi altre cose come
come i laudevoli uersi narrauano. Ma inuolti i candidi membri
(Note: the scribe has repeated the word *come* in error in the last two lines.)

[Here begins the first chapter of the second book which tells how Venus went to her son begging him that, disguised as the king, he would make the young people love each other.]
So the young people even in the early years of their youth began to learn amorous verses. When the holy goddess, mother of the flying boy, came to hear of this, hearing herself mentioned by name in other kingdoms, she boasted about it among the other gods. But she would not allow for long that they should get all these things into their young hearts as these praiseworthy verses told to no purpose. So she wrapped her beautiful limbs [in inviolate purple surrounded by a bright cloud and she alighted on the top of Mount Cithaeron. There she found her beloved son. He was tempering some new arrows in the holy water. She begins to address him thus: 'Beloved son . . .']

## BIBLIOGRAPHY
O. Pächt and J. J. G. Alexander ii.393 (with five bibliographical references)

C. H. Clough 'The Library of the Gonzaga of Mantua' in *Librarium* (Review of the Swiss Society of Bibliophiles) XV, no.1 (1972), pp.50–63

Colour transparencies on Bodley roll 145B (10 frames)

# LA VIGNE DE
# NOSTRE
# SEIGNEUR

c.1450–70, FRANCE

[PLATE 32]

Lucifer
MS. Douce 134 folio 98 (Selden cupboard 45)
235 × 171 mm / 9¼ × 6⅝ in.
There are seventy-five pictures by several hands, of which four
illustrate Antichrist, thirty Judgement, twenty-eight Hell and
eight Heaven.

## OTHER ILLUSTRATIONS IN MANUSCRIPT

Perhaps the most interesting series of pictures in this manuscript is that illustrating
the 'Fifteen Signs of Judgement' which occur on the last fifteen days of the world.
The sea rises up, then vanishes away, the fish roar, the waters burn, the trees sweat
blood, buildings fall, rocks clash together, the earth quakes, the mountains are
levelled, the folk come dumbly out of their hiding places, the dead rise, the stars
fall, the people perish, and the universe burns. Finally, there occurs Christ's Second
Coming. Apart from this manuscript the most striking series is in the fourteenth-
century Holkham Bible Picture Book and the most widely known series in fifteenth-
century stained glass is in All Saint's Church, North Street, York, where there are
explanatory texts taken from *The Pricke of Conscience*.

[PLATE 32]

## DEVILS

However, this manuscript also contains some vivid devils which are so often the subject of the mediaeval imagination. Any cycle of illustrations of the Apocalypse, or of Dante's *Inferno*, would require devils, and they also occur more rarely in contexts such as Christ's Temptation. Also, any depiction of the Last Judgement, such as often stood on the chancel arch of a church, would show devils removing or tormenting the damned at God's left hand, and in any picture of a sinner's death his naked soul is made off with by a devil. In the *Caedmon Genesis* (see plate 4) we see how devils came into existence originally. Although a belief in a force of evil has diminished in the modern world yet the devil's existence seemed self-evident in the Middle Ages. Indeed there were probably more contemporary accounts of him and his works than of any human personality of history, no matter how great his deeds.

Normally in illustrations he is shown wielding a flesh-hook such as cooks use for butcher's meat, but sometimes he carries a hod for his victims. Often he has horns and a tail, and faces often grin wickedly at the points of his body. This particular illustration embodies in straightforward manner the various conventions about him.

## ILLUSTRATION

Within a rectangle which is mainly painted in a pink wash, shading to grey at the top, stand or kneel four devils attendant upon one splendid monster, twice their size, in a symmetrical arrangement of an heraldic character. This central figure is Lucifer, the Prince of Hell. From Lucifer's head spring six others, with flat or hooked noses, rolling eyes, tusked mouths and the ears of beasts. Though grey in colour their eyes and mouths are touched with the red glare of Hell; four of them have single horns, while two sport horns of the apocalyptic beast. Lucifer himself has a face part human, part feline: his fangs are blue and his mouth emits flame while puffs of grey smoke shoot from his ears. His body is shaped like a man's, but his feet are the claws of a bird of prey, he is covered in scales and he displays beasts' faces at the shoulder, below the waist and at the knee. Painted to resemble a dull metallic gold, he carries in each hand a long blue fork with two curved prongs. He is so large that his clawed feet and the topmost of his pyramid of horns trespass on to the parchment beyond the margin. Although the artist has made every effort to render Lucifer a horrifying sight, the carefully foreshortened snub nose deprives him of the appearance of rage and power. His frown is faintly puzzled.

The devil on Lucifer's right hand is painted a livid green, save for his grey head, which is part goat, part boar, and curved horns. Flames burst forth from his mouth and he too bears a curved and two-pronged fork. He wears a tail, and his legs are human, but hairy, while his arms in part have scales. He wears fish-like faces at elbow and shoulder, a nose on the breast bone, and, below the rib cage, a gaping mouth. With his left hand he seems to be calling attention to his presence. Below him kneeling upon one knee is a devil of pale blue, with a fanged but approximately human face, a pair of horns hooked at the top and wings. He too wears a face at the knees and his hands and one visible foot are cruelly clawed. One hand holds the tormentor's fork, while the other seems to be pulling open his mouth to help him spit fire. His body is naked but he appears to wear a clout of the same colour as his body which bears a tail.

On Lucifer's left hand the upper devil has a head like a boar's, but with horns as well as tusks and huge ears. Like his counterpart in green he faces inwards towards Lucifer and breathes fire. His hairy head is brown shading to grey blue on the torso, and his legs are a bright blue. Like Lucifer he wears a face where the trunk ends which, seen in profile, suggests the sexual organs. He also has a curled tail. His right hand would appear to be clutching a curved thorn-like claw emerging from the breastbone, and his left arm is held straight out, the paw clutching his pronged fork. Below him, the fourth devil kneels on one knee and bends his elbow above his head to deliver a blow with his fork. To balance this gesture he has placed his left hand on the buttocks from which springs a curled and spiky tail. This devil is grey all over, save for his green beak like that of a bird of prey, the red fire he breathes and his red eyes. He wears two straight horns. His clawed and hairy lower legs emerge from the mouths of fanciful creatures, as do his elbows. The artist was obviously pleased with this idea of having an arm or knee, or even a pair of thighs, emerging from a beast's face as if from a cap sleeve, a trouser-leg or a shaped tunic. However all this piling on of motifs is in fact rather less horrifying than endearing, particularly in the case of Lucifer, who looks mildly pleased with himself like a masked child 'dressing up'.

## BIBLIOGRAPHY

O. Pächt and J. J. G. Alexander i.710

W. O. Hassall *Facsimile edition of the Holkham Bible Picture Book* (Dropmore Press, 1954), pp.152–6

Colour transparencies on Bodley rolls 89 (Fifteen Signs, 18 frames) 208E (Seven Deadly Sins, 6 frames), 218.6 (Antichrist, 4 frames), 218.7 (Last Judgement, 7 frames), 218.8 (Heaven, 11 frames), 218.9 (Hell, 16 frames)

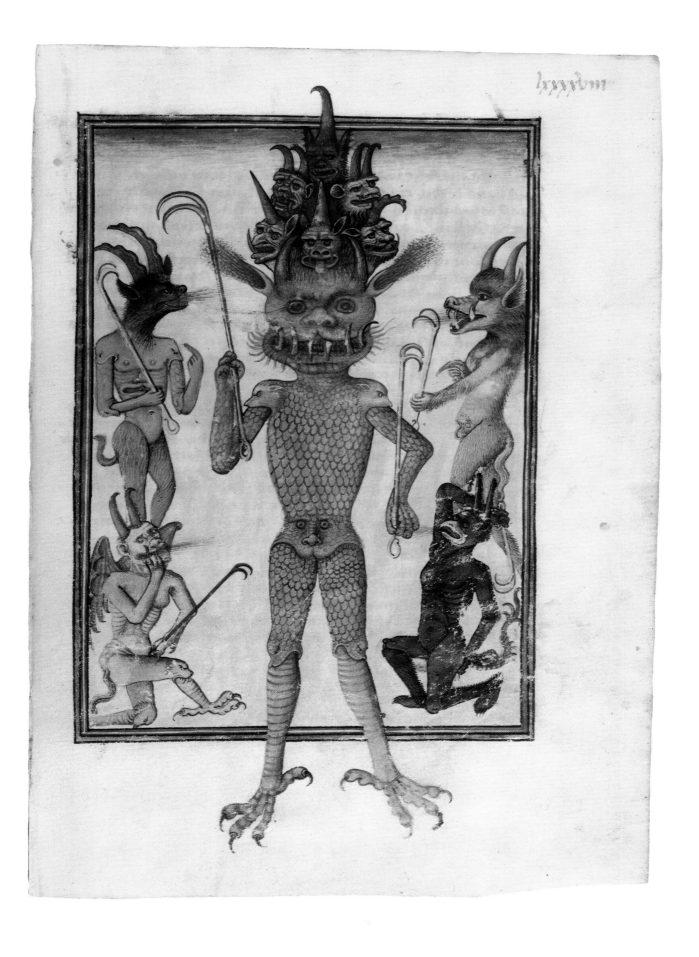

# MORAL AND RELIGIOUS
# TREATISES

1475, GHENT

[PLATE 33]

Margaret of York praying
MS. Douce 365 folio 115
368 × 260 mm / 14½ × 10½ in. (Here slightly reduced)
This manuscript contains four pictures, each occupying about
one-third of a page, in grisaille with one primary colour.

## MARGARET OF YORK

These moral and religious treatises were written by David Aubert at Ghent for
Margaret of Burgundy, being completed in 1475. Margaret, who was originally
of York until she became the third wife of Charles the Bold, Duke of Burgundy
(killed in 1477), was a noted bibliophile (see G. Doutrepont's *La Littérature Fran-
çaise à la Cour des Ducs de Bourgoynes*). The binding of this manuscript bears the
badges of Burgundy and Margaret's arms are in the borders. A similar manuscript
of the *Chronicles of the Counts of Flanders* executed by the same artist and scribe and
which contains Margaret's autograph signature is at Holkham.

Among the members of her court were not only William Caxton, later to be-
come the first Engish printer, but also a painter dubbed by Winkler as 'The
Master of Mary of Burgundy' because he worked for Margaret's stepdaughter
Mary (born 1457), and who according to Pächt designed an engraving for Cax-
ton's first book in English, the *Recuyell of the Histories of Troye*.

## THE ARTIST'S IDENTITY

Attempts to identify the artist have been rather unsatisfactory so far: candidates
are Simon Bening, a member of the community called the Windesheim Congre-
gation at Rooclooster near Brussels, and Nicholas Spierinc. C. A. J. Armstrong
might have found the answer if his search in Margaret's household accounts had
been more productive, but as yet the most likely archives have not yielded up the
secret. Whatever his name was, he proved to be, as Pächt agrees in his monograph
on him, an artist, like Fouquet (*c.*1420–*c.*1481), of the first order, unlike other book-
illustrators whose work did little more than echo the great panel-painters.

[ PLATE 33 ]

## STYLE

Furthermore his later style differs from any previous manner of illumination: 'trompe d'œil' borders seem to project in front of the flat surface of the script, behind which one looks through to a distant scene. An example is a beautiful Book of Hours for Englebert of Nassau, which was published in superb facsimile by George Braziller in 1970.

His earlier style up to about 1480, of which this plate is an example, is more conventional. He employs a grisaille, enlivened by being slightly tinted with delicate gold highlights so that the finished result falls half-way between the richer effects of the panel-painters and the black script of the text (well illustrated in the large colour-plate of the Battle of Crécy in the volume presented by Lord Leicester to the Roxburghe Club in 1971). Also he resembles Hugo van der Goes, in showing part of the interior in a naturalistic style and by using formal elongated proportions which are well suited to hennins or steeple head-dresses – the transitory Burgundian fashion for ladies.

## FRAME

Framing the illumination and its accompanying text is a narrow band of gold, which is a border, wide at the right hand of the page, away from the binding, and the base. This consists of somewhat mechanical arabesques among which formal acanthus leaves of blue, gold, and grey writhe and twist, while some develop into real plant forms, naturalistically rendered, such as violets, strawberry fruits and blossoms, and pink-tipped daisies. Although the text is written mainly in black, the first two lines are vermilion, and the illuminated initial A to the third line is gold with a background of blue and pale pink, delicately embellished with white.

## ILLUSTRATION

The illumination itself shows Margaret of Burgundy praying beneath a canopy whose curtain has been drawn back to reveal her, and is executed in grisaille touched with a little blue and red and two shades of gold. On the left Margaret wears a hennin, its veil still neatly creased from storage. She wears a gold robe with a wide belt and a low neck which, like the hem of her dress, is bordered with ermine. Beneath this is a veiling 'vest' over her breast and neck, as is the case with her ladies, in the form which suggests modesty whilst revealing the flesh beneath. Her narrow sleeves widen a little to come part way over her praying hands and she kneels on a tasselled cushion. Before her, in a round-headed niche, hangs a golden statue of a saint in monastic garments, and a book lies open on a delicate linen cloth. This itself rests on a long table cloth covered in trefoils over what looks like a sloped book-rest but may be an altar, since the setting, with round-headed windows and severe columns suggesting Norman architecture, appears to be a church.

Behind her kneel two ladies, one holding open a book resting in a kerchief, the other with her hands joined in prayer. The further lady is dressed in pale pink with flecks of gold and a wide belt of gold; her collar and hemline are of some dark fur. The other lady wears no belt; instead her dress, opened at the front, is laced across a blue undergarment, and she wears a narrow girdle of gold below the waistline. Her dress is trimmed with narrow gold braid at cuffs, opening, collar and hemline. Both ladies wear the hennin. To the right stands an elegant young man in a fashionable swaying pose. He carries his hat in his hand and his thick hair is a mass of little curls. He wears a long gown cut on a narrow line and tight at the waist, a gold necklace and a red undergarment, opened to show a white shirt. A thin gold girdle descends at an angle from his waist to his left hip.

## DRAUGHTSMANSHIP

The picture is a marvel of delicate workmanship. The 'stipple' technique which is very visible on the architecture and the curtained canopy is elsewhere so delicately done as to suggest, under an ordinary magnifying glass, a fusion of colour. Although the picture is exceedingly naturalistic, despite some trouble with the perspective of the columns, yet the picture retains a strongly individual character by virtue of the convention of the grisaille, and the delicate layers of semi-transparent colours, which give effects of special beauty. This is particularly true of the robe of one of the kneeling ladies, painted in semi-transparent white over pink, then touched with gold and given darker shadows above the ground tint. The quality of the whole makes it easy to understand the esteem in which Flemish art was held in Italy at this time.

Ly commence vng moult notable et deuot traitie
Intitule· Les douze fleurs de tribulation· Prologue

A sa chiere anne en ihesucrist ses loiaulx
anne en nresaignur salut et confort En
cellup qui tous les desconfortez rconforte
Sicomme dit la sainte escripture Nulz ne
poeult loialment amer en lamour de charite cest
de ihesucrist se il na ioye de tous les biens qui a la
sainte ame poeuent aidier de benir a nresaigneur
Et se il nest doulent de coeur par compassion de
tous les maulz corporelz et espirituelz ij la destôbet
de paruenir a la ioye du ciel Sicomme saint pol le
tesmoingne quant il dit· Gaudere cũ gaudentibz
et flere cum flentibus· Mais ilz sont aultves tene

[PLATE 33]

## TEXT

Cy commence vng moult notable et deuot traitie
Intitule. Les douze *fleurs* de tribulation. Prologue

A sa chiere amie en ihesucrist ses loiaulz
amis en n*ostr*e seign*eur* salut et confort En
celluy qui tous les desconfortez reconforte
si comme dit la sainte escriptue Nulz ne
poeult loialment amer en lamour de charite cest
de ihesucrist se il na ioye de touz laes biens qui a la
sainte ame poeuent aidier de venir a n*ostr*e seigneur
Et se il nest doulent de coeur par compassion de
tous les maulz corporelz et espirituels q*ui* la desto*ur*bent
de paruenir a la ioye du chiel si c*om*me saint pol le
tesmoigne quant il dit. Gaudere *cum* gaudentib*us*
et flere cum flentibus. Mais ilz sont aulcu*n*es gens

Here begins a very notable and devout treatise
entitled 'The twelve flowers of Tribulation'. Prologue

To his dear friend Jesus Christ, his loyal
friends in Our Lord, health and comfort. In
that all discomforts give comfort,
even as Holy Scripture declares, 'none
can truly love in the love of Charity that
is of Jesus Christ if he has not the joy in all the goods which
can give help to the blessed soul in coming to Our Lord,'
and if he is not in grief of heart by compassion with
all those corporal and spiritual ills which disturb it
from attaining to the joy of heaven even as St Paul
bears witness when he says, 'Rejoice with them that do rejoice
and weep with them that weep.' But there are certain people

## BIBLIOGRAPHY

O. Pächt and J. J. G. Alexander i.352 (with six bibliographical references)

Exhibited in 'Flemish Art 1300–1700' at the Royal Academy (1953–4) no.592, and in 'La Miniature Flamande' in Brussels (1959) no.192

Colour transparencies on Bodley roll 119A part 4 (5 frames)

# BOOK OF HOURS,

## USE OF ROME

c.1470–80, FRANCE

[PLATE 34]

Priest at death-bed
MS. Liturg. 41 folio 147
168 × 108 mm / 6⅝ × 4¼ in.
Panels showing the occupations of the month face ones with the
signs of the zodiac in the calendar. These are followed by
thirteen full-page miniatures within architectural frames that
illustrate one pericope (an extract from the scriptures), the Hours
of the Virgin, the Penitential Psalms and the Office of the Dead
(here reproduced). There are also twenty-nine small miniatures
for three of the pericopes. Every page is decorated. The
manuscript is incomplete.

## BOOKS OF HOURS

Books of Hours or 'Prymers' were private prayer-books for lay people, and on
those occasions that they were made for particular persons, for example as a wed-
ding-present for a noble lady, they would be beautifully illuminated. MS. Liturg.
41 is just such a copy, produced in northern France about 1470–80. Unfortunately
it is still hardly known, although it does appear in Pächt and Alexander's cata-
logue.

A Book of Hours normally contains the divine office for the various hours of the
day and night (matins, lauds, prime, terce, sext, none, vespers and compline), and
other devotions such as hours of the Virgin, the seven penitential psalms (6, 32, 38,
51, 102, 130 and 143), the fifteen gradual psalms or songs of degrees (120–34), the
litany, and the offices of the dead ('Placebo' and 'Dirige') for matins and evensong.
However as the order of the service could vary from diocese to diocese, so did the
contents of Books of Hours according to the 'use' of the diocese for which they
were made.

This manuscript follows the use of Rome. It starts, as many of them do, with
illustrations of the twelve signs of the zodiac and the occupations of the months
accompanying a calendar: feasting (January), the fireside (February), pruning
(March), flower-picking (April), carrying green branches (May), hay-making
(June), binding wheat (July), threshing (August), treading grapes (September),
sowing (October), knocking down acorns for pigs (November), and finally a
peasant killing a pig while a woman catches the blood in a dish (December). The
rest of the manuscript contains prayers, hours of the Holy Ghost, some hours of
the Cross and commemorations of the saints, the hours of the Virgin, penitential
psalms and the office of the dead.

[PLATE 34]

## OTHER ILLUSTRATIONS
## IN MANUSCRIPT

The thirteen full-page miniatures that illustrate some of these sections are attributed to Maître François ('egregius pictor Franciscus'), and in order to make the more mechanical aspects of production easier, the patterns on the recto of each leaf are traced through the transparent vellum on to the versos. The ten that precede the one reproduced here are: St John before the Latin Gate in a tub of boiling oil; the Annunciation; the Agony in the Garden (Christ kneels before a mound on which stands the cup He wishes might pass from Him – Luke XXII.42 – while the soldiers approach and the disciples sleep); the Baptism of Christ (His clothes are held by an angel – a motif iconographically derived from an antique river-god); the Nativity (Christ lies on a white cloth with His finger in His mouth, half a loaf and a pewter jug rests on a three-legged stool, shepherds, not with crooks, but long iron-shod tools called 'spuds' look over the low stable wall); the Annunciation to the shepherds (a white dog in a protective spiked collar watches a shepherdess making a wreath); the Adoration of the Magi (Christ on the Virgin's knee fingers gold coins in a box presented by the oldest king, while retainers sit on camels beyond the garden wall); the Flight into Egypt (Mary holds some fruit and Joseph a crutch, staff, sack and water-bottle; a maid in a white cap and apron carries a basket on her head behind the donkey; also visible is the idol which, according to tradition, fell when Christ approached Egypt); the Coronation of the Virgin; and David slaying Goliath to illustrate the penitential psalm 'Domine ne in furore tuo arguas me'.

### FRAME

The illustration practically fills the page, leaving a narrow unilluminated margin. On either side, two columns of Renaissance type in buff, picked out with gold and red decoration, support an elaborate late Gothic arch of rather debased type. Upon it is written in red Lombardic letters: circumdederunt. me dolores. mortis.et.per. This architectural framework is completed at the base with a broken wall in carved grey stone, painted with such miraculous naturalism that cracks and chippings are shown.

### ILLUSTRATION

The picture itself shows a death-bed scene. Beneath an elaborate tent-like canopy of gold with red linear patterns, whose curtains are drawn back to reveal the pale mauve lining, the dead man lies on a high pillow, nude but for a turban-like nightcap. His drawn-back lips reveal his teeth, his lids droop, his bare arms lie outside the coverlet, with the hands crossed in submission to God. Above his head, a devil, coloured greenish blue, red, and yellow, with bat's wings, scaly limbs and claw feet, leaps through the air to catch at the escaping soul, as usual shown as a naked figure. But an angel protects the newborn soul and threatens the devil with the cross, while bearing the little figure triumphantly towards God. The Father is shown in an opening at the top of the picture, white-bearded, while golden rays stream from Him towards the new soul who raises his arms high in prayer. Rays also flash from the head of the Father, and He holds an orb surmounted by a cross in His left hand. His right hand gives a blessing.

In the background, the room of grey stone shows handsome, if somewhat fanciful, late Gothic openings. A square window, with small, leaded glass panes in the right hand wall allows a glimpse of the soft blue sky, in marked contrast to the brilliant blue of Heaven behind God the Father. On the far side of the bed, a priest leans towards the dead man, raising his 'asperge' in his right hand to sprinkle holy water, whilst in his left he holds a reliquary in the shape of a building. Behind him, an acolyte carries a processional cross and a dish of holy wafers, and in turn, behind him, six men kneel in prayer. Before the bed, and seated on the rush matting of the floor, a woman prays, her arms folded across her breast, her head thrown back and her face marked with grief. She wears a white kerchief on her head, and a plain but well-cut dress of brilliant blue. On either side of her a seated priest, one in grey and one in black and white, read the office of the dead.

The picture tells us much about how a bedroom in a wealthy household at this period would be furnished. The bed is on a raised platform, the coverlet pink, touched with gold, and the white sheet is turned down over it. The very elaborate canopy is placed at the side rather than the head of the bed (where there would be no room for it), since the artist evidently delighted to depict it and meant to fit it in somewhere. At the foot of the bed, a handsome dressing-table has been covered with a cloth and used as an improvised altar; on it is placed a 'ciborium', an elaborate gold goblet which would contain the Host. A semicircular chair stands to the left of the room.

### CONCLUSION

The picture is painted with careful minuteness and some feeling for human psychology: the formal attitudes and expressions of priests and mourners contrast with the spontaneous grief of the woman. It also balances movement, the flying angel snatching the new-born soul, stretched out in longing towards God, from the fiend at its heels, with the calm, still form of the corpse and the gentle, inclined attitude of the priests. Also, the colours of the death chamber, quiet in the main, though everywhere touched with gold, offset the vivid gown of the mourning woman and underline the violence of her sorrow.

### BIBLIOGRAPHY

O. Pächt and J. J. G. Alexander i.749

Colour transparencies on Bodley rolls 242.5 (24 frames), 242.6 (37 frames)

# JACQUES DE
# GUYSE,
## ANNALS OF HAINAULT

c.1500, FLANDERS

[PLATE 35]

The first six Franciscan friars received in Flanders
MS. Douce 205 folio 32
375 × 270 mm / 14¾ × 10½ in. (Here slightly reduced)
The manuscript contains one small miniature portrait of Jacques
de Guyse in his study followed by eight large miniatures
illustrating various books.

## INTRODUCTION

The *Annals of Hainault* by Jacques de Guyse was translated into French by Jean Lessabé (and not Wauquelin, as stated in the *Summary Catalogue of Western Manuscripts in the Bodleian Library*). This copy is the work of the 'Master of Antoine Rollin' – Antoine Rollin being son of the Chancellor and Grand Bailli of Hainault, Nicholas Rollin, and his wife, Marie d'Ailly. The initials A. M. and the arms of Rollin's descendants occur several times, though by 1660 it had passed into the hands of the Conte de Lalaing.

Its style is that of the southern Low Countries at the very end of the fifteenth century and its provenance is more likely to have been somewhere like Arras or Valenciennes than Bruges. In fact, the manuscript closely resembles another copy of the *Annals of Hainault* by the same artist, and since this is in the possession of the Earl of Leicester and illustrated in a volume which he presented to members of the Roxburghe Club in 1971, it is possible to compare them.

[PLATE 35]

## OTHER ILLUSTRATIONS
## IN MANUSCRIPT

MS. Douce 205 contains eight large pictures and one small one, in which Jacques de Guyse is shown at his desk with a townscape visible through the window. In the others Count Baudoin gives his insolent younger brother his inheritance; Baudoin, Emperor of Constantinople, presents his daughters either to the King of Portugal or his son; Philip of Namur kneels in homage before his brother Baudoin of Flanders and Hainault; Baudoin the brave fights the Count of Nevers; the Imperial Court; Baudoin defeats Gossiun of Avesnes; Margaret, Countess of Flanders and her two sons before the King of France and the Cardinal-Bishop Odo of Tusculum; and the first six Franciscans received in Flanders by the Bishop of Arras at Valenciennes in 1215.

The last incident is the one reproduced here. It comes on folio 32 and illustrates book 20, chapters 70–1 (called in the manuscripts book 21, chapter 1).

### FRAME

Illustration and text together form a rectangular shape slightly curved at the top, and surrounded with a border painted in a yellow tint simulating gold. Near the binding the border is narrow and contains single objects, naturalistically painted, each with its cast shadow. At the top is a single thistle flower, below it a closed bud, followed by a house-fly, two more buds, a small blue flower, a strawberry, and one below the other more buds and flowers. The margin on the outer edge is broader and contains decorative narrow acanthus sprays in grey, which, though purely formal, also have cast shadows. Intermingling with these are convincing, but probably fanciful birds, a snail, and a butterfly in brown and gold, resembling the 'meadow brown'. A spray of thistle and another of pansies are placed amongst the acanthus, the pansy-flowers being considerably larger than those of the thistle. The lower border is widest of all and has the same grey acanthus sprays, on one of which is perched a bird resembling a thrush, his breast stippled with gold. In the centre, between sprays of vetch and strawberry in fruit and flower, is a shield with arms – sable, three chevrons or beneath a crest coronet. This shield has been inserted in place of a predecessor, and now shows the arms of the descendants of Nicholas Rollin and Marie d'Ailly. The insert has been painted on the reverse with the letters A and M in brown and gold joined by a knotted and tasselled green cord on a blue ground.

Margins of other pages also contain identifiable renderings of cornflower, daisy, bee, poppy-seed head, pea-pod, hazel nuts, brown daffodil, bird's eye, pink, speedwell, seed of 'lords and ladies', moth, rose, harebell, dragonfly and lily.

### TEXT

The first two lines of the text are in red and stretch right across the space allowed, even exceeding it, so that the painter of the border has had to make allowances for the extra length. The rest of the text is in sepia ink, in two columns of six short lines and graced by a handsome initial letter R in brown and gold formed of somewhat spare foliage shapes on a ground of pale blue stippled with a darker shade.

### ILLUSTRATION

In the illustration itself the Franciscan friars kneel before the Bishop of Arras, who, also kneeling, clasps hands with the foremost. He wears a bright blue robe, lined with grey fur, and his black cap, with its long, scarf-like tails, lies on his right shoulder. He is tonsured, but, in spite of grey hair and eyebrows, his face is young and unlined. The Franciscans, likewise tonsured, have bare feet and wear the plain hood and habit of their order. This has a knotted girdle of rope and is a plain grey, which the artist has painted in various attractive shades. Most carry staffs, and two have shallow crowned hats. Some have bags, in one case tucked into the girdle, in another case carried across the forearm, while two have leather satchels with a broad strap buckled across the shoulder.

The scene takes place on a grey ground which breaks into green on the right, while the angle of a wall encloses it to the left. This wall has a bench set in it, whereon a book is lying, an entrance arch with 'crow-step' gables and a wooden fence. Beyond this can be seen a series of buildings, gabled, with fairly steep roofs, and round-headed openings. On the left is a large building in blue, and next to it a chapel in grey with a bell-cote. What looks like a third building may be a semi-circular apse to the chapel. The enclosure also has trees growing in it, so many that it seems thickly wooded.

Behind the friars, a path winds through short grass to a walled city, with tall and handsome buildings and a well defended gate. Trees, both slender and bushy, stand near the path, and along it stroll a tiny couple, a man in hose and his companion in a long gown, both carrying staffs and with a microscopic dog before them. Far away rise the towers of another city, blue in the distance, and beyond that the sky is in shades of blue, with a little gold.

### CONCLUSION

This illustration, although belonging to the very end of the fifteenth century, illustrates a stage of art that was common somewhat earlier in the century. For while it displays an intense naturalism of observed detail, the whole suffers from some curious visual discrepancies, which are not always obvious at a casual glance. For instance, although the friars are in some cases further away than the bishop they seem to be painted on a bigger scale, most noticeably in the faces. A similar error occurs in the case of the trees within the enclosure, since they are unnaturally small compared with the buildings. Furthermore, one of them has its trunk in front of the apse-like building, while its head of foliage disappears behind. In fact, the general perspective of the enclosure has confused the artist. The chapel seems to be placed in front of the large blue building, yet its base,

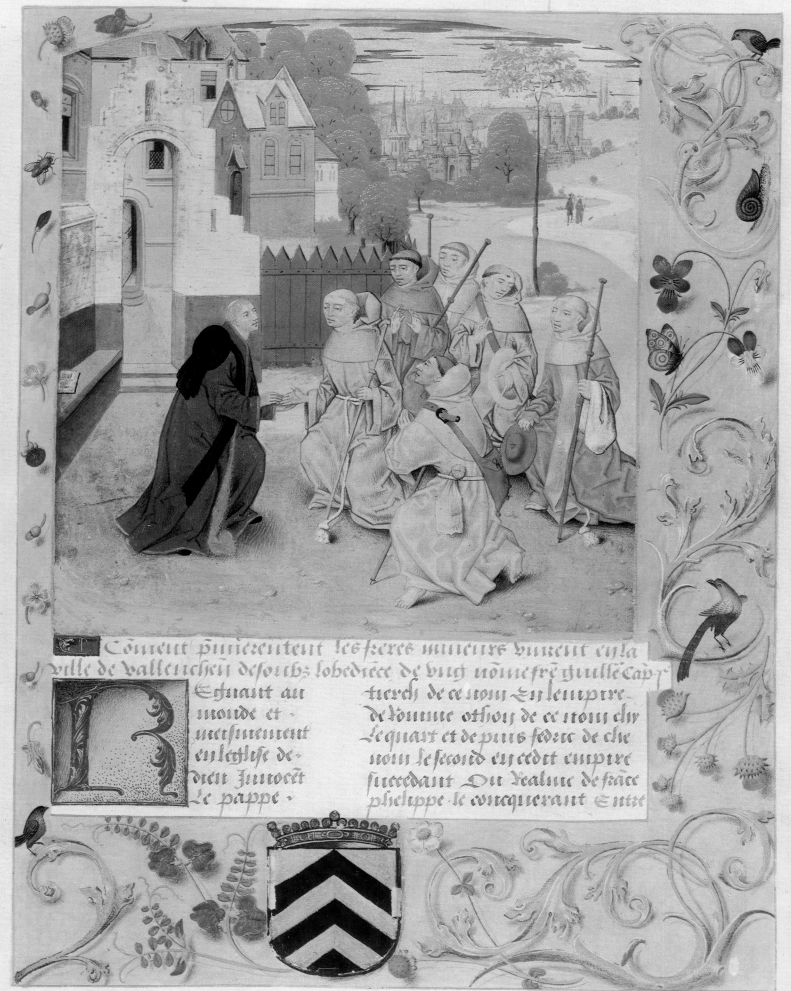

Comment premierement les freres mineurs vintrent en la
ville de Vallenchien desouths lobediece de vng nome fre thuille cap̅s
Estuant au                    tierch de ce nom En lempire
monde et                       detonune othon de ce nom chr
meismement                     le quart et depuis federc de che
en leglise de                  nom le second en cedit empire
dieu Innocẽt                   succedant Ou Realme de frãce
Le pappe.                      phelippe le conquerant Entre

[PLATE 35]

masked in part by the presence of the gabled entrance, is higher, i.e. further away, than the bigger building, and the relative size of the doorways reinforces this relationship. Despite these confusions, the artist has succeeded in conveying the general relationship between the figures and their surroundings, and by adding touches of gold to the illustration he has made the rather sober greys and browns to sparkle.

## TEXT

*Comment premierement les freres mineurs vinrent en la ville de Vallenchennes desoubz lobedience de ung nomme*
                              (*frere Guillaume*      Cap.1

| | |
|---|---|
| Regnant au | tierch de ce nom En Lampire |
| monde et | de Romme Othon de ce nom chy |
| meismement | le quart et de puis Fedric de che |
| en leglise de | nom le second en cedit empire |
| dieu Innocent | succedant Ou Realme de France |
| Le Pappe | Phelippe le concquerant Entre |

How first the Friars Minor came to the town of Valenciennes under the obedience of one called Brother William

| | |
|---|---|
| During the reign | the third of that name; in the Empire |
| in the world | of Rome, Otto of that name |
| and at the same time | the fourth and Frederick of |
| in the Church of God | that name the second in the |
| Innocent the Pope | said Empire. In the kingdom of France |
| | Philip the Conqueror. Between . . . |

## BIBLIOGRAPHY

O. Pächt and J. J. G. Alexander i.388 (with two bibliographical references)

Colour transparencies on Bodley roll 1871 (9 frames)

# CODEX MENDOZA

c. 1540, MEXICO

[PLATE 36]

The site of Tenochtitlan
MS. Arch. Selden A.1 (Summary Catalogue 3134) folio 2
315 × 223 mm / 12⅞ × 9 in.

## PROVENANCE

This comes from an Aztec pictographic manuscript with a Spanish text and is so-called because it was done on the authority of Don Antonio de Mendoza, first viceroy of New Spain, as a present for the Emperor Charles V. Made in the second quarter of the sixteenth century in Mexico, it was sent from there to Europe, only to be captured at sea by the French. It then passed into the hands of the geographer, André Thevet, and from him to Richard Hakluyt, who bequeathed it to Samuel Purchas in 1616, calling it 'the choicest of my jewels'. It is now one of five famous early central American manuscripts in the Bodleian.

## CONTENTS

It consists of three sections: first, a history of Tenochtitlan, or Mexico City, from 1324 to the death of Montezuma II in 1520. The second section lists the tribute due to Montezuma from 371 towns, mostly mantles or other garments, feathers, cotton or fibre, maize and beans (the number of complete suits with feather war tunics was 645, and the small annual tribute of feathers totalled 30,000). The last section deals with social customs – birth, marriage, education, punishment, and dedication to, and life in, both priesthood and army.

Azcatitli

ocelopa

aguexotl

tecineuh

tenuch

xomimitl

xocoyol

tenochtitlan

xiuhcac

acacitl

colhuacan. pueblo.

tenayucan. pueblo/

[PLATE 36]

## USE OF COLOUR

An interesting feature of it is the use of colour to give meaning. Thus males are darker than females; a blue diadem when worn denotes a 'lord', otherwise it means a 'judge'; a blue coil in front of the mouth denotes the ruler's words; black faces with blood in front of the ear signify priests; warriors have black bodies; red is the colour of the heart, yellow that of dead flesh.

## ILLUSTRATION

This plate comes from the beginning of the first section and depicts the beginnings of Mexico City. A rectangular frame of pale blue represents the region of Lake Tetzuco within which are shown green sedges ('tuli') and blue cane plants. A St Andrew's cross of blue streams runs from corner to corner and, at the crossing, is the brown rock on which grew the great 'tuna' plant or prickly pear. When the migrating Mexicans saw it an eagle had made its home there, and since it was surrounded by water and safe from attack, and the nearby countryside was both fertile and full of game, fish, and shellfish, they decided to settle down. Below the spirited eagle is first the prickly pear which grew out of the stone of Tenochtitlan, and second the round shield of Mexico showing seven eagle down-feathers upon it, and a bundle of spears – symbol of the seat of government. Above, the eagle is the 'town house', and at the right is the skull-rack where the Mexicans kept the skulls of their foes – at which even stout Cortez is said to have quailed.

Within the frame sit the ten, whom they chose as the rulers of the new city, with their knees up to their chins. They may be identified in various ways. The supreme chief squats just to the left of the eagle, with the sign of the rock and the prickly pear repeated just to his left. Unlike the rest who have pale brown complexions and are seated on bundles of green rushes, he sits on an ornamental yellow mat and his face is grey with the hair-style and the patch of blood before the ear that signify a high priest. Also unlike the others his mantle bears a fringe, he wears a blue ear plug and a little blue tongue in the air before him signifies his right of speech. Around him sit those of lesser rank, distinguished by symbols such as the hare, the bell, the foot or the willow. They all wear long mantles and their hair is elaborately twisted and dressed with a red leather thong – a symbol of army rank.

Below this are two symbolic battles. The Mexicans, who have grown strong and warlike, are shown fighting and conquering their much smaller neighbours, whose towns, Colhuacan (left) and Tenayucan, are represented as impressive stepped structures in the process of tumbling down in flames. The victorious fighters, who also wear the red leather thong in their hair, are dressed in short tunics quilted for protection, loin-cloths and sandals. They each carry a wooden club, though in one case it has teeth, in the use of which ferocious weapon they were said to be expert. Their shields bear the device of the eagle down-feathers but with seven instead of eight as shown above, and beneath each of these crouches the enemy, bare-footed and unarmed except for the round shield displaying the device of their city.

Around the whole page runs a broad blue margin broken up into small squares, each of which means one year, and each with a significant number of dots which can be translated to mean the reigns of the lords of Mexico. At the bottom right-hand corner above the symbol of the cane and two dots is the symbolic fire drill. This meant that the Mexicans had completed a fifty-two year cycle during which time they carried out all sorts of actions to try and placate the evil fortune said to occur every fifty-two years. When the danger period had passed, the priests, who, amongst other precautions, had ordered all fires to be extinguished, since the earthquakes that were possible in the year of ill omen would cause destruction in a country of thatched buildings, returned from the nearby hills with a new fire.

## CONCLUSION

The drawings are done with delicacy and spirit, with nothing mechanical or dully repetitive about the handling. The colours, applied in thin washes, include black from various soots or ferrous sulphate, sepia from the cuttle-fish, reds from many sources including cactus juice, red earths and cochineal, blue from indigo and turquoise, greens from plants, and yellow from ochre or plant juices. In pre-conquest Mexico the deer-hide pages were first whitened with a sort of gesso, or chalk varnish, to set off the colours and smooth the surface as in European medieval painted panels. Oil was also used to make the colours glisten and perhaps to assist adhesion. The *Codex Mendoza*, however, is on the splendid paper which had come into fashion in Europe during the early Renaissance, and which did not need these elaborate preparations. As long as the colours were thin the stain remains, but a heavily painted green mound at the bottom right has flaked a little.

## BIBLIOGRAPHY

James Cooper Clark (ed.) *Codex Mendoza* 3 vols. (London, 1938) colour facsimile

Lord Kingsborough *Antiquities of Mexico* (1831) colour facsimile in vol. 1

Spanish text in vol.5, and English translation in vol.6

*Codex Mendoza* is not included by A. R. Pagden in *Mexican Pictorial Manuscripts* (Bodleian Picture Books, special series)

Colour transparencies on Bodley roll 113D (73 frames)

# INDEX

References in this index are not to pages but to plates or their accompanying text.